CLAY

Also by Jennifer Lucy Allan

The Foghorn's Lament

CLAY
A HUMAN HISTORY

JENNIFER LUCY ALLAN

PEGASUS BOOKS
NEW YORK LONDON

CLAY

Pegasus Books, Ltd.
148 West 37th Street, 13th Floor
New York, NY 10018

Copyright © 2025 by Jennifer Lucy Allan

First Pegasus Books cloth edition March 2025

ISBN: 978-1-63936-833-4

10 9 8 7 6 5 4 3 2 1

Printed in the United States of America
Distributed by Simon & Schuster
www.pegasusbooks.com

For Madelaine

Contents

What I want to say to you here about our selves . . . arises out of my experiences with physical substance in the transformations of clay, out of my experiences of language, out of my dreams and my deeds, out of my sense of touch and my experience of death.

M.C. Richards, *Centering*

What else can tell you about human life more than a pot does?

Magdalene Odundo, *The Journey of Things*

Introduction

Clay is earth locked in a cycle with water and air that is only broken when we surrender it to fire. Lots of water makes clay liquid. Less means it is mouldable and can manifest our visions in the material world. Subject it to enough heat and it becomes a ceramic form that may survive 20,000 years or more into the future. Because of this, to mould a fistful of clay is to encounter a fission and a fusion of deep time and the human present. This way of making began in our most distant prehistory, and persists into the present.

The Japanese American sculptor and designer Isamu Noguchi described his working with ceramic as a 'close embrace of the earth, as a seeking after identity with some primal matter beyond personalities and possessions'. It is this – an encounter with humbling geological timescales – but it is also about a tactile moment of human creation, because clay contains infinite possibilities in its transmutations, evidenced on the shelves of our homes, our galleries and museums. Every time we make something with clay, we engage with the timelines that are in the material itself, whether it was dug from a clifftop, riverbed or pit. In firing what we make, we bestow the material with function, meaning, or feeling, and anchor its form in a human present.

Objects made from clay contain marks of our existence that collectively tell the story of human history more completely than

any other material. There is a reason there are so many pots in museums: because fired clay is one of the most effective keepers of stories we have. Archaeologists call fragments of pottery not shards but sherds. This book, then, is one of sherds – of fragments assembled and inspected. These sherds do not form a complete vessel that holds human history; instead they show us something about the way we make and create, the way we live and die, about the esoteric and the universal; the intimate and the global; the prosaic and the profound. They are about the sacred and the secular, the natural and the synthetic.

Our engagement with clay as a plastic material that can be pulled from a riverbed and formed in the hand runs further back than our earliest civilisations. There is enough history and narrative in any single ceramic object to write an entire book, but clay contains many more stories than that. As such, there are as many non-potters in this book as potters – if not more – because I wanted to create a cacophony of voices, to explode the narrow approaches that have come before me, that have restricted their writing to pots and vessels and objects. Contained here are the voices of architects and artists, scientists and musicians, poets and geologists, a witch and a geometer. I want to bring them all into the stories told here about this most profound material that almost every human on the planet interacts with daily, whether it's a toilet on the tallest skyscraper or the raw ground on which we walk. The chapter themes emerged from encounters; from questions I asked about the connections between people, places and processes, between knowing and making, then and now, whenever 'then' and 'now' might be.

I am a writer, but I have been working with clay for nine years. I began in a converted shipping container perched on the tidal

salt marshes on the edge of the Thames, guided by a potter and teacher named Madelaine, who was more Socratic than didactic and whose mission was to help people get the image in their heads out into the world. She set no classes, taught no courses; instead she initiated you with a question: 'What do you want to make?'

From Madelaine I learned to handbuild, to throw, to make moulds and coil. I learned how to print on clay, how to manipulate it with wires and wood, shells, shrapnel and gravity. I have clear memories of walking there after a day of work, drawn like a moth to the golden light that flooded from the steamed-up windows on cold dark nights.

Then COVID hit, the studio was temporarily shuttered and I moved house. I did a little work at home in a tiny brick shed in our small back garden. I ran shelves up the wall and piled clay by the door. I paid for kiln firings in other studios, carried my unfired work in taxis, coddled in newspaper and bubble wrap, clutching the box like it contained a new kitten. I yearned for the chaos of the communal spaces that lent me their kilns. I wanted their dirty, messy, busy energies.

I found another shipping container studio for hire, run by a potter named Toshiko who was always in a rush. She told me about Cernamic, a huge community-style studio in an old zip factory behind a row of terraces in north London, run by two tireless potters called Nam and Susie, where I am now a member. It is bustling and happy, teeming with people coming and going, many having just thrown their first pot. Some people make incredible work, others are still learning, but everyone is *making*, and everyone wishes they had more time to make.

I am not a master potter; I am not even a very good potter. I still can't make two things exactly the same and I always have trouble throwing dinner plates. But I've made things I like and

that I use, have gifted things that people treasure. I have thrown the crockery that I now eat off, made candlesticks, fruit bowls, tiles and miniature sculptures. I have mixed my own glazes from white powders and water; I have made large bowls imprinted with the sweeping gestures of my fingertips, and my mantelpiece is lined with my own replicas of figurines dating to the moment when prehistory became history. My shelves are a mess of unfinished experiments: twists of red clay, porcelain origami cranes, a string of glaze tests, slipware chargers. The windowsill holds things that went wrong: a platter perfectly cleaved across its middle by a fault when firing; a bowl made from herbs soaked in slip in a mould; an empty teacup I use daily that was only ever intended as a test but which I have since become attached to.

Somewhere in all this, I began reading alongside all the making. I began asking questions about this material, about what clay could do and where it came from, how things were made and why. I went from making things for fun to making things for research. I mixed up batches of imitation Mars clay (because there is clay on Mars); I trialled glaze recipes; I pulled fistfuls of clay from skips and riverbanks. I went to museums, galleries, studios, archives, and on pilgrimages to see objects and structures built with clay. I have a particular fondness for archives (and archivists), having sought them out for my last book, on the sound of the foghorn, and I sought them out for this book too. I descended into the bowels of the hallowed hill of the Getty to read the letters and papers of potter, poet and educator M.C. Richards. I was able to handle pottery by Bernard Leach at the Crafts Study Centre in Farnham when searching for a glaze designed by Indian potter Nirmala Patwardhan. I spent a day with archaeologist and anthropologist Marija Gimbutas's archives at the magical Pacifica

INTRODUCTION

Graduate Institute, a postgrad college in the dappled canyons behind Santa Barbara. I stepped behind the scenes at the Natural History Museum and the V&A, visited the studios of potter Florian Gadsby, artist Charly Blackburn and repairer Helen Warren, and browsed open studios in Tokoname, Japan. There are places I wish I could have gone: to Iran to see the massed geometric tiling on the mosques of Isfahan; to India to see Nirmala's house garlanded in glazes; to Auroville to see Ray Meeker's fire-stabilised Mallika house. I walked the rooms of museums and galleries from Bogotá to Dresden to Kyoto, but there were dead ends too: in Colombia I went to visit what claims to be the largest pot in the world – a house, made from clay and fired. When I got there after a long and troublesome drive, I found I couldn't quite verify it wasn't made of something else entirely. It has become another story, one that will be told elsewhere.

This book is a beginning. It is the beginning of a lifetime of thinking and making, manifested in words and clay. It is the beginning I wanted to read when I first started making things. It is about individuals, some well known, some almost forgotten, who have contributed to our material histories. It is about pots, but it is also about people, and materials, their hands and their minds, and perhaps hidden among the stories told are questions about the way this history is kept, transmitted and preserved. The first love poem we have is from a bride to her groom, inscribed in clay thousands of years ago in Nippur (present-day Iraq), and this book is my love letter back to the material I received an initiation into in that shipping container on the edge of the Thames almost a decade ago.

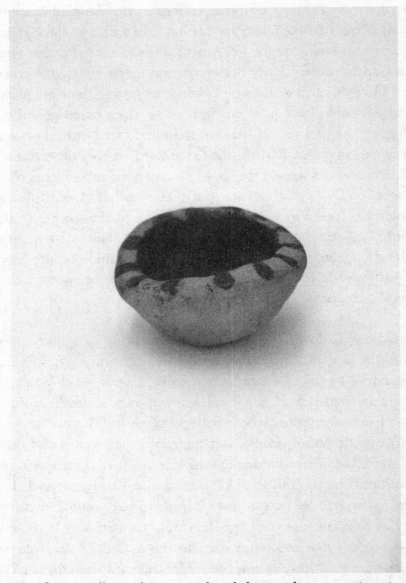

The first small pinch pot made while standing in a river in
Cornwall, fired a week later in an outdoor log burner.
Decorated in red slip found elsewhere on site.

1
Mud

In the beginning, we were clay.

In forests and fertile crescents, clay is and was the primary material from which humans were made. Across cultures living and ancient, genesis stories tell of gods acting as potters and sculptors, forming our bodies from one of the most abundant materials on the planet; bringing us to waking life and giving us souls with words and breath, blood and spit.

Literature on clay as origin material can be traced to some of the earliest known writing. In the *Atrahasis*, an early piece of Mesopotamian literature inscribed on clay tablets from around 1700 BCE, the lesser gods go on strike, tired of digging canals and working farms for those higher up. To ease their exertions, Mami, the midwife of the gods, mixes lumps of clay to make people. The gods spit on them and one is slaughtered for their blood and brains. Seven women and seven men are born from fourteen lumps of clay.

In Greek mythology, Prometheus also creates humans out of a mixture of earth and water, a story 'proven' to be true by ancient travel writer Pausanias, who in his second-century text *Description of Greece* claims to have found two wagon-sized chunks of sun-dried clay at the town of Panopeus that are Pro-

metheus's leftovers. He knows this, he writes, because they give off unspecified 'human' smells – perhaps old sweat and unwashed feet. The clays 'have the colour of clay, not earthy clay, but such as would be found in a ravine or sandy torrent', he writes. 'They smell very like the skin of a man. They say that these are remains of the clay out of which the whole race of mankind was fashioned by Prometheus.'

The Qur'an and the Bible also tell of the first humans being made from clay. In Genesis 2:7, God makes man from clay, and breathes life into him. The Qur'an 23:12 says that man is created from the essence of clay, and one hadith tells of angels coming down from heaven to collect red, white, brown and black earth that is soft, malleable, hard and gritty, from mountains, valleys, deserts and fertile plains, for Allah to use in forming Adam. The Talmud, too, says Adam was 'kneaded from mud', and the Hebrew word for 'formed' that is used in these passages is one often more associated with the actions of a potter.

A Yoruba genesis story explains how people came to have disabilities or deformities. An orisha – a god or divine being – named Obatala makes land, palm groves and light, and is living peacefully with his black cat when he decides to create people. He takes clay from the ground and makes figurines that he lays out to dry. He works hard and builds up a thirst, quenching it with the invention of palm wine. He drinks until he feels 'everything around him softening' but upon returning to his work becomes clumsy. He forgets to finish some figures, or makes them crooked, but does not notice. When the sky god Olorun breathes life into the figures and the people rise, Obatala sobers up and notices his mistakes. Overcome with guilt, he swears off the palm wine for good, and pledges himself as the protector of the disabled, the lame and the blind.

There are more: Chinese texts tell of the mother goddess Nüwa, who makes people from clay when she becomes lonely, moulding aristocrats carefully from yellow clay, then taking a shortcut for everyone else after finding the process too time-consuming. In Hindu mythology, Ganesh was made from clay; the Ainu in Japan tell a story of the first people being made from clay and sticks on the back of a giant fish. Humans are made from clay in the Popol Vuh, in the Korean Seng-gut narrative, in stories told by the Efe and Songye in the DRC, the Māori, the Iñupiat in Alaska, the Malagasy on Madagascar, the Blackfeet in Montana and more.

In a more recent story from Jewish mythology, the Golem is also created from clay. Its origins are thought to be a rabbi in sixteenth-century Prague called Rabbi Judah Loew. The scholar Elizabeth Baer describes how, at the time, the Jewish community in the city were suffering invasions and attacks from outside. The Rabbi, wanting to protect his community, asks the help of God in a dream. God directs him to go to the banks of the Vltava, take the mud from the riverbank and make it into a figure. Then, in a secret ritual that is sometimes told as a chanting of words, or an inscription of words upon the figure's body, the Golem is given life. Baer writes of a version where a *shem* – a paper on which God's name is written – is placed in the mouth of the Golem. In another, the carving of the Hebrew word *emeth* brings the Golem to life. When the first letter is erased, it becomes *meth* – the Hebrew word for death – which stills the Golem. (In one tale, a rabbi must trick a particularly tall Golem into tying a shoelace so he can reach the word he needs to edit.) In all of these versions it is the word – the alphabet – that animates the Golem.

The repetitions in these stories are seductive: we are formed from inanimate matter and given life through the gift of language,

9

thinking, or consciousness. We are earth and we are breath; we are clay and we are spirit. What this means for us as humans when we work with clay is profound. When we mould or throw, we undergo an act of creation that connects us to these stories. It's tempting to imagine a single source for them: a story first told in grunts and gestures with a fist of clay, around recently discovered fire, the story spreading as we spread across the world. All these versions might be modifications that find their root a million or more years ago, passed down until the grunts became syllables, became words, became language.

Clay's predominance in creation stories might also simply come from its abundance. We cannot model with water, or soil, or fire. We can carve wood, but we first need something to carve it with. Even young children can mould clay. It can be dug with bare hands and transformed in minutes.

Over the last seventy years or so, clay has played a role in some scientific theories around the origin of life. This is nothing short of the ultimate question: how did organic life come from inorganic matter? How did something come from nothing? By way of clay, say some scientists.

The way life arises from non-life is called abiogenesis. Theories of abiogenesis explain how organic material gathered and formed to eventually turn into a living cell. Multiple theories feature clay minerals in crucial roles of one type or another. One suggests that the way chemical reactions happen in clays could have provided the spark for life to form. Others suggest that the plate-like structures of clays set the stage on which the material that eventually formed cells gathered.

One of the best-known theories was posed by a scientist called Graham Cairns-Smith in the mid 1980s. He suggested that the

perplexing transition from non-life to life might have been down to the irregularity of the crystalline structures in clays. Simply put, as *The New York Times* described in 1985, Cairns-Smith proposed that it was 'an accumulation of chemical *mistakes*' that led to life on Earth.

Scientist and writer Robert Hazen notes that, until recently, rocks and minerals have been outliers in theories of life's origins, sidelined by theories that begin with water and atmospheric conditions. He details the experiments of mineralogist Joseph V. Smith, explaining how a mineral such as feldspar can have 'millions of tiny weathered pockets' in its surface, which provide a place for molecules to congregate, 'each pore and crack a separate experiment in molecular self-organization'.

More recently, emeritus biophysicist Helen Hansma told me about how she noticed a 'green crud' that had collected around the edges of some mica sheets when she was, as she described, 'playing with her microscopes', growing crystals and the like. She added a drop of water to the mica sheets, and realised it might be a perfect environment for the first inklings of life. 'Granny Says Life Evolved Between the Mica Sheets', read one news story covering the paper she published of her findings. Others think that clays lack the complexity to have fulfilled this role. In *The Vital Question*, scientist Nick Lane, writing on the encoding of the RNA- and DNA-like material required for a cell to form, holds that 'minerals are too physically clumsy to encode anything even approaching an RNA-world level of complexity, although they are valuable catalysts'.

What theories involving clay insist on is that in the beginning, we may have our origins in clay in one way or another. If we did – and that's a big if that will likely never be proven – all these myths and genesis stories might contain a renewed

imaginative force. The earthen bodies in our genesis myths could be understood as latent memories from the clayey soup we came from. Might this knowledge have been inherited as a cellular memory that passed into sacred doctrine – an echo in our bodies like J.G. Ballard's re-emerging reptile brains in *The Drowned World*?

But what is clay anyway? Defining it can either be so simple it's borderline redundant, or very complicated indeed. Anthropology professor and pottery specialist Prudence M. Rice writes that: 'It is of little use to minimise its complexity, for it is clays' very diversity that enhances their desirability as raw material and leads to the variety of objects that can be manufactured from them.'

Clay is made of lots of different things depending on where it is found, such as which rocks weathered to form it, what minerals are present, and where it has been deposited. Clays might be categorised as primary or secondary; for where they're found; for what sort of rock they're composed of. Primary clay deposits are found next to their parent rock. Secondary have been moved, usually by water or weather. Clay by rivers or streams is an alluvial deposit. Lakes leave lacustrine deposits. Exactly what elements and minerals make up the clay affects what the clay looks like and how it feels in the hand, and why pottery made in Philadelphia is a different colour than pottery made in Puducherry. Because clay reveals something of its geology in its colour, texture and plasticity, the clay a potter uses ties them to a place.

Largely, defining clay depends on who you are. A gardener, a geologist and a potter all have different definitions that are applied for different purposes. The *Encyclopaedia of Geology* says clay is 'a diverse group of hydrous layer aluminosilicates

that constitute the greater part of the phyllosilicate family of minerals'. This is not as specific as it looks – aluminosilicates are molecules that contain particular arrangements of silicon, oxygen and aluminium, along with a broad possible range of other elements and minerals. My uncle Nigel, also a geologist but one who taught in schools for decades, gives me a more digestible version. He tells me clay is 'a particle 1/256 mm in size . . . the result of extensive weathering of rocks'. That size boundary is about the simplest scientific definition of clay, and one that's been in use since the nineteenth century, usually expressed as 'less than 2μm' (that's two micrometres) or two one-thousandths of a millimetre. Sand, in comparison, runs from 63–2,000 micrometres.

For gardeners, clay is something different – typically, it's the stuff you don't want too much of in your garden. I ask my friend Jane Porter, a professional gardener, how she describes clay in her line of work. 'Clay is at the far end of the scale when it comes to soil types,' she replies. 'It has the smallest particle size of all of them, and it is pretty uncompromising. The particle size means there's barely any space for air or water to move. It's seen as hard to grow plants in because it doesn't drain, but this also means it's rich in nutrients because they are retained.'

For potters, who can't measure particles and aren't growing plants, clay is largely defined by its behaviour; by what we can do with it that cannot be achieved with soil or sand or rock. Clay for potters is earth that is plastic and can be moulded, shaped and formed in a damp state. It can absorb water, and when subjected to heat will harden to become ceramic.

Many potters now use clay that is refined and bagged in plastic, but I want to pull clay from under my feet, from as close as pos-

sible to where I live and work and breathe and eat, to reconnect with something of myself upon the earth.

It is illegal for me to dig up clay in most of the UK, without permission. I cruise geological survey maps looking for nearby seams. There is always clay under my feet because London is built on clay. I had plans to dig down in my small back garden, dreams quickly shelved when it was revealed that my six-foot square of patio was in fact many patios on top of one another, probably with an air raid shelter at the bottom. I also found two sites in Essex and Kent where the sea is pulling squat clay cliffs into the surf. But coastal clays are usually no good, because the high salt content makes them temperamental and liable to melt.

I ask around for someone to let me dig a big hole in their garden, then discover that the house across the road is undergoing a massive renovation that involves some new foundations. As the skips are filled, emptied and replaced, I see the excavation in sequence: first patio, then gravel, then soil; and then, coming home one night, I find the skip filled with chunks of sticky ochre-orange stuff. I sidle over in the dark, give it a poke. It is sandy, soft, cool – a little damp.

There are two main tests for whether what you have is workable clay: the pinch pot and the sausage. First I tear off a lump, squish it into a ball and push my thumb into the middle, forming a rough thimble-sized pinch pot. I squash it back into a lump, roll it into a sausage between my palms and loop it round my finger. It barely cracks. If the sausage and the thimble hold, you've probably got something workable. This is a little gritty, but it can be easily sieved, so I bring a big yellow trug from my house and fill it with stolen dirt as casually as possible. I scurry back home like a thief, top the bucket up with water from the outside tap, and leave it there, slaking and settling behind the back door.

It turns out skips and roadworks are not bad places to find clay – in the 1960s diaries of potter, writer and activist Emmanuel Cooper, he writes of setting up in London, and how 'there was time to experiment, try out new glazes, to collect clay from holes in the road'. The first extant monograph on the art of the potter, from sixteenth-century Italy by artist and writer Piccolpasso (whose brother was a potter), says clay was dug in summer: 'The men in the potter's art in the city of Urbino use the clay which collects in the bed of the Metauro, and this clay they get in the summer more than at other times,' he wrote. 'When the rains fall in the Apennines at the roots of which the said river rises, its waters swell and become turbid and coursing . . . they leave behind the finer particles of the soil which in their downward flow they steal from this bank and that.'

When the skip clay has slaked, I sieve it to remove grit and other debris. In an ideal clay deposit, no processing is necessary – for the last 10,000 years or more, clay has often been used straight from the ground. But mine might contain small stones, and it's going in an electric kiln, which may cause them to explode.

When the sieved clay has settled, I pour off the water, let the sun do some work, then slather it on a plaster slab like Nutella on white bread. The plaster draws the water from the wet clay. Like frying an egg, the thinner edges cook first, and I can't resist tearing off a chunk and rolling it in my hands to see if it is still workable. It's a little short, perhaps, like pastry, but then it did come from a skip.

I leave it a while longer until it's ready to wedge, a process of kneading that squeezes out air bubbles. I have no idea until I fire it if this clay contains anything that will act as a flux, which makes things melt, or if it has the right chemistry to

hold together. I don't even really know what colour it will come out.

I am excited to fire something from my own street. I test a very small pinch pot, which, once dry, feels worryingly friable, like a muddy sandcastle. I fire it in a saggar (an already-fired ceramic canister that protects the kiln and everything in it if my test clay melts, explodes or gives off corrosive gases). I fire it to 1,000 degrees Celsius and it fails, spectacularly, crumbling when I pick it up a little clumsily, its form made brittle by the intense heat of the kiln. Without lab-level analysis, I cannot really know what's wrong with it, but it likely contains too much of something that is not clay. I later find out I also might have had better results from drying and sieving rather than soaking the clay. What I do know is that it is not good enough to work with. It is a heart-sinking failure, and I mope around for the day. When night falls, I traipse back across the road and, as quietly as possible, dump the unworked clay back in the skip.

I'd been making just with my hands, but I wanted to know what it was like to meet clay with your whole body. Artists have been increasingly exploring the possibilities of clay in its wet and plastic state. In artist and choreographer Florence Peake's performance piece *Rite*, dancers were sunk and slowed in their movements by a floor that was ankle deep in wet clay, following which the stage was cut up into tiles and fired. Others have borne clay as a weight, or fought against it as if questioning the binary between animate mind and inanimate earth. In artist Chinasa Vivian Ezugha's *Uro*, clay is loaded onto her back, lump by lump, and she strains against the cumbersome clods of earth. In the performance artist Cassils' *Becoming an Image*, a one-ton monolith of clay is attacked in the dark by the artist; kicked and punched and re-formed, the

process lit only by a photographer's flashbulb. In sculptor and artist William Cobbing's video works, people are connected by thick clay umbilicals, or transformed into homunculi by bulbous wet clay heads. They stroke their protuberances in squelching petting gestures, or lean in for a thunking kiss, where earth meets earth. It is cartoonishly absurd, but deeply primal.

A much earlier performance took place in 1955, at the First Gutai Art Exhibition, where the Japanese artist Kazuo Shiraga stripped down to a white loincloth and mounted a mound of wet clay on which he 'painted' with his body. The performance was called *Challenging Mud*, and he rolled and squirmed in the sludge, dragging and grasping at its formlessness. It was a new form of painting, he said, the body imprinting on clay and the nothing becoming something through human action.

Yorkshire artist Jade Montserrat's video performance *Clay* was partly inspired by Shiraga's painting, one of a series of vignettes where she made improvised, impulsive performances with her body in a landscape. In *Clay*, she is naked in a muddy hole, kneading and dragging the clay over her body. She pushes clumps of it into her hair and head and around the back of her neck. Many of her gestures, which are spontaneous and impulsive, resemble bathing. In the film's final shot, she is in a worship-like pose.

The hole is perhaps two or three feet deep; a pockmark gouged from a field on a shooting estate, filmed by her collaborators, the duo Webb-Ellis (Caitlin and Andrew Webb-Ellis). The estate is not an aristocratic seat in any sense, but a plot of land used for shooting that belonged to her stepfather, where Montserrat grew up relatively isolated. She had set out with Webb-Ellis on a cold, clear and blustery November day to make a vignette. They came across a hole made by machinery, flanked by a pond dug when

she was little and named after her, where she used to make mud pies and swim. When they found it, 'it was immediately clear I would be making a performance in that hole', she says.

She had also been researching the dancer Josephine Baker, relating it to the way her own idea of blackness had been stifled or developed when growing up on the estate, as the stepdaughter of the white owner of that specific piece of land. 'I had been making these drawings of mud pies, and remembering feeling very content there,' she explains, 'even though I was very lonely as a child. I would mould or fashion something with the mud and clay that I found in the duck pond to the back of me [in the film].'

There's something in her performance about mess – about what we class as dirt. In the film, she moves hunks of turf to get to the clay – the latter didn't feel dirty, she says, whereas the grass and crumbly topsoil did. She sees a connection between minimal urban aesthetics, as sterile signifiers of gentrification, and a break in connection to the natural world. 'I sense a loss of connection to a natural world that shaped me,' she says. 'My efforts are ultimately futile – there's nothing *useful* about it – but by smothering my body; pressing clay *into* my body, I'm making a plea for connection beyond the human.'

The performance happened in a stolen moment, an opportunity taken before Alan, the regular landscaper and gardener, returned to finish digging the hole. It was done by stealth, without permission, and she was criticised by family members afterwards for doing it at all. She says it was tense, frenetic and confusing, despite the outward calm that the vignette possesses. It wasn't until afterwards that she reflected on the resonances of the actions and images. 'Everything was instinct in how I related to the material in that moment,' she says. 'I was

thinking about Kazuo Shiraga, and deliberately being intimate with the material.'

Her nakedness was a necessary choice. 'There is nothing I could have worn that wouldn't have placed a particular emphasis on a time or fashion,' she points out.

She had washed herself afterwards in a stream that is just out of shot. 'It felt good. It was a cold day, but it felt like it does on a crisp day when you get into the sea. There's something that feels clean about doing that. It felt totally natural. Totally intimate.'

Montserrat's mud bath is a reminder of the clash of the human timeline and the deep geological time that patterns our interactions with clay. In descending into the pit, past the topsoil to its sludgy and silky bottom, she seems to me to have got closer to meeting the clay on its own terms. By slathering clay over her body, she returns to the earth we came from – a reverse telling of the origin stories from the *Atrahasis* to the Golem. The gesture of smearing ourselves with clay is a gesture that contains a return and a beginning. I found a profound and humbling sort of spirituality in it. Ashes to ashes; dust to dust. We must return to the earth from which we were formed as a fistful of clay and the spit of a god.

In Montserrat's own history – as a person who is connected in troubled and conflicting ways to the comparatively recent ownership of that piece of land and its geology – the clay offers her a way to circumvent those claims to connect with a different history, one that exists on a timeline much deeper than the legislation that binds that land to a person. 'It's difficult to grasp according to time as we consider it,' she says. 'It's awesome in that respect.'

*

My second attempt at collecting clay from the earth under my feet is more successful. I go and stay with some friends in a valley in inland Cornwall who tell me there's something that looks like clay in the riverbank near their house. I've just arrived, but now is as good a time as any, so they give me a spare pair of wellies and a set of gardening gloves, and we grab a large plastic bag from the boot of the car. We walk through a sloped meadow and down into the stream, a tributary of the River Tiddy. We wade along up the river, using the trees as monkey bars to broach deeper sections, towards a spot where the slate riverbed is banked by what looks like grey clay.

I scrape a finger into the sludge – it leaves a perfect impression. I sink my hand into the bank and pull out a handful, roll it around in my palm. A sausage loop holds, and I roll a ball, sink a thumb into the middle and pinch out a pot. It is sticky and a little springy, like dough. I take another handful, make a neat palm-sized bowl standing there in the river, with the water rushing round my wellies.

We fill the bag and drag it back to the house, where I make a stubby vase and a figurine. By the end of the week, they're dry enough for a firing. We're all excited about the prospect of firing something from where they live. We will burn their fallen trees and the pottery in their outdoor stove, so the palette will be literally of this place. The stove will probably reach somewhere around 300 degrees, although I have no pyrometer to check it. This is not hot enough for much to happen, but since the skip clay crumbled, I've become more interested in the process than the product.

We pile up the pots in the fire and fiddle with the placement of the logs before lighting it. Should we move that one? Will we

push that bowl further in? Should we keep the fire raging or let it burn down? As the flames flicker, I keep expecting our clay creations to fall apart, melt, or pop into pieces, but they don't. Over the next few hours, they continue to hold firm, and I'm surprised. I don't know what sort of chemical transformations are happening, if any, because I have no idea how hot the fire is, and I know there's a lot of heat escaping.

Some time later, by which point they've stayed solid in a few hundred degrees of raw flame, I get excited that this most basic of making and firing might just work. As the wood burns down at bedtime, we cover the stove and leave it to cool overnight.

In the morning, I pull on my boots and a jumper and run down to the burner to see what is left in the ashes. Some sort of miracle has occurred, because the pots are all where we left them, sunk in grey ash, whole and solid. I pull each one out and brush it off – the wood firing has turned swathes of the pots orange, a flashing that wraps around the forms that is the result of atmospherics in the wood firing, along with smoke blushes on the side and a splash of caked-on ash deposit (which might have smelted to a glossy glaze had this been a higher temperature). I tap them, and while they don't exactly ring, it's not the dull sound of soft material, and the clay doesn't scrape away under a nail. I take them to the sink and scrub them off. We put them on a piece of slate on the windowsill that's also been pulled from the ground. The fire has rendered the clay in orange, oxblood and smoke stains, which sit pleasingly against the dark slate. It is a palette that makes sense: a palette of place; an echo of the woods and the water, the skies and the stone.

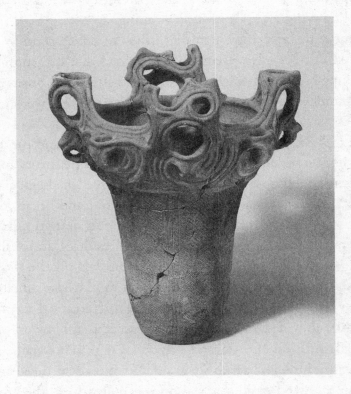

'Flame-Rimmed' cooking vessel (Kaen doki)
from Japan, Jomon period.

2
Fire

Fire is transformative. It is 'the ultra living element', writes French philosopher Gaston Bachelard. It is 'cookery and it is apocalypse' and it 'shines in paradise' and 'burns in hell'. Clay's ability to eternally oscillate between liquid and solid is broken by fire. Placing one's pots in the kiln is a surrendering to its opposites; to unpredictable forces that the writer and ceramicist Daniel Rhodes described as a 'giving up to metamorphic forces', in a way that is about chemistry and alchemy; physics and chance.

The application of fire to clay is the reason we know so much about our own history because clay fired thousands or tens of thousands of years ago persists into the present. If clay in its raw state presents infinite possibilities, fire extinguishes those possibilities in a thousand degrees of heat, fixing forms, words, images and fingerprints of the past. The fire that licked my Cornish clay was wild, and in comparison to most pottery firings, a very low heat. It did not reach high enough temperatures to force the chemical change that turns clay into ceramic.

There are simple ways of firing clay, in ad hoc bonfires and pit firings, and there are complex ways of firing clay, which might involve the addition of other materials like soda, the restriction of

oxygen, or the 'holding' of temperatures at particular points in the process to induce chemical reactions in a glaze. The temperature at which different clays fire is the main way they are categorised. The West divides clays into categories of earthenware, stoneware and porcelain. In Asia, no separate porcelain category exists; it is counted as a type of stoneware.

Earthenware pottery is clay that fires below around 1,100 or 1,200 degrees Celsius. At this level of heat, the clay may not be fully vitrified, meaning it might still absorb some water. Earthenware is often unglazed, like Berber pottery, terracotta plant pots and many large storage vessels made across traditional rural communities. Earthenware water jars can keep water cool because some of it evaporates through the walls of the vessel.

Stoneware is fired at higher temperatures of over 1,200 degrees. While in the UK, firing temperatures are often given in degrees, the heat of a kiln is more often measured by pyrometric cones of specific clays, which are placed into a kiln for the firing. They bend, then droop to show a temperature has permeated the cone. They were invented by a German ceramicist called Hermann Seger in 1886 – he called them '*kegel*', which means bowling pins. Josiah Wedgwood also developed a way of measuring heat through clay hoops that shrank at certain temperatures.

Counterintuitively, a numerical temperature reading from a kiln is often less reliable than a cone, because it will only be accurate for one area of the kiln. Cones are considered more accurate because they are designed to bend or collapse under grades of 'heat work', which does not just determine temperature but includes a measure of time as well, showing how the heat has penetrated the material.

The first firing of a pot is called a biscuit or bisque firing. It runs to around 1,000 degrees. The second firing is for glazing.

These rules are not hard and fast: there are single-fire glazes, while some vessels are fired again and again to intensify surface effects. Separate firings for biscuit and glazing have only been around for a few hundred years. The second firing is usually somewhere between 1,200 and 1,300 degrees Celsius. That might only be 100 degrees of difference, but the breadth of colours achievable from the same glaze at temperatures even 30 degrees apart can be vast.

While the advent of electric kilns in the last century has provided acute control and regulation of temperature, there are still plenty of potters, sculptors and artists who chase a success that exploits not control, but chaos. In pursuit of such a firing, I drag myself out of bed on a cold, sunny winter morning, and take myself and my hangover down to Woolwich, in south-east London.

I hop on a bus a few stops out of town to an industrial estate, where I trace access roads to a huge complex of artists' studios within throwing distance of the Thames. I round a corner to see my friend Charly Blackburn coming towards me in a thick woollen hat, green overalls and a bobbly jumper, wheeling a big silver bin in a supermarket shopping trolley. 'This is my kiln!' she says brightly. 'Come on, let's get it into the yard.'

'The yard' is a boxed-off corner of a car park, a single car space blocked off with garden fencing, with nothing much inside except a paint-spattered old sink. It's for doing dirty work like spray painting, or in Charly's case, high-speed gas firings of ceramic sculptures in what is essentially a souped-up rubbish bin.

Charly is an artist who started out in ceramics making friable raku vessels – spheres and fishbowl forms dunked from a gas kiln into a trough of burnable materials like sawdust, horsehair or dried leaves, gifting their crumbling surfaces oily charcoal

smudges and smoke bruises. She has since moved into more intensive alchemy, experimenting with short raw firings, and a parallel, opposite set of experiments in more lab-like conditions, to create surfaces with crystalline blooms. Today, she's doing the former.

Charly gathers the equipment she will need: a canister of propane gas, a seven-inch Bunsen and bendy pink pipe, a brick to prop it up on and a pyrometer to measure the temperature. The bin is the type you'd use in an allotment: galvanised steel with a lid that has a stubby chimney. There are holes punched around the bottom and it stands on short legs to keep the base off the ground. Inside it is lined with ceramic fibre – a white squashy blanket that will insulate the bin and can withstand temperatures of up to 1,260 degrees Celsius.

We walk back across the car park to the studio, where Charly shows me what she will be firing: tall sludgy piles that look like decomposed coral, or the frozen remains from a bilge pump.

The sculpture she's firing today has been curing for a couple of months. It is made mainly from terracotta and salt, which has encrusted it in a spiderweb frosting of criss-crossing crystalline formations. When we carry it out of the studio, the surface that looked dull under electric light glitters a little in the winter sun. We trek back across the car park to the yard. Charly lifts the sculpture carefully into the bin, stabs the wand of a pyrometer through the ceramic fibre and puts the lid on.

And then we light the gas.

The flame roars through a hole in the bottom of the bin kiln. She starts low – low-ish, anyway – and the temperature on the pyrometer begins to climb. Bit by bit, she inches up the gas, and as the Bunsen starts to roar, the numbers on the pyrometer begin to tick up faster and faster.

She doesn't make what we might recognise as pots any more, and is instead making these sculptural pieces, which are full of salt. Salt is corrosive. It can act as a flux, lowering melting temperatures, burning out kiln elements and affecting clays and glazes alike with an immense chemical power. Changes have been happening in these pieces since she piled them up and left them to dry, and reactions will continue on and under the surface even after the firing.

Charly is interested in the elements of her process that are uncontrolled: what unexpected chemical reactions might bring about. What she's after is something that looks like it has been created without human touch. She wants a sense of movement and 'liveliness', which can come from the sculpture being made from a mixture of materials that have different melting points. She wants texture and colour – any colour, so long as it isn't brown. Successful pieces look like they've been belched from the ocean floor at the bottom of a marine trench; like stalactites chipped from cavernous geodes. A failure means 'a load of boring beige', she says. Whether a piece comes out as a spangled ceramic armature or as leaden debris is always unknown before the firing. She has built a sort of tacit knowledge of what *might* happen, an informed intuition based on an agglomeration of facts, understanding and experience, but she cannot tell me what exactly *will* happen, and afterwards may not be able to explain what *has* happened.

The brutality of this firing is the antithesis not just of an electric kiln firing, but of most traditional gas and wood firings, too. Usually in a kiln firing the temperature is brought up slowly, on a controlled and monitored curve. Anything too hot and fast can cause faults: can vaporise water and explode pot walls; might send glazes awry or create combustions that threaten the stability of everything in there. The velocity and drama of those reactions are

exactly what Charly is inducing. She is chasing these unruly aspects of fire and clay through permitting the wild and unpredictable variables other potters might want to control. The outcome might be affected by any number of factors: by the humidity of the studio where her work has sweated; by the outside temperature on the day; by the wind and weather or the internal make-up of the sculpture at the moment it is fired. The often-repeated maxim is that one potter's defect is another's special effect.

The numbers start climbing by the second and we're soon past 100 degrees Celsius. After fifteen minutes, we're past 300 – hotter than a domestic oven. Charly fiddles a bit with the Bunsen as it's not quite lined up; a finger of flame bounces off the edge of the hole, meaning there's some heat loss. She adjusts it and the temperature continues to climb. Somewhere above 700 degrees Celsius the fire escapes its confines and a flame begins fluttering yellow-orange from the stubby chimney, like a tongue searching out the sky.

Charly does a few things to harness the forces at work, but for the most part she ramps up the gas and pulls it down when she feels it's ready. She occasionally leans near the chimney to see if she can see any reaction. When she stops, what temperature she heats to, is partly a gut feeling. She reckons she'll need some-where near 1,000 degrees Celsius for good reactions – which is an earthenware temperature used for terracotta and garden pots – but the salt reduces the temperature at which things start to go gooey.

After an hour or two, we hear something. Not so much a noise as a change in the noise coming from inside the bin kiln. Standing a couple of feet away, Charly tries to find an angle whereby she can peer down the chimney without losing her

eyebrows. In most normal kilns there are peepholes of one sort or another. Here, there is just the lid and the chimney. Wearing huge yellow fireproof gauntlets, she tentatively lifts the lid – an action that itself might change the outcome as cold air is sucked into the bin, but she can't resist. She felt that something shifted, and it did. The sculpture has begun to change. 'We've got some movement,' she squeals. 'At least I think so . . .'

At 800 degrees the ascent slows to a crawl. Into the 900s we both spring into action, pacing around, trying to peer down the chimney. The last 100 degrees tick up painfully slowly.

At 990 degrees, Charly thinks it's the right time to stop. She watches another few degrees tick up, umming and ahhing over when to pull the heat. In a normal kiln the temperature is brought down slowly – a general rule of thumb is to have at least as much cooling time as firing time. Wood-fired kilns are left bricked up for days – anything from three days to a week – before being opened. For Charly, there is far less waiting around. She leans over, turns the gas off, pulls the burner away from the hole. She dons the yellow fire gauntlets again and whips off the lid. At this point the chilly outside air and the glowing interior of the bin meet. More reactions will be caused by this unruly infraction. We peer briefly inside, our faces seared by the heat.

The bin glows red and molten, and the sculpture looks slumped to one side, as if one of its legs has given way. As the air cools the throbbing interior, the highest tip begins to blacken and the edges are picked out in ridges. 'It's very black,' she says, sounding slightly disappointed. A few firings ago she made a dull coal-like lump, and she is hoping this isn't a repeat. But we won't know anything until it's cool enough to move, so we go for lunch while the cold air does its work.

This method of firing is satisfyingly fast. A standard modern electric kiln takes around a day to climb ever so slowly up and down its pre-programmed temperature curve. A wood-fired kiln takes days to fire, and is often the work of a small community, temporary or fixed.

What Charly is doing is akin to a messy, urban version of traditional bonfire or pit firings without kiln architecture. These are easy, fast, also unpredictable, but have successfully produced earthenware pottery for thousands of years, if not more. Pueblo potters in New Mexico fire with dung and scrap metal, and in large open bonfire firings in Mali, pots are stacked then covered with branches and grass. These firings also take hours not days, and while they can't reach the same temperatures as kiln firings, they are relatively immediate, and involve almost direct contact with the fire.

Different types of kilns produce entirely different effects on the surface of a pot, even at the same cone or temperature. The orange flashes and smoke clouds from a wood firing are colours and surfaces that cannot be achieved in an electric kiln, for example. In turn, a wood firing cannot produce the uniformity in colour that an electric one can, and an electric kiln will give different colour results than a gas firing. Even within the same kiln, firings can produce a wild spectrum of effects, as the passage of heat around the objects, or the flames that smother their surfaces, are written onto the pot.

The principle of a kiln is simple, although the design can be frustratingly complex to make efficient. Heat is generated then directed into a chamber, where it meets the wares to be fired and is trapped, built up and managed through the kiln's capacities for convection, conduction and radiation of heat. Piccolpasso wrote that Italian potters considered the actual construction of a kiln

to be fundamental to the art of pottery: 'The manner of making the kiln [is] as an important secret, and [they] say that in this consists the whole art.'

There are as many types of kiln as there are types of vehicle: muffle kilns, tunnel kilns, bottle kilns, clamp kilns, scove kilns, Cassel kilns, down-draught kilns, beehive kilns, climbing kilns. There are dragon kilns that snake up hillsides. There are kiln designs named for the place they were built in: Sèvres kilns in France, Khmer kilns in Cambodia.

The vast differences in the design and construction of kilns have defined who could produce what at different points in history. Advances in kiln technology – bigger kilns; more efficient kilns; kilns with fireboxes that push temperatures higher in the firing chamber; kilns that could be better controlled – have literally and metaphorically fuelled or stalled advances in the production of pottery. Advanced kiln technology was the key to porcelain manufacture in China and held up the production of the same in Europe. In China, kilns that could reach high temperatures were developed hundreds of years before anywhere else in the world.

Robert Finlay describes how even in the Neolithic period, kilns in China could reach 800 degrees; by the Shang dynasty's rule in 1600–1046 BCE, kilns could reach stoneware temperatures of 1,200 degrees Celsius (which would take European kilns thousands of years to achieve). A major innovation came in the Warring States period, 481–221 BCE, with horseshoe-shaped mantou kilns that were built into hillsides of loess (an often yellowish silty sedimentary soil) and could reach 1,350 degrees Celsius. Then the dragon kiln arrived – a multi-chambered climbing kiln also adopted in Korea, and later developed in Japan into the anagama kiln.

There are still dragon kilns in operation – some old, and some newly built on these ancient principles. Their arched brick backs are said to swell as though they are breathing, as the bricks expand under the intense heat of a firing. They take days to load, days to fire and even longer to cool. In a luminous essay on a firing he attends at his friend's anagama in Oregon, the essayist Barry Lopez writes of looking through a port: 'I actually saw the current of white heat moving slowly through the kiln. It flowed visibly around sculpture, vases, and kimchi jars, stroking the larger pieces . . . It moved through like a storm front, unfolding over low hills and a wooded plain, a silent susurration.' The pots inside look like 'spectral eggs visible in a fundament of white heat', the peephole like a door to a parallel world, the inside of the kiln existing on a wholly different plane to the jumble of seats and muddy oomska he describes surrounding the kiln shed.

A pot needs to be dried fully before it is fired (unfired clay pots are called greenware). A pot might look dry – might even feel dry – but it might still be wet inside. Fire it too damp and it will explode, when the last of the water vaporises into steam instead of being drawn slowly from the clay. Most pots need a week or two to dry. In winter it might take longer; in hot summers it might be a couple of days. Even when bone dry, a pot still contains water, chemically speaking, so firings begin slowly. It must sweat out those last drops of moisture gently.

I once decided to have a go at firing a wet pot in a stove. I knew it wouldn't work but I wanted to see what would happen, to see how casual one could be with the most profound and elemental part of the ceramic process and still produce a pot that might hold water. I made a couple of pinch pots and a figurine,

got the fire going and propped them on a ledge inside. I shut the door, and heard them go: *pop, snap, bang.* They all exploded. I had known this would happen, but I wanted to experience the conflagration, to better understand the difference between a cup whose base had popped into tiny pieces and one that could not just hold liquid but outlive me by thousands of years. The pots were too wet and the fire was at once too hot and too cold. Firing in a stove is not the problem, as I had found in Cornwall, but still-damp clay going straight from a cold kitchen to a hot fire was a thermal shock inducing changes that put a strain on the form, which broke the bonds that kept it whole, shattering it into pieces.

A firing begins slowly so that the water can gradually evaporate from the clay – punching up to 100 degrees too fast will cause the water to turn into steam and might destroy the shape. Between 300 and 800 degrees, organic matter will decompose (but not combust). This is not, and should not be, lumps of soil or twigs, but largely invisible vegetal dust that has worked its way into the clay. It is said that if you are in the kiln room when this decomposition of organics happens, you can sometimes smell it – a hot compost whiff coming from the kiln. During this, at 573 degrees Celsius, as the kiln's interior begins to throb with a dull red glow, the clay undergoes what's called a quartz inversion (where quartz turns from alpha to the beta state, causing it to expand and contract on heating and cooling).

This heralds the most important part of a firing, called the ceramic change. This is where the fundamental structure of clay changes into ceramic. When the water is freed from the clay, it shrinks and the whole form is held together as crystalline structures that are only just touching. This is called sintering,

where similar particles are held together in a seemingly impossible stasis. Particles at this stage in a firing have just the briefest points of contact but hold the object together in a way that *The Potter's Dictionary* describes as being 'as if a vibration at these points creates an incandescence of sufficient heat to fuse the tips together', and which Rhodes describes as the pot suffering 'a kind of death' in the extremity of its transformation.

After this occurs, the material can never be the same again. 'That's the point at which there's no going back,' the artist Keith Harrison once explained to me. He described how, while studying ceramics, he would stand outside the kiln and watch the temperature silently tick past. Above 600 degrees he knew a threshold had been passed and an irreversible transformation had happened. It was a moment he savoured and respected, he said, but that was usually utterly out of sight and otherwise undetectable.

The crystalline structures then become welded together with glass, and particles form crystals. The original clay has microscopic pores in its surface, which are filled, and then dragged into this chemical change, and the kiln interior becomes incandescent. It burns orange, then yellow, and – if the temperature is pushed to 1,300 degrees or above – will glow in a blinding white light of white heat.

Once a pot has survived this structural transformation, it must enter a process of cooling down, like a runner after a marathon. It's not just the heating part of the firing process that induces chemical reactions, but the speed at which the ceramic is cooled.

Opening a kiln, even for those on their thousandth firing, is heart-pounding and nerve-racking. What's within are objects nobody has ever seen before, so each opening is a birthing of sorts. It is the moment where months or weeks of work are

revealed; whether the thing you imagined has been manifested in the world.

The process of firing is so unpredictable that there are often surprises. No cameras can survive the temperatures, and even if they could, the brightness of the heat masks the changes occurring. Peepholes can show you a little but not enough. Until it is cooled and opened, a kiln might be a treasure chest or a decimated tomb.

A kiln will usually still be giving off some heat when it is opened, suffusing each revelation with a miasma of scent and warmth; the smell of fired earth and new glazes. Sometimes you receive gifts: a glaze has bled in rivulets like fur; an oil spot glaze has bloomed with the desired iridescent puddles; pinholes dance on a surface and make a form tactile. Some of these might be considered errors. Wood ash falling from the kiln roof can transform into glossy riverine green glaze, an aesthetic now cultivated, which some have suggested might have been the first glaze discovered, when ash melted on wares in ancient China.

Sometimes it's a total disaster. I am haunted by a story I heard of a potter whose first firing in a hand-built kiln revealed exquisitely beautiful pots beyond his wildest dreams when he opened the door, only to find when he picked each one up that they collapsed, having shattered invisibly into thousands of pieces during firing, inexplicably retaining their form until touched.

It is perhaps no surprise that there are offerings and rituals around firing, often by potters who are not otherwise religious. Superstition can mortar the gaps between knowledge, experience and the unruly power of fire. Often a clay cup of wine or sake is added to a firing, its spirited evaporations a tribute to the kiln gods, whoever they might be. Kilns in Renaissance Italy were lit by invoking God's name, taking a handful of straw and setting

fire to it while making the sign of the cross. In the porcelain city of Jingdezhen, shrines were dedicated to Tung, a protective god of fire and porcelain.

After lunch, I return to the yard with Charly. Around the top of the bin, the ceramic fibre has cooled to a brown crust that looks like toasted marshmallow coddling for the blackened creature within, which has cooled off and looks matte and monstrous in the gloom.

Charly dons the big yellow fire gloves again to pull it out. As she lifts it from its tomb, we both gasp audibly. Once it's out in the air, it is revealed not to be a coal-like lump of brown sludge. The deep bubbling and puckered surfaces gleam with a heavy violet that glistens like petrol. On the side that's slumped, there are slobbers of silvery pewter that look like drippings of molten iron paused while on the run. Hidden in crevices under the armatures and outcroppings there are glittering diodes that shimmer like galaxies in the wintry sunlight. The top is like purple coal, a jagged geology in unfamiliar colours. Charly is thrilled – this is the sort of movement, texture, surface she wanted, even if purple wasn't top of her list. 'Often the kiln confers graces on the pot which exceed even the potter's dreams,' wrote Rhodes. 'The greatest pots are those one meets coming from the kiln as strange objects; they may seem, in texture and colour, quite beyond one's power to visualise and predict.'

I can't stop looking at it – it's ugly and beautiful, wrong and right. There is something unexplained about its presence – because we don't really know what happened to produce it and the variables in these firings cannot be reproduced. Charly can say something about what's happened, could make notes on the weather, the temperature, the state of the ceramic fibre,

the position of the pyrometer, but she won't be able to replicate this again; it's a total one-off, which is exactly the point. She is excited by these extremes, by the unpredictability, by the big reveal when it cools and she lifts it from the silver bin like a blobby extraterrestrial emerging from a low-budget spaceship.

Charly likes her bin kiln, and says that when she does more controlled firings, she feels far away from everything that's going on. Here she can watch, listen, adjust. I like Charly's firings too – they are brutal and fast and shouldn't work, in a way that appeals to my impatience. Seeing it happen speeds up a firing process to the length of an afternoon, a pace I can understand.

Charly's sculptures manipulate materials into forms that echo the lesser-seen parts of the Earth. They are almost unrecognisable as things that have been intentionally created. I am struck by a thought that if an artist had experimented like Charly does, with mud and salt and heat, in a Shang dynasty kiln, unless history had recorded their intention their art would have been discarded as a misfire, which archaeologists might pass over as debris. I like to think that somewhere lost to time, there have been other Charlys: makers of radical ceramic sculptures that look like molten forms frozen in time; unexplained material belches found around a former kiln site. Perhaps Charly's purple pewter sculpture will be excavated from the ruins of this civilisation by another that has lost our lineage. Will they wonder what this thing formed by fire is; will they wonder if someone made it at all?

Exactly when humans discovered how to fire pots is unknown, and not just because very low-fired pottery lacks durability. The origin of firing pottery is shrouded in as much mystery as the origin of fire itself. Most theories – and they are very much

theories – suggest that it was discovered accidentally, when unfired clay pots were used as vessels or surfaces for cooking. Prior to this, dried clay may have been a disposable vessel, good for a night or two before being discarded to melt back into the ground. Another theory suggests that the sun may have baked clay hard, and eventually humans made the link between heat from the sun and the potential of heat from a fire to make clay forms last.

The earliest low-fired material might not have survived the millennia, but there's a chance it remains buried or frozen, sunk or submerged, in caves now below the water level that were once primitive dwellings for our distant ancestors. Pointing to anything and calling it the earliest pottery only means it's the earliest pottery we have found so far, and discoveries keep coming. Prudence M. Rice reminds us that it is pretty much impossible to know when the earliest pottery was made, primarily because we don't actually know *where* the first pottery was made. In other words: we might be able to find the oldest tree in the forest if only we knew which forest to look in. There may also have been multiple emergences of this technology around the same time.

At present, the earliest fired fragments of vessels that have been found are dated to around 20,000 years old. They were unearthed at a cave in China in 1993, but only properly dated in 2012. The 282 fragments were excavated from a cave site called Xianren in the Jiangxi province. They have markings on from smoke and fire, so were probably used for cooking. The deer bones found nearby and residue on the sherds suggest venison stew was on the menu. They may have been made and fired before use, in a pit or bonfire firing, or they may have been fired as a by-product of the stew, as the clay hardened when it was used. There's no real way of knowing.

Prior to this, the oldest pottery was from the Jōmon period in Japan (still listed as the oldest in many books, sites and on museum displays). There may be older pottery than this in inland caves or coastal regions that are now inaccessible. Along the coast of Japan, in particular, the water level and coastline were in a very different place 15,000 or 20,000 years ago. However, the earliest evidence we have of humans making with clay is not pottery from China or Japan, but an object that has no obvious practical purpose. These first fired objects in our human timeline are figures, dated to thousands of years before any known vessels for eating or cooking, one of which is an image of a woman: a palm-sized Venus figurine unearthed in current-day Czechia.

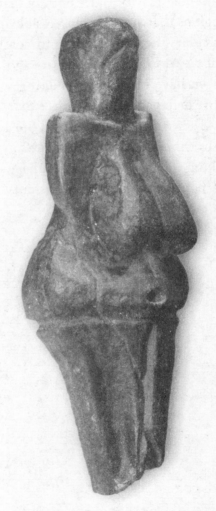

Venus of Dolní Věstonice.

3
Figures

Around 27,000 years ago in current-day Czechia, give or take a few thousand years, a person took a handful of earth and sculpted a female figurine. They gave her big drooping breasts, a waist that narrows over a fleshy tummy: a soft-looking muffin-top with a deep belly button poked in its middle; there is a vertical line across her broad hips. Her head is small, simplified, pea-like; her shoulders are narrow with pronounced collarbones. Her arms finish at the elbow, her legs at the shins. She has a voluptuous heart-shaped ass, and her concave spine has dashes cut on either side. Above one of these dashes there is a partial fingerprint left by a child – perhaps her maker, perhaps not.

She is not without emotion. Her eyes are two straight slits like accents – acute and grave – or eyebrows on a person in despair. What's not often visible in photos of her are the fine marks made by a tool dragged down her noseless and mouthless face, leaving faint lines like tear tracks. She is in two pieces, and has been varnished to protect her since she was excavated almost a century ago, meaning she looks shinier now than she ever would have when she was made. She is the oldest ceramic object that has ever been found, pre-dating the pottery found at the Xianren site by around 7,000 years. She is called the Venus of Dolní Věstonice,

named after the site where she was found. She may be a sculpture, an offering, a goddess, or a portrait, but she is not alone.

Other Venus figurines have been found from this period, the Gravettian industry (33,000–21,000 years ago), carved from mammoth ivory, bone and limestone. What's unusual about the Venus of Dolní Věstonice is that it appears she was thrown into a fire while still damp. She was found in the ashes, broken into two pieces flung about 10 cm apart by the force of the explosion. Excavated along with her were more than 5,000 other ceramic artefacts, including miniature models of bears, lions and rhinos, as well as thousands of lumps of grey fired matter (but notably, no pottery or other vessels that have an obvious practical or domestic purpose) that represent the oldest known instance of humans making with clay.

For decades it was thought that she was made of clay mixed with bone ash for structure, but more recent analyses have confirmed she is largely made from local loess, a silt deposit that contains traces of clay and sand.

Some archaeologists speculate that she was thrown into the hearth with the express intention that she explode, perhaps as part of a ritual or ceremony. My experiment with the pinch pots and figurine in the log burner may have been an unwitting re-enactment of this scene from 27,000 years ago. In what appears to have been a purpose-built kiln or hearth, she was baked at around 500–800 degrees Celsius, meaning that she survived through to being excavated on 13 July 1925 just south of Brno at Dolní Věstonice.

This is about all we can know about her. The silences around her form a cacophony of questions. Did she tell fortunes? Was she connected to sacred rituals around life, death, harvests or seasons? Did she signify health, was she the discarded work of

an artist? Or just a sculptor who didn't understand what would happen when wet clay met hot fire? Whoever formed her made creative decisions: they had to choose a tool to poke a belly button; they spent time on the perfect curve of an ass, but not on extending the arms into hands, or the legs into feet. These are acts of creative choice equal to brushes on canvas and chisels on stone.

Her modern honorific – as a Venus – is an archetype only a few thousand years old. The place she comes from – Czechia – has borders less than a century old. In the scope of her existence, the erection of Stonehenge and the birth of Jesus are recent events. Between us and her are tens of thousands of years, but how many people even saw her before she was unearthed nearly a century ago?

In the time since she was made, much has changed, but what has not is the impulse to make images of ourselves. Dwelling on her raises the question of how, when and why we began making self-portraits. Was 'what shall I make?' a question we asked as soon as questions could be asked? The puzzle turns in upon itself like the whorl of a seashell and she vibrates with the power of millennia: a woman formed from a lump of clayey loess. There is not much I can really know about her, but what I can know is tied up with her material presence: by what it was like to make her, and what it is like to hold a form like her in my hand. I need to make my own.

In the studio, I drop a fresh bag of clay on the desk with a slap. I peel back the plastic, plunge my hand into the cold reddish block and pull out a handful. I squeeze it to make a rough sausage. I pinch a head, shape stubby arms and draw the clay into a full bosom and the belly beneath. I add more clay, use my fingers to give her full breasts and push in her waist with a wooden tool;

I pull and sweep my fingers over the clay to gift her a fat belly and big bum. I find that 27,000 years of human development has not made me a better sculptor than her maker. I struggle to get her rear rotund enough; I notice how perfectly the tummy falls on the original Venus: the fat sits anatomically accurately, a tyre bulging around the hips. I smooth and sculpt her elegant décolletage, poke a belly button and slits for eyes, and make shallow chevrons on her back. The surface of the clay begins to crack, so I dip a finger in water and run it over her curves. When I finish, I have an imitation: a pocket-sized model of a woman. She is not a girl: she has lived to our middle age at least; her body suggests the bearing of children. She is not starving: her muffin-top makes her look well nourished. She looks strong. I leave my fingerprint on her back, just as someone else did back in the Gravettian industry, and set her on the shelf to dry.

When I come back the next day and pick her up, she sits pleasingly in my palm. I am moved in a way I did not anticipate. I was interested in the process, but now I feel swamped by the emotional resonances of creating her. My hands have the same number of fingers and thumbs as her maker; I eat, sleep and breathe like they did. My motions and this material represent a connection of sorts, all the way back. My basic intent – to make a female form – is as present in me as it was with them, but between us are millennia, and the meaning of the Venus, the rituals she was part of, are wholly lost.

Female figurines, heads and other humanoid figures form a pantheon of ancient and prehistoric clay objects that proliferated in cultures and societies now extinct. The Venus of Dolní Věstonice is roughly contemporary with the Venus of Willendorf, carved from

oolitic limestone and coloured with red ochre. She is preceded by other Venuses, the oldest being the Hohle Fels figurine dated to 41,000 years ago, carved from mammoth ivory and covered in slashes and incisions. She is possessed of an impressive shelf-like bosom and a muscular back, and has a tiny head (which may be so she could be worn as jewellery). She is a proud and busty ur-Venus – pointed stubby legs, a deep gash carved between them, a huge bosom supported by her arms. She is not so rudimentary as to be expressionless, despite her tiny head and absence of a face. I see a figurine that is proud, joyful, lusty. Before her are even older, stranger, more uncertain Venuses – crude maybe-figurines that are not always even humanoid, like the Venus of Berekhat Ram or the Venus of Tan-Tan.

I first became interested in a different sort of clay figurine, from Mycenaean Greece. These simplified goddess figurines were painted in wavy lines of slip decoration, with headdresses, fluted skirts like serifs, and simplified faces with noses pinched by thumb and forefinger. They have tiny ball-shaped breasts pressed onto their chests, and arms that were sometimes hidden in gowns, or reached up to the sky in praise, or were folded in front of their bodies.

I had started to make copies of these figures when the idea for this book was still forming. I made multiples, because they were so numerous, forming their faces and skirts over and over again. I wanted to know not just what it was like to make one but what it was like to make lots of them; what I could learn from repetition. Now, a group of them line my mantelpiece and watch over me. I still make them and give them away to friends, one of whom has a toddler who swiped it as his favourite toy. They often come out of the kiln reminding me of someone, and I put them aside to pass on as familiars or protectors.

For many years the Mycenaean figurines were little studied: they were found in such great numbers they were not considered useful or interesting. They have been interpreted as votive offerings, possessed of divine power, as fertility talismans, or as representative of either the worshipper or a goddess. They were found in what appear to be both sacred and domestic settings: around burials and in shrines, but also in storage areas, used as bottle stoppers when they broke.

In the early 1940s, an archaeologist named Arne Furumark divided them into types using the Greek alphabet – Phi, Psi and Tau. The Phi goddesses are flat and round, arms apparently tucked under gowns; Psi have arms upstretched and open, the figures I make most often and what two friends call my 'yea-sayers', since they seem to be saying yes to the world. Tau describes those standing in a T shape, their arms open in a warrior stance rather than cosmic affirmation.

They were first properly researched by an archaeologist and former director of the British School at Athens called Elizabeth French, who wrote the defining academic work on the subject; she is sometimes called the 'grandmother' of Mycenaean figurines. She drew up a typology of how the designs had changed over time, and placed them in an existing Mycenaean chronology, meaning that the figurines could be used for dating of archaeological sites. Until French, figurines were used to inform what sort of site an archaeologist was looking at, but she inverted this and said that it was the site that was more likely to inform the purpose of the figurines – a shrine would suggest they had religious significance, a domestic house might suggest they were toys. I called French once to arrange an interview that never happened. She was elderly, surprised by my call, and denied she had done any important work on the

figurines, telling me simply that 'they were pieces of clay that you play with'.

Ceramic figurines are found almost everywhere there was a ceramic tradition, and there was a prehistoric ceramic tradition on four of the five continents. In 1943, a terracotta head was found at a tin mine in Nigeria. It is now thought to be the oldest known figurative sculpture south of the Sahara, from the Nok culture, which existed roughly between 500 BCE and 200 CE (although the comparative lack of extensive archaeological study within sub-Saharan Africa means that much remains unknown). Many more heads have since been found, one of which was being used as a scarecrow. The variation in faces suggests they may have been portraits, and they sometimes depict ailments, including facial paralysis. Often their mouths are held in a perfect 'o', which makes them look as if they are singing. They are hollow and finely worked, with carefully sculpted hair, and skin that was once painted with liquid clay. They were once attached to whole bodies, which were standing, sitting or genuflecting.

In Japan, Dogū figurines from the prehistoric Jōmon are astronaut-like characters with strange goggle eyes, dressed in ornate costumes that look like bejewelled space suits. In Tell Brak in Syria, miniature idols proliferate, possessed of little but large eyes and flat torsos. Cycladic figurines from Greece hug themselves in protective gestures, found made from clay but also alabaster. They are possessed of a shyness, with simplified faces and narrow noses. Miniature Indus Valley figurines are dressed up in hooped earrings, bold necklaces and headdresses over massive hairdos, with peas of clay for eyes and breasts. They are sometimes thought to have been used as toys, like prehistoric Barbie dolls.

Venus figurines and other small ceramic animals were also made in significant numbers in Neolithic Europe. Ethnoarchaeologist Marija Gimbutas wrote that small ceramic figurines and animals can be found spanning all Neolithic time periods in almost all archaeological sites in Italy, the Balkans and Central Europe, as well as at sites in Turkey, parts of the Near East, western and northern Europe. 'Often where sites reach several metres deep, representing centuries or even millennia of occupation, figurines occur at almost every level,' she wrote. 'In these significant sites, we can often discern an artistic evolution from the earliest levels to the latest ones, indicating the importance of these objects to generation after generation of inhabitants.'

Gimbutas is effectively the intellectual mother of European Neolithic figurines, a sometimes controversial Lithuanian folklorist and archaeologist who was the originator of ethnoarchaeology, which studies present-day peoples to inform interpretations of prehistory. She believed that symbols and practices from folklore retained traces of the very distant past, and that the Baltic folklore she had studied earlier in her career contained symbols linked to those she was finding in Neolithic south-eastern Europe. In a 1950s publication on symbolism in Lithuanian folk art, she posed a question:

Should we ask ourselves 'when did the symbols come into existence?' We should have to reply that they are indistinguishable and inseparable from the entire religious ritual; further, that they are closely associated with the ideas which ancient man attempted to express in his symbolic art . . . These symbols survived the millennia by being repeatedly recreated.

Gimbutas left Lithuania in the 1940s, carrying nothing but her year-old daughter and her master's thesis. She had started out as a folklorist, documenting folk practices and researching existing Lithuanian traditions, which included what she described as the 'kissing of the earth', particularly in spring, when the earth was pregnant with new life. She could read, by her own estimate, around twenty to twenty-five languages.

She moved to America in the 1950s, becoming one of the first female lecturers at Harvard, but didn't last long – she was being asked to do dogsbody translation for her colleagues, and as a woman, some of the university libraries and social spaces remained closed to her. She left for the comparatively progressive UCLA faculty on the West Coast.

She studied a Neolithic group called the Kurgan, which she named for the burial mounds they left. She developed what is known as her 'Kurgan hypothesis', which suggested that a patriarchal, nomadic, warmongering society from the steppes had made their way down through the Volga basin, riding domesticated horses, and bearing forged metal weapons. This work, though, made her miserable. She began to feel 'sickened' by the endless weapons she was finding. An *LA Times* article from 1989 quoted her as remembering how it was all 'weapons, weapons, weapons . . . This was a cruel period and the beginning of what it is today – you turn on the television, and it's war, war, war.'

However, the Kurgan hypothesis was significant, because their movement was not just about the movement of people, but about the movement of language, specifically, the Indo-European family which is the root of 46 per cent of the world's languages, covering those spoken in Europe, huge portions of the Indian subcontinent, Russia, parts of Iran and elsewhere. Others in the field had differing theories. Her former collaborator, an archae-

ologist called Lord Colin Renfrew, proposed its slow spread via agriculture.

The aggressive Kurgan herders, Gimbutas said, had caused the collapse of a peaceful society known as Old Europe, a series of cultures that had thrived between about 6200 and 4300 BCE in south-eastern Europe before disintegrating fairly suddenly. It was focused around Bulgaria and Romania, but her map showed its influence stretching from the Dnieper river, down through southern Italy and across the Mediterranean, to the coastal edge of Turkey. This society, she said, was egalitarian, and at the heart of her research was a pantheon she outlined based on the ceramic goddess figurines and the designs she found on pottery, which she claimed was evidence of a matrifocal, goddess-worshipping society.

A monograph on Old Europe states that at its peak, it contained settlements that were 'citylike' in size, 'larger than the earliest cities of Mesopotamia'. There were artisanal metalworkers, and extensive trade networks for gold and Aegean spondylus shells. Clay goddess figurines were found in almost every settlement. Houses were timber-built with thatched roofs and plaster walls, sometimes two storeys tall. Villages and towns could contain hundreds of homes: one large town south of present-day Kiev had 1,500 houses spread over 700 acres, with an estimated potential population of 20,000 people, about the same as Manchester just before the Industrial Revolution.

Most of us have never heard of Old Europe, and study of it was interrupted and influenced by the Second World War. An advanced society living in prosperous communities in south-eastern Europe was dangerously close to aiding the Nazis' distortions of prehistory. Old Europe offered a white European origin story for civilisation and, as such, many archaeologists avoided it in the post-war period.

But Gimbutas was interested in its culture, which appeared peaceful and harmonious, and which teemed with figurative objects.

Her archive is kept at a small postgraduate college called Pacifica, tucked off the road in the canyons behind Santa Barbara. It's a small and startlingly idyllic campus specialising in depth psychology that was formerly a seminary for Jesuit priests and is still possessed of a contemplative aura. In the grounds, sharp shadows are cast by modernist cloisters held up by white columns, around verdant lawns upon which sprinklers dance quietly. Inside there are Jung quotes on the walls over spiralling fractals. As well as the depth psychology and dreamwork that happens here, the Institute holds OPUS, an archive of work by a handful of archaeomythologists and Jungians like Joseph Campbell, as well as folklorists and psychologists. For reasons beyond my control, I only have one day here. One day to try and inhale decades of her work; decades of images documenting a history too far away to know, but close enough to encounter through its artefacts. What I am here for, in the backwoods of Santa Barbara, is not to match Gimbutas's understanding, or find my own problems with it, but to meet her work in its massed repetitions, with the countless images she collected and illustrations of objects she made.

She spent a decade sourcing and photographing over 30,000 miniature sculptures – mostly made of clay, but also marble, bone, copper and gold – from across 3,000 sites including Cucuteni, Sesklo and Varna. Within this was a proliferation of goddess figurines, as well as models of shrines and shrines full of figurines, some marked with Linear Old European script, a proto-writing we cannot translate. She toured museums, archaeological sites and local archives, taking pictures of all the figurines she could find. The director of publications from her

department at UCLA travelled with her in Hungary, and told the *LA Times* she was amazed by Gimbutas's 'unending energy' and that she would have to distract the museum directors so that Gimbutas could photograph as many of the stashed-away artefacts as possible.

At OPUS I'm given a desk in a grey lab room, across the hall from the office. I'm not actually sure what I'm looking for, but I begin with the huge black binders of slides – thousands of them – of clay figurines from Old Europe, but also from other cultures too: there are Vinca goddesses and Greek statues; Hindu goddesses and Peruvian figures. The decoration on the Vinca figurines gives them movement – they have swirls engraved across their entire bodies, spiralling over butt cheeks. The photos are endless: there are reams and reams of pots, goddesses in clay and stone, fragments – loose heads and hands – unlabelled contact prints. It's when looking through these slide books that the repetitions Gimbutas saw become clearer to me too. I see the goddess made from clay across cultures; I see a visual through-line. I see the pantheon she had identified in her books: the double goddess, the masked goddess, the thinker.

The different types of figures she had found, she said, represented specific deities, characterised by forms and markings such as zigzags and chevrons denoting particular roles within this largely peaceful, egalitarian and goddess-worshipping society (one paper on her work goes so far as to connect the chevrons on the back of the Venus of Dolní Věstonice with the chevrons Gimbutas discovered from Old Europe 20,000 years later). She described in detail the motif of a bird that laid a cosmic egg; there were symbolic images of frogs, hedgehogs and bulls that represented various processes and powers, and a figurine with a prominently stylised triangular face she called the masked

goddess. She identified figurines with deities involved with the earth and its fertility; the few male figurines she said were representations of the dying vegetation god, or consorts of the goddess.

Gimbutas published the results of her research in 1974. In *The Gods and Goddesses of Old Europe*, she concluded without any doubt that these figures were not just evidence from a society she called Old Europe, but that they formed a comprehensive sacred pantheon of goddesses, and in no uncertain terms she stated what each one symbolised and how they related to one another. (The book's title was later revised to *The Goddesses and Gods of Old Europe*, to denote the relative lack of obviously male figurines.)

When *The Gods and Goddesses of Old Europe* was published, it saw her denounced by many in her profession, not just because they proposed differing theories. It was the language she used that alarmed a lot of her contemporaries: here was a well-heeled, highly respected archaeologist who had built an entire religion from her interpretations of these clay figurines, undermining the very foundations of the discipline by saying that she *knew* these things to be the case.

In the eyes of those in her field, she had little material evidence to back up much of the detail in her thesis. Her work on the Balts had been hailed as ground-breaking (and still is), but here she was writing about how a single mark on a figurine from a society we know relatively little about represented a water goddess from a group of interrelated female deities. She transgressed the per-mitted language of her field, applying her knowledge of folklore but also her intuition and imagination to the research, using a language of absolutes in a field where it was not permitted, with prose that stood starkly apart from most archaeological texts and

that reads much more like New Age or esoteric doctrine. Her chapter on the bird and snake goddesses begins:

> The presence of the bird and snake goddess is felt everywhere – on earth, in the skies and beyond the clouds, where primordial waters lie. Her abode is in the upper waters, i.e. beyond meandrous labyrinths. She rules over the life giving force of water, and her image is consequently associated with water containers . . . the eyes of the bird or snake goddess even stare from the very centre of the world – a sphere with a mythical water stream in the centre.

Gimbutas's work is seductive for precisely the same reason it is criticised: the application of imagination. She explicitly built a multidisciplinary approach that allowed learning from extant folklore and mythology. This was material not often considered useful by other archaeologists at the time because it was too flimsy and lacked the provenance required to rest many conclusions on. But she was sure, she said. She had studied folklore they hadn't, learned languages they hadn't, read more papers. She knew more about this region, these long-dead people and their traditions than anyone. She *knew*, she said.

As I write, her work is being read and written about again, and not just because parts of her theories have been posthumously proven true. In the last ten years, DNA evidence has shown that the Kurgan did come down the steppes in a fast and brutal incursion into Old Europe. Opposing theories had brought about a rift between Gimbutas and Renfrew, her former collaborator, but in 2017, at the first memorial lecture dedicated to her at the University of Chicago, he got up on stage to deliver the keynote, and admitted that he was wrong and she was right.

*

Outside of academia, Gimbutas's work caught on. It was perfectly pitched in its themes and propositions for second-wave feminism, for the New Age and earth-centred movements that were blossoming in the 1970s. What she offered was a vision of a real society from our past that was peaceful and egalitarian; that lived in harmony with the earth, and in doing so had prospered.

In the archive I find a box filled with cards, mostly, but not all, from women, saying thank you, thank you, thank you – an overwhelming gratitude for the possibilities her work presented. I wanted to know more about this aspect of Gimbutas's legacy – how the imagery of the figurines had filtered into the world outside archaeology – so I called Starr Goode, a writer on feminist spirituality and a member of Nemesis, one of the longest-running covens on the West Coast. She was part of the radical scene around 1960s Berkeley and published the first feminist newspaper there, and in 1986 she made a documentary on Gimbutas called *Voice of the Goddess*.

Before we talk, she sends me a recording from a book launch she hosted for Gimbutas in 1991, to mark the publication of *Civilization of the Goddess*. I am surprised to find that it captures an audible excitement from the room: Gimbutas had meant something to the people at the launch; had brought them an alternative future from the past, brought hope and a sort of vindication of the feeling that the hierarchies of society could be otherwise, represented in the multitudinous clay Venus figurines she had studied.

Goode can't remember where she first heard about Gimbutas's work, but they met at one of her talks in the eighties. She remembers how Gimbutas was working two slide projectors at once, so she could show as many images as possible. She recalls

feeling that at the time this work on prehistoric female figurines tapped into the zeitgeist. 'It was rising up from the unconscious,' she says. 'It was something that was in the air, for those who were receptive to it. And as a feminist, I was receptive to it.

'When she said that once we lived in peace, my whole world-view overturned. Because I had always been taught through patriarchal institutions that violence was an indelible stain on the human character. And then, she's presenting all this evidence, all these visual images. It wasn't some random object in a cave in lower Siberia – it was all throughout Europe.'

In talking to Goode about her rituals and research, about the way she understands Gimbutas's work, and the way her work on the goddess figurines sat outside of the traditional academic frameworks, I realise I've not been paying attention to the ecological implications of Gimbutas's goddesses. These were deities of the earth, made by a society living in respectful harmony with nature. In this reading, the act of taking a fistful of earth and forming a figure is an entirely different act if you consider yourself part of the same cycles of the earth you hold in your hand than if you conceive of it only as dead earth, separate from yourself.

Gimbutas is not just arguing for the existence of this sacred pantheon, but also for a return to respect for the earth via this society, a plea that we might remake our connection with the earth now, a connection she had seen in the folk practices that had been preserved in Lithuania, this kissing of the ground. Our thinking towards the figurines depends on how we think about ourselves in the world. In one reading, we might not need the breath of a god to bring clay bodies to waking life, because the breath is in the earth itself.

Gimbutas died from cancer in 1994. When she was ill, Goode's coven performed a ritual for her around her bed. 'She was a

revolutionary,' says Goode. 'I mean, she didn't start out that way. She was just following her nose, following the evidence. She couldn't ignore what she saw. And she came to the goddess because of what she kept seeing. The last time I saw her was in the hospital before she died, I said to her, you brought the goddess back to the twentieth century. And she said, I had to, I had to do it.'

The rub with Gimbutas is how much we might *want* her theories to be true. What she presents to many of us is a lost utopia – her work is often simplified or distorted, described as arguing for a matriarchy when it only proposes the existence of an egalitarian society that was peaceful and earth-loving, that traded not in weapons but in beautiful shells, and that appeared to worship, or at least centralise, a wide variety of female deities.

The society Gimbutas pictures is one where women are at its centre as a variety of characters and deities who might have also existed in a non-hierarchical society. This peaceful characterisation of Old Europe also has implications for today. One set of figurines that has been widely discussed is a group of female figures seated on chairs, or thrones. They were found together, which suggests discussion in a group setting and has been interpreted as a democratic council of sorts.

I wonder if the pantheon of goddesses appeals because within it women exist in a greater number and as more complex characters than female stereotypes of the mid twentieth century. These ideas of power and gender that are inherent to Gimbutas's work are emotionally charged – are we arguing about whether this utopian, egalitarian, peaceful society existed, or are we arguing about whether it's conceivable for us to think that a society like this could ever have existed?

Anthropology professor Douglass W. Bailey questions the way we interpret the figurines, arguing that their miniature size and portability are key to this, but also asks about what matters in our interpretations. We know they were everyday objects that were seen, held and touched, he writes, and so 'the function of these objects is to be found at a deeper level of reality . . . They contributed to a shared understanding of group identity; they stated without words, but in always visual and tactile expression, "this is us".'

Reading Gimbutas is, for many of us, not just a question of weighing up the evidence but also weighing up our place in society as it is imposed upon us in the present moment.

With clay artefacts older than writing, the challenge isn't just working out what an object is. How we articulate ideas about these objects often poses a barrier or bias upon the material. Thinking about something from this far back in our collective history requires a constant mental check – the words we use for things come with associations that don't apply to a prehistoric society. How do we even begin to talk about something made by human hands six or twenty thousand years ago, except to say: here it is, this was made?

Even the language we use to describe or name these figures imbues them with something – we call it a Venus, after the Roman goddess of love and beauty. But Venus was borrowed from the Greeks, and is much younger than the figurines themselves.

Our current values are a lens through which we interpret objects from the past, and that lens is not without distortions. Interpretations have often suffered from the biases of those who interpret them. Other theories have also been posed. Former director of the Institute of Archaeology at UCL, Peter

Ucko, suggested the figurines were toys. One paper suggested that some of these bulbous female Venus forms are similar to how a woman would see herself when pregnant – that in the absence of mirrors, when a woman looks at her own pregnant body, the form she sees corresponds remarkably to a figurine like the Venus of Willendorf. It strikes me that it has taken decades to recognise that some figurines may be self-portraits: the act of creation in the hand to mark the act of creation in the body. That it has taken so long to consider this possibility tells you something about who has been writing these histories.

Another recent paper suggested that these figures – so apparently well fed, so healthy, and many perhaps having birthed children – were made at a time when changes in climate made survival, childbearing, health and nutrition a difficult task, and so the older, healthy body was an idealised symbol. Even this reading grounded in the impacts of a changing climate might be more understandable to us now than it was in the 1970s, as our awareness of the impending environmental crisis becomes more acute.

I project my own emotions and values onto the figurines too: it is hard to remove oneself from perceptions of body types and body language. In most prehistoric cases, any certainty about what idols and figurines mean or were used for is lost, and when we go back this far, it is not necessarily the theories with historical precedence that are the most likely to be true. In the case of prehistoric Venuses, there is very little that could ever give us proof as to what they were actually used for, and more than that, is it not the case that an object might have multiple uses, a purpose that shifts over time, or a significance that is brought by an individual rather than a community? An extraterrestrial archaeologist might struggle to define a single purpose for the

Virgin Mary, given that images of her are as likely to be found in homes as in churches.

In the case of the early female figurines – those with breasts or deep slits incised between their legs suggesting genitalia – theories on their purpose often cite interpretations around religion, sexuality or fertility: they are goddesses, sex objects or mothers. It has been suggested they were models to teach midwifery; or talismanic items to grant health and fertility; or the first pornography (although whether the notion of pornography holds that far back is another question). These interpretations have begun to smart with some, seen as overly influenced by the status and experience of the people who wrote them, principally white men in Europe and America in the nineteenth and twentieth centuries. These issues bothered a Turkish artist called Ceylan Öztrük, and she began making work based on her own research.

Her first act was to walk into the Natural History Museum in Vienna and switch out the museum's information leaflets on the Venus of Willendorf for her own. She replaced the language; challenged the terminology and the root of this knowledge. Her first idea was to declare these figurines as symbols that were about female body confidence, but as she reproduced these forms she realised they might also be reinterpreted. She looked at the shapes and forms of Venuses from across prehistoric periods and the project developed into a provocation: what if these Venuses were not fertility objects, but were in fact sex toys? She asked why, if these objects came without context, this interpretation might be considered less credible than that of a proposed 'ritual' purpose? Upon encountering her work, the question it prompted in my mind was: what is the difference between self-pleasure and a ritual act anyway?

The resulting exhibition was called *Call Me Venus*, a series of Venus figurines cast in ceramic, silicone and glass. 'I made them into pleasure objects,' she says over video call from New York. 'I looked at all the Venuses. The most significant thing in these sculptures is saggy breasts and a significant vulva. All sorts of Venus figurines have this feature. I copied these features, and created these phallic objects, which are meant to be inserted.'

The first thirty of them she made in a month. 'These are such significant objects,' she says. 'They show us so many things: how we see them; how they have been seen. What are they to us? A body? A female? We still try to claim this female body, but it's a link to everything; a connection to a different time.'

That first iteration largely transformed the Venuses into phallic forms – a loaded symbolic process in itself, I suggest: turning a female form into a phallus used for pleasure. 'I started to criticise myself when I was just producing a phallus,' she explains. 'Penetration-based pleasure is heteronormative, male-dominated. So the later ones are not phalluses at all.' She turned the Venus of Monruz – carved from jet with a hole so it might be looped on a necklace – into a clitoral toy. 'You can really please yourself with anything,' she says, 'you just need to like the idea of it. So I put this new narrative on it – that it was a clit toy you could wear.'

She says her favourite is a voluptuous green figurine. I ask why, but she says it feels subjective, 'Like: you like blue and I like green,' she says.

She showed her Venuses outside of vitrines – they were to be touched and handled – and she photographed the works in people's hands, undermining the sterility of museums and museum photography that takes humans out of the picture.

She had ambitions to mass-produce one of the models, and got as far as prototyping some with a dildo manufacturer, but it hasn't happened yet, although she says she wants them to remain sculptures first. 'They represent a narrative or an idea; they state a criticism, manifest something,' she says, mentioning Martin Bernal's *Black Athena*. 'He says that the most challenging and interesting things [in archaeology] are coming from people *outside* of the profession,' she says. 'Because once you're inside it, you have to deal with it: with its language. When I read a history book, I always underline the verbs. It's interesting the confidence with which people write, "this is made for this", instead of "this might be made for this". They say: "this woman is a mother". I mean, this woman might be a mother, but this confidence is interesting . . . In 50,000 years when they find our monuments, they might be asking why we did all these guys on horses – it also doesn't make much sense.'

The Venus of Dolní Věstonice ties us up in knots of language and meaning: object and understanding. Gimbutas and Öztrük stand both apart and together, in questioning and reinterpreting the symbolic meaning and purpose of these ceramic Venuses. When I make a figurine today, I connect with the past by understanding it in a tactile way, by comprehending something of the skill of the person who made it (even if that is just someone more skilled at making figurines than me).

The creation of a human figure is one of the most profound developments in human history. To make a tool, to make a cooking pot, is seismic and forever alters the habits of a species, but the creation of a figurine is one largely unnecessary for survival in any literal way, and instead is significant for what it contains about our self-awareness; about our impulse to create images of ourselves.

FIGURES

We could call the Venuses the first sculptures; we could call them the beginning of culture. We could call them many things and they would be all of them and none of them. These figures represent the earliest evidence we have of much I hold dear about the world. I am preceded by them, as clay formed by humans into a woman that will forever hold secrets about our most distant past, one who pre-dates even the first pottery we made to eat from.

A vessel with incised decoration, made by Ladi Kwali at
Richard Batterham's Bryanston Pottery in August 1962.

4

Hands

I was in my late twenties before someone put a ball of clay in my hands and showed me how to pinch a pot. It represented my first real contact with this material; a door that opened onto new possibilities for making in the simplest of hand gestures. I still have it: a handleless cup in a grogged buff clay with a cracked rim and uneven footring, decorated with the dregs of glazes I found at the back of the shelf. It didn't seem to be deserving of anything better. The decoration is frankly appalling – a brown and bile orange glaze with multicoloured speckles – but like most terrible pots, it has a rustic charm when planted up with a cactus. It sits on my desk as I write, bulging and irregular. It is a reminder of my own beginnings with clay, one that mirrors many people's first experience of making a pot.

To pinch a pot, roll a ball, sink a thumb into it to make a hollow. Just this action transforms a lump into a shape that can hold a gulp of water. Hold it with the thumb sitting inside the hollow and set your fingers flat against the outside. In this position, between your fingertips and thumb is the vessel's wall. Pinch this clay with your fingers and thumb ever so slightly, to make the wall thinner. Repeat this around the hollow in small, regular movements. Keep

the shape contained with each small pinch by dragging the finger-tips ever so slightly upwards as you release, almost as if massaging the vessel's wall. Pinch too firmly or move too fast and your wall will come out uneven in wobbles and lumps. Let your thumb act as an anchor. Turn the pot little by little as you pinch. Within minutes, a ball of clay becomes a beaker, a bowl, a cup.

Pinching like this is one form of handbuilding. Most early pottery is presumed made by a combination of pinching, coiling and slabbing. In coiling, long sausages of clay are looped upon one another and built up into vessels. Slabbing uses flat pieces fixed together to make a form, sometimes using a mould of some sort. These modes of making are cross-cultural and prehistoric, appearing in most early civilisations and societies the world over. A combination was often used. In her effervescent and plain-speaking book on *Coiled Pottery*, Betty Blandino writes that handbuilding techniques are harder to contain because they 'spill out' into other methods: the 'coils' may be more like long slabs; pot bases may be thrown or moulded.

In many cases, we do not know how ancient and prehistoric pottery was made. Walking round museums as a potter is frustrating, as information plaques almost never include details on how something was formed. In recent decades, advanced imaging techniques have begun to be applied. Before this, it was faults and fragments that revealed technique: sherd edges might expose cross-sections of a pot's walls, or a vessel's surface might have cracked over a bad coil join. Marks might remain that contain clues, as with some prehistoric pottery, which still carries impressed marks from the weave of the long-decomposed basketry used as a mould.

There are many ways to handbuild a pot. There are things to avoid: air bubbles, walls with irregular thicknesses, coils added

when the clay is too dry, a slab too thick to dry evenly. But these things can often be overcome. Handbuilding is generously forgiving for learners and can be extremely tolerant of error, permitting of repairs that are not an option on a wheel. The possibilities are endless – as are the potters – and there is no pot so big it cannot be made by handbuilding: it is only the kiln that restricts what you can make. In South Korea, onggi jars like those made by Kwak Kyungtae can be huge, some big enough to fit two people inside. French–English potter Monica Young and Finnish potter Kristina Riska both used the freedoms offered by coiling as ways of making forms six foot tall and more.

Modern potters have often pushed these techniques to their limits. Arizona Navajo potter Louise Goodman made vessels like the Pompidou Centre, leaving her coils visible on the exterior of the pot, in perfect rows like cartoon beehives. These pots are deceptively simple, because the joins must be solid but not visible from the outside. Their regularity stands in contrast to the work of others using related techniques, such as English ceramicist Ewen Henderson, who made free-form vessels with coils and slabs, adding water mixed with rum and pulling from different clay bodies with competing shrinkages that brought out colour and rough textures on his vessels, which were doused in splurges of heavy and tactile glazes. His vessels often seem barely held together, but they have a freedom and revelatory immediacy that undermine the rules and guidelines often given in instructional ceramics books, which tend to deny that such maverick techniques could ever produce a finished pot.

Some of the oldest known handbuilt pottery was, until fairly recently, from the Jōmon period of Neolithic Japan. Scholar Tetsuo Kobayashi says that the period is bookended by the

beginning of cord marking on pottery 11,000 years ago at one end, and by rice cultivation at the other, which began 3,000 years ago. The Jōmon period, then, is enormous. It is split into six distinct periods (sometimes more, sometimes fewer), in which the shifts in pottery styles become the boundaries between time periods; the trends in making used to gauge archaeological eras.

The cord markings are what name the period – Jōmon means 'cord marked'. Twisted string was rolled across the surface of the pot when it was wet to imprint patterns on the surface. Sometimes these marks are simple, and have been interpreted as functional, making the pot less slippery to pick up. In other instances they form elaborate decorative herringbones. Despite a number of systematic studies that catalogued the patterns, the discovery of the exact technique used was made by chance in 1923 by a young researcher named Sugao Yamanōchi, when he rolled a spring across his desk in a moment of idleness. In the shape it left, he found he'd made an accidental copy of the Jōmon designs he had been painstakingly recording. He later became one of the foremost Jōmon archaeologists.

The Jōmon period was formalised by Edward Sylvester Morse, an American who had arrived in Japan in 1877 to research molluscs. On a train outside Tokyo, he looked out of the window and saw what he recognised as a massive shell midden – a prehistoric waste disposal site. Subsequently he organised several archaeological digs – the first Western archaeological digs in Japan – which produced reams of artefacts (and had some surprising historical tangents in and of themselves – namely that one of his assistants went on to invent fingerprinting techniques).

Jōmon pottery was known about long before Morse arrived, with records as far back as the Edo period suggesting encounters with artefacts from the Jōmon. Kobayashi has written about

a seventeenth-century text in which the authors talk of places where 'peculiar ancient earthenwares' were excavated. He doesn't mention what pots the Edo writers unearthed, or describe them, but there is a subset of Jōmon pottery that is incredibly peculiar, if not some of the most remarkable on record, which stands in contrast to other simpler cord-marked pottery. These mystifyingly ornate vessels are known as flame or kaen vessels.

To encounter a kaen vessel is to step out of time. There is nothing quite like them. The sculptural and imaginative flair they display just doesn't scan as something that syncs with any pre-existing assumptions you might have about the type of pottery that was being made at this very early point in pre-civilised human existence.

Kaen vessels are handbuilt and are bewildering in their modelled decoration. They are usually knee-high or smaller, flat-based vases that widen to flared and ornamented mouths, with dramatic stylised flames around the domineering rims that whip upwards, carved in banded motifs and deeply incised stripes, with tongues and swooshes that finish in points; looping finials that have been interpreted as cockerel or bird heads. These heavily sculptural details are so dramatic as to render the pots utterly impractical for holding food, drink or anything else – pouring would mean it would spill out at any angle – and currently nobody knows what their purpose was. The general presumption is that they were used for a ritual purpose, but as we saw with the figurines, what this means in practice remains obscure. The similarities across these vessels – all different, but of the same style – are remarkable. However, after a short period, they disappeared and comparatively dowdy pots re-emerged. 'The flame pots, as if predicting their own destiny, blazed brightly like flames that burn ferociously before being extinguished,' writes Kobayashi, 'and then died without a fight.'

*

One of the best (and best-known) handbuilding potters of the twentieth century is also the only woman to be pictured on Nigerian currency, currently found on the back of a twenty-naira note. Ladi Kwali was one of the master handbuilders of the last century. She largely made pots through a traditional method that began with hand-forming a base, then adding coils. On the naira note, though, she is pictured at a pottery wheel. She was skilled and trained in throwing, but her large, round-bellied handbuilt pots were what she is best known for.

'Ladi' means 'born on Sunday', while her surname, Kwali, is the name of the village in which she was born in the Gbari region, where pottery is made by women as part of everyday domestic labour. Ladi was the daughter of a farmer and was taught pottery by her aunt, in an apprenticeship system. She was highly talented, and by 1950, the Emir of Nigeria had begun collecting her pots. He then showed her work to the English studio potter Michael Cardew, who later came to colonial Nigeria to set up a training centre that would preserve and promote traditional pottery techniques in the country, while incorporating twentieth-century studio techniques. Cardew drew one of Kwali's pots that he saw on a visit to Abuja in December 1950 – a round Gbari pot decorated with splayed lizards and stripes, which he described as 'the best I ever saw'. The Emir put pressure on Cardew to take her on, which he did, although he wrote in a letter home that she would likely be better off carrying on with what she was already doing.

The Pottery Training Centre in Abuja was set up in 1951. Kwali was its first female apprentice, after Cardew had been urged by the Emir to take her on despite Pottery Training Centre policy (one of the initial errors made was to only permit male potters at the

Pottery Training Centre in a country where most of the pottery making was done by women). She was already highly skilled, and while she could not read or write, she often signed her initials on a pot, not a convention for Gbari potters, which indicates she might have had some ambition for her craft beyond the region.

When she joined the centre, Kwali was in her late twenties. She had no children and few ties (although a husband appeared in the 1960s). She was, writes Cardew's biographer Tanya Harrod, 'a dazzling personality, by turns imperious and amusing'. She took pleasure in her work and would sing when she was pleased with a pot. In 1955, Cardew combined clays into a body particularly suited to her work, so that she could make 'big fine pots' that could also be glazed.

Kwali was a supremely gifted decorator – she inscribed her designs on pots freehand – with a particular talent for gauging the spacing and balance of her improvised designs. She scratched into damp clay with a quill, crosshatching angular lizards, stylised birds, and bands of incised textures. These incisions were later filled with a wash of white slip, and then a glaze was used, which the potters sometimes called 'truthful', presumably for how unforgiving it was. Often she used a heavy dark iron glaze. Some scholars have written about how, at the time, black African potters collected in the West were expected to make dark work, whereas light-skinned potters could make pale pots.

While the Gbari pottery Kwali would have made had functional purpose, the pots she made at the Pottery Training Centre were often removed from their functional life and made specifically for an art and collectors' market. She translated Gbari traditions into her own distinct style, through incorporating European studio techniques in glazing with her striking decoration. This made her pots an evolution of traditional techniques,

which Harrod goes so far as to call 'skeuomorphs', in that 'the translation of her traditional hand built pots into glazed stoneware made them into . . . close copies of objects using another material and technique'.

The central surviving document of Kwali's technique is twelve minutes of grainy footage of her making a pot, with scenes filmed at the Pottery Training Centre in Abuja and Cardew's Wenford Bridge Pottery in Cornwall. She would start making a pot by forming a base from a 12–15 lb lump of clay, which she beat with her fist to form a hollow. From here she pulled up the walls with the very tips of her fingers – it's this part of the process that the film opens with, the clay apparently dangerously floppy and wet, moving like a flannel under her hands but never collapsing or splitting. She drags the wet clay diagonally upwards inside the pot, so that its walls rise to the height she wants. At this point, the inside of the pot is, as Cardew described it, 'marked inside with a diagonal pattern of finger marks like the fluting of a shell', these markings just visible as shadows in grey and black striations in a fragment of the film. Then, he says: 'without waiting for the clay to stiffen and without any trimming of the irregular rim, she begins to add short thick coils, made by rolling them vertically between her palms. Each coil is applied inside a well below the old rim, and is drawn up diagonally past it. In this way not only the height is increased, but also the diameter, so that gradually the pot becomes fatter.'

As she makes, she moves around the pot in a way he described beautifully, capturing the steady pace of her process like a dance: 'All this time she moves rhythmically backwards around the pot, sometimes in a clockwise direction, sometimes (as in a dance) reversing to avoid giddiness.'

There's much about handbuilding that is like this: a dance of learned gestures and bodily movements that betray little of the complexity and precision of the actions being performed upon the clay. It requires incredible dexterity between fingers, palms and mind. Even just rolling coils, when Kwali holds a lump of clay between her hands, out in front of her as if in prayer, she appears to simply rub her hands together. Oozing from between them come perfect tubes of clay; muddy vines stretching towards the floor. She makes it look so easy, I am fooled into thinking it is simply repeatable, but inevitably, when I try the same, I fail miserably. My first attempt produces only a stubby tail that flaps about and snaps, and I realise that the nuance of the pressure needed from different parts of my palms requires more than a video to understand it. This is a movement so controlled and so automatic when it has been done for a lifetime that a moving image is not enough to learn it.

As Kwali moves around the pot, she bellies out the middle, builds a neck with a single coil and smooths the surface. In no time at all, the flopping clay has become a smooth-surfaced round-bellied pot — to skip between the beginning and the end makes it look like the two pots have been swapped out.

How Kwali might have described her process, or how she felt about it, we don't know, because there is no documented interview with her anywhere. While she did not write, and could not speak English, on tours of the UK and US there was always someone around able to translate, and by this time she was well known and highly respected as a craftsperson. She spoke Gbari and Hausa, while Cardew and his assistant, Kofi, both spoke Hausa and English, and yet there are no direct quotes from her anywhere. This feels like a particular loss when I learn that she

was said to be 'ebullient, wayward and especially keen to go shopping for shoes' on a visit to the UK, and that when she returned from London, her studio mates at the Pottery Training Centre nicknamed her 'Radio London' because she talked so often about her trip, although nobody says what exactly it was she spoke about.

It's known that there were translated Q&A sessions when she did demonstrations and attended gallery shows; she was photographed for *Tatler* by Jane Bown in the early 1960s. There were evidently questions asked of her, and answers given, but nobody wrote them down. There are also scant second-hand reports of her speaking or telling stories – Harrod writes that at one meeting 'she talked at length of the economic importance of learning to make pots for the women of her community'. Later on that day she is said to have described 'how a mist rose up from the floor of her grandmother's firing area after she died', but a mention of this story is all we have, despite teasing her motivations for making and the spiritual beliefs that surrounded her craft.

Kwali died in 1994, and with no interviews, she remains a person outlined by others, with the limited reports of her speaking in Harrod's book the most comprehensive account of her to date.

I call up curator and researcher Jareh Das, who curated an exhibition called *Body Vessel Clay: Black Women, Ceramics and Contemporary Art*, which was squarely focused on profiling Kwali as an individual and upended the usual mode of presenting her as framed by Cardew and his work and influence. Das had come to Kwali's work from her Nigerian heritage and a background in performance, interested in movements and gestures of pottery making. 'The biggest challenge and frustration [in curating] was

the fact that every sort of interpretation of Kwali is secondary,' she says. 'It's always somebody's account of the time, but never quite the individual's position on what was going on.'

I had called her largely because I wanted to check whether I was missing something, whether what appeared to be the case was accurate: that there is no recorded interview in any form with one of the best-known potters of the twentieth century. It is perplexing, because Kwali was not 'discovered' nor 'rediscovered', but was known, lauded and collected in her lifetime, and so the absence is striking. 'She was never interviewed, or at least there are no records of this,' Das confirms. 'I've gone through tons and tons of press clippings – I haven't come across a single reference where someone asks Kwali anything, not even about her demonstration, for example. There's just nothing, even though she received accolades and there were ceremonies. I don't know how that was overlooked. It's really astounding that there wasn't a moment to ask a question.' There's also incomplete provenance in museum collections, added to which, Kwali didn't always sign her work.

While Tanya Harrod's detailed biography of Cardew does much work filling in details, we are left to wonder how Kwali felt about her work. What was her apprenticeship like? Had she always wanted to be a potter? What were her earliest memories of making with clay, and what revolutions had she felt in her own making? Crucially: what made her want to step out of the traditional expectations of a Gbari woman, to make pots that she glazed, signed and sold to an international market? This turn is at the heart of her story, but it remains frustratingly inaccessible. 'I don't think it is accidental,' says Das. 'I think it speaks about the fact that whatever was happening – even as she rose to international recognition – it was still a Cardew-led project.'

Das's research will continue. When we speak, she has a trip planned to Kwali's birthplace, and to Suleja, a city in Niger state, where her old house still stands, and where Das plans to meet Kwali's relatives and begin fleshing out the story where Harrod left off. There is only second-hand information left about Kwali's life and work, so until more research is done, she does not speak in words but only communicates with us through the vessels she formed by her dance around wet clay. The German philosopher Walter Benjamin once wrote that 'traces of the storyteller cling to a story the way the handprints of the potter cling to a clay vessel', but with Kwali, her pots *are* the story. While we can assemble facts, her vessels remain the primary source for who she was and what she made, and her skill in manipulating and decorating clay is what speaks loudest from her life.

In previous histories, much handbuilt pottery – particularly traditional low-fired pottery that was being made in the twentieth century – was reduced to a few pages on 'primitive pottery', an inevitably brief chapter that tried to encompass unglazed wares from countries across sub-Saharan Africa as well as many others. In *Wild Thought*, the French anthropologist Claude Lévi-Strauss writes against this tendency to oversimplify so-called 'primitive' techniques:

> to turn unstable clay – quick to crumble, pulverize, or crack – into a solid, watertight piece of pottery (but only after having determined, among a multitude of organic and inorganic materials, the one most suitable as a tempering agent; the appropriate fuel, temperature and duration of firing; and the effective degree of oxidation); to elaborate on the techniques, often long and complex . . . all this required, we cannot

doubt, a genuinely scientific state of mind, a sustained and perpetually alert curiosity, an appetite for knowing and for the pleasure of knowing . . .

Handbuilding techniques have ancient roots that are perhaps prehistoric, but the relative simplicity of the technique obscures the tacit knowledge required to fully master it. Coiling in particular enables very large pottery to be made relatively quickly; it allows for wild possibilities in shape and form, from vessels big enough to step inside to those that balance on such small bases they appear to be levitating.

Despite being one of the earliest modes of making with clay, coiling presents its own challenges. It is a little like playing the bass guitar: very easy to do, but very hard to do well. To be very good requires masterful control of the clay; intimate knowledge of exactly what stage of plasticity and hardness you should be working at during each stage of the process; a sense of timing, and sometimes rhythm. While handbuilding is sometimes disparaged as being 'an exercise towards "real" potting', as Blandino puts it, looking at the work of some of its twentieth-century masters like Kwali undermines this hierarchy.

Handbuilding is so widespread it's incorrect to think of it as having any sort of containable lineage; instead it has many, many branches that will not converge on the same trunk. It is a technique that represents a forest of makers, a skill and a science that is often dismissed. Blandino describes the methods of coiling beautifully, as being:

a way of building pots in which the form grows by the addition of clay in layers, one upon another. They may be as regular as bricks layered to build a wall, as random as dry

77

stone walling, or as rhythmical as knitting. They may give to the pot the quality of the geological stratification of a cliff face, the wispy structure of the Earth's crust – or they may be smoothed to make the surface indistinguishable from that of pots made by other methods.

She describes various potters who use traditional handbuilding techniques, including Kwali, and the way they each form the base differently: Kwali punches a hollow into a solid lump of clay; a potter named in a photo as Mallam Garba from Nigeria pounds a bowl-shaped base in a hollow in the ground with a stone pestle; pueblo potters in New Mexico begin on a fired saucer of clay to make a pot with a round base, rather than a flat one, and an image shows rows of bases thrown by potters in Beit Shebab in Lebanon.

After a basic form has been made, it is usually left to dry, before being pared back to thin the walls and smooth the form. Paring back a pot sometimes feels like the concertinaing of the connections between the mind and the hand, the body and the pot. One hand is inside the vessel while the other scrapes back the outside. When I do this, I try to feel and scrape at the same time – feel the weight of the pot, watch the pressure on the surface, feel the distance between the scraper and my other hand. In these repetitions I'm thinking all the time with my hands upon the clay. It's not quite right to say I'm thinking *about* the thickness of the pot's walls, because it doesn't feel that 'about' is the right word; I'm closer to the clay than just *paying attention* to its thickness. When I pare back a pot, I feel more that I am *knowing* the pot's walls – it's bad grammar, but feels accurate. There's a drummer I know who talks about forging a link between hand, stick and skin that's so direct it creates unbroken contact between her skin and the drum skin: the stick becomes an extension of

the body. Just like this, my hand and the scraper and the pot become fused in a rhythmic pattern – the right hand scrapes, the left hand shifts the pot; the left hand tells the right where it's thin and where it's thick, the scraper works it till it's even.

One renowned potter who used coils and handbuilding and was recorded extensively in her lifetime was the San Ildefonso Pueblo potter Maria Martinez. There is no formal record of Martinez's birth. It's thought she was born around the 1880s, but she was not concerned with her exact age, often expressing surprise at how long she had been alive. She lived in San Ildefonso in New Mexico, the matriarch of a five-generation family, and worked with a group of other potters and decorators on the pueblo, many of whom were related to her by birth or marriage. In photos she always looks chic, dressed sharply in layers of bright florals and strings of beads, her hair cut in a crisp Anna Wintour bob. The brightness of these patterned dresses, the multitudes of prints she wore, stood in stark contrast to the black-on-black ware she was best known for making.

Martinez's skill as a handbuilder was in her ability to make perfectly round forms without a wheel. She put this down to having 'more patience' when scraping back the walls of her pots, but it is the symmetry and balance in her work that are perhaps most astonishing. Her pots are so strikingly smooth and even, light and polished, that, at first glance, they appear mould- or factory-made. But no machines touched the Martinez pottery – and Maria knew how good she was. The potter and writer Susan Peterson spent a long time in the pueblo talking with Martinez and her family for a monograph on her work. In it, Martinez tells her a story about only getting second place in a competition despite making 'the most perfectly symmetrical pot by hand'.

Peterson described how the San Ildefonso potters built forms with clay coils, then left them to dry. A week or so later, they were pared back with a scraper and sanded, then slip was added to the surface, which was polished to a high shine with stones that had been smoothed by use and passed down through generations. Martinez favoured a scraper made from a metal tin lid, but not all tin lids were equal. She and her daughter-in-law, Santana, preferred baking powder tin lids, and Peterson writes of how they would scour yard sales and antique shops to find a particular brand. Other potters used the cases from typewriter ribbons, Scotch tape can lids, or those from jars of fruit, with each one chosen for the way its size or shape helped to scrape particular sizes or forms of vessel.

Martinez and her husband, Julian, began making black-on-black pottery after an archaeology professor named Dr Edgar Lee Hewett came to see her in the first decade of the twentieth century. Hewett was researching ruined Tewa pueblos and burial mounds. Excavations had uncovered fragments of pottery that were black, not polychrome like other traditional pueblo wares. He searched out someone who could re-create the sherds as full pots, and Martinez was recommended as the person who could make the thinnest, roundest pots the fastest. She looked at the sherds and could guess at the forms, but she did not know how to make the pottery black, nor did anyone else.

So Julian experimented with smothering and smoking the fire, using dried cowpats and scrap metal, and a few years later discovered a process of decoration and firing that blackened the pots, leaving some areas with a mirror shine and others deep matte. The first real success, Peterson writes, was a pot from 1918 that Julian decorated with a horned water serpent called Avanyu,

which he said represented the first rush of water coming down an arroyo after a thunderstorm. But the couple didn't feel the pots were 'true' San Ildefonso pottery, so they hid them, until Hewett returned with people from a museum who accidentally saw them and were struck by their style. Maria and Julian took note of how much the museum people had fawned over the black pottery and wanted to buy it, and so they began experimenting more with this style.

By the 1920s, people began seeking out their work, and the family joined in the making and production of both traditional polychrome pottery and the black-on-black ware, the secret of which they initially kept to themselves, later sharing it so that all the potters in their pueblo could reap the benefits of the sales that were being generated. After Julian died young in 1943, other family members decorated Maria's pots, by which time the pueblo had grown into a highly skilled dynasty of interrelated families.

There is much in the practice of Martinez and the pueblo potters that is connected to the landscape in a way that some modern pottery in the mid twentieth century was not. She would bless the clay she was about to collect, and when Bernard Leach and the potter and writer Sōetsu Yanagi travelled to see her, Leach described being struck at first meeting her while she poked at a bonfire, perceiving her to be as if 'belonging to the landscape'. Other modernisations, however, were allowed: there were no electric kilns, no mills to pug clay, but she and Julian were the first in the pueblo to have a car, which Julian painted with the same designs he used on pottery.

Crucial to both Kwali and Martinez's pots was their skill not just in coil-forming, but also in the thinning of the pot. Thin-

ner doesn't mean better, but thinner is more difficult. This is a creative choice: choose the heaviness of your pot; choose its surface. When a coiled clay pot is created on a curved base and made smooth and fine, it can be made light as air, as if it might lift off any moment. To levitate a pot like this it needs to be perfectly balanced.

Dame Magdalene Odundo met and trained with both Martinez and Kwali and is a crucial living link between these two women. She was introduced to Kwali in 1974 by Michael Cardew, and trained at the Pottery Training Centre in Abuja. 'That time influenced my trajectory and my choice to become the potter I am today,' she has said, adding that the experience of learning Gbari techniques with Kwali had been enormously influential on the development of her own work. In conversation with Ben Okri in *The Journey of Things*, she says how she thinks of what she's doing as 'arresting a dancer in a gesture they cannot repeat again'. 'They are just on tip toe and have momentarily stopped,' she says. 'They are staying still for just that moment.'

There is something in all three women's work that speaks to me of why the immediacy of handbuilding is so appealing. Its many possible gestures create a connection to the clay I find utterly absorbing: the repetition of movement, the possibilities of form, the minimal tools all appeal for their directness and the way they tolerate mistakes or a change of heart mid-make. It perhaps shouldn't be surprising that people made flame pots thousands of years ago. Our hands are versatile tools, our imaginations are peerless creators.

Martinez and Kwali were at a crossroads of the ancient and the modern. The pottery traditions they learned are of unknown age – there is some speculation that in the case of indigenous pottery practices, the making of particular types of vessel might

represent an unbroken connection to very ancient, even prehistoric crafts. However, both Kwali and Martinez partially broke from these traditions, innovating and altering their processes to create distinctive work that represented a clear coming-together of the traditional and the contemporary, in part fuelled by the suggestion of a marketplace for their new takes on traditional forms. However, there is one thing you cannot make through handbuilding – unless you are Maria Martinez – and that is a perfect circle. A perfect circle requires a wheel, a technology that was emerging in Mesopotamia just as the flame pots were burning out.

M.C. Richards soup mug, gifted by the composer
Annea Lockwood.

5
Wheels

'Anyone who watches a pot grow into a shape out of a lump of clay for the first time is astonished at the seeming ease with which it happens,' wrote Bernard Leach of the potter's wheel.

If there are a million ways to work with clay, the wheel might be the most mesmerising. It's miraculous to watch, but try it for the first time without instruction and you might as well have hooves. The clay feels unruly, the pot refuses to rise. To throw a pot requires a knowledge that connects the hands and the mind. It is a dance between potter, wheel and clay that is a triumph over physics every time a pot is thrown.

The wheel is a mainstay of studio pottery practice. It is both versatile and limited, and also hypnotising – dangerously so in Junji Ito's iconic horror manga *Uzumaki*, where a potter is driven mad by obsession with the spirals he first sees in the wheel. Many have fallen into similar obsessions after encountering spinning clay on the pottery wheel.

For many studio potters, throwing is their primary skill. Over time, its learned gestures become ingrained as muscle memory, and the initial difficulty of the act is forgotten. Once learned, these gestures return. Even after two years not throwing anything

in lockdown (and despite being an amateur thrower in the first place), when I sat down at a wheel again, my hands remembered. I could meet the clay again and form a pot.

Learning to throw is a multisensory barrage of information, where verbal instruction or written words can never quite bridge the gap and provide the tacit knowledge one needs to develop skills. In simple terms, you push the clay into the centre with the wheel spinning, make a hollow, drag thumb or fingers outwards to widen it, and then 'knuckle up', which is when the fingers or knuckles squeeze the clay, lifting from the base to the rim, and the pot walls begin to rise. This sounds like an easy step-by-step, but there is much nuance in the precise pressure of gestures; the speed and movement needed. Every step poses its own problems, and while the movements needed seem easily described, what's difficult to communicate is the *feeling* of it going right.

There is a fundamental gap between the dexterity required to use the wheel and the teaching of it: a void between tacit knowledge – things we know in a non-verbal way, or that we know through touch – and explicitly verbal knowledge. The polymath Michael Polanyi described this with the example of riding a bike. The principles of guiding and correcting a bike are not known, he says, so although we might know *how* to ride a bike, we may not be able to fill in all the information relating to what rules, feelings and physics keep the bike upright and us moving. This is like learning to throw on the pottery wheel – it is rarely the case that we can fully articulate everything about the act, particularly the physical forces at play.

Many instructional pottery books acknowledge the intractability of this disconnect. 'Any verbal description of the manipulation of clay on a potter's wheel is bound to be inadequate, if not mis-

leading,' Leach continued. Michael Cardew prefaces his section on throwing with the caveat that 'No written description, however careful and vivid, can be a substitute for practical tuition'; Daniel Rhodes writes that 'The simplicity of the process in terms of tools contrasts to its unusually rich and complex involvement with coordination, sensory perception, gut feeling and intellect.' Other instructional manuals, such as *The Japanese Pottery Handbook*, lean on static illustrations – which pose their own problems for a fundamentally dynamic process, often requiring decipherment like a complex flat-pack manual.

When throwing a pot, you first need to centre a lump of clay. Centring is the first, most difficult step in throwing, and it can be utterly perplexing for beginners. In just this first act, you ask a piece of earth to submit; to be rationalised and made into what it is not: a perfect circle. One practically minded 1969 book by a potter called John Colbeck so plainly described it that anyone sitting down at a wheel for the first time with only his instructions would be alarmed that each step was not as simple as making a sandwich: 'Centring is done by the logical application of steady firm pressures on the surface of the revolving piece of clay. No great amount of strength is necessary.'

Centring brings a ball of clay into the centre of the wheelhead as a perfectly even, circular dome of clay. This enforces a sym-metry upon the clay, which will be drawn into the finished pot. To do this, you slap the ball of clay on the wheelhead, then lock your left elbow against your hip or waist, so your forearm forms a rigid strut all the way to the ball of the palm. With this hand in front of you, curl the palm a little, and meet the clay with the soft pads below the little finger and under the thumb, then

push the clay into the middle of the wheel. The arm should be so stiff that the clay has no option but to conform – your palm is a snowplough and the clay is the snow. It will become unruly if any allowances are made: if you wiggle your fingers, or move your arm. Your palm is herding the clay into the centre: as the base of the hand herds, the fingers curl around the lump and it becomes a smooth shape, as if pulling warmth from around a mug. The other hand acts as a guide.

This is a rudimentary description, rife with mixed metaphors, but there are plenty more details that could be added: plenty of hiccups, troubleshooting moments and minutiae, and also variations depending on the weight of the lump you're throwing, among other things. You might be a left- or right-handed thrower; you might use both hands to bring the clay to centre. After the pot is thrown, there is often more wheelwork to do. Trimming or turning is often done by putting a pot that has dried, so it is leather-hard to the touch, back on the wheel to carve off any excess.

The potter, poet and educator M.C. Richards was taught pottery by Robert Turner at Black Mountain College, who said to her that 'the hardest thing comes at the very beginning, if you are learning to throw on the wheel: the centring of the clay'. The act of centring had a 'curiously compelling magic' for her that became hugely significant, even though she said it took her seven years to master.

Richards was a founding faculty member of the radical Black Mountain College in North Carolina, later living in various communes and independent communities, and was the first translator of Antonin Artaud's groundbreaking work, *The Theatre*

and Its Double. She participated in Black Mountain College's very early happenings (she is the poet reading from the top of a ladder in John Cage's 1952 *Theatre Piece No.1*, often credited as being the first happening), and was present at Yoko Ono's early loft performances. She brought together craft and writing, and it is as a potter that she wrote most affectingly, about the spiritual and metaphorical aspects of making, which became a foundational part of her teaching. She was fundamentally tapped into the possibilities of clay, how working with it operated between language and learning; self-knowledge and communal practices of making.

Centring became a central metaphor for her, beginning as a lecture delivered in 1962, and later commissioned as a book in a series alongside John Cage's influential text *Silence*. *Centering: In Poetry, Pottery, and the Person* remained in print for decades. It was starkly different to other pottery books, if in fact it is a pottery book at all. There remains little comparable to it now – largely because it contains minimal technical instruction, but also because it remains locked to a poetic philosophy of craft.

Centring, Richards explains, is not something that only happens on the surface of the lump of clay. When you centre, you bring *all* of the clay into the centre – every molecule is arranged, and it becomes evenly distributed, 'so that when touched at any one point, the whole body of the clay will take form'. In her reading, the act of centring is not about imposing order necessarily, but about setting up the clay in an optimal state for the forms it might take. This becomes a metaphor for ourselves, and an action Richards considered an archetypal activity, in that it was symbolic and metaphorical; a worthwhile process for spiritual growth. It was, she said, an impossible act

of creating possibility.

She remained committed to centring as a metaphor in her later book, *The Crossing Point*, where she wrote: 'I find the potter's craft of centring the clay enacted in all realms of life: bringing into centre all of the elements of experience and the creating of forms out of that centred condition.'

When I sit down at the wheel, I know this acutely. How well I can centre a lump of clay tells me what sort of day I'm having. I find I can't centre if I'm not *feeling* centred. When waste buckets fill faster than the drying boards, I turn to books, videos, fellow potters to find out where I'm going wrong. On very bad days, I often take my first tutor's advice and walk away: do something else. Madelaine delivered this advice after I had doggedly persisted one evening despite feeling frazzled. I had gone through half a bag of clay without creating anything, covering myself in slip from thigh to ankle; fingertip to elbow.

Florian Gadsby is one of the best-known potters on Instagram, with almost a million followers at the time of writing. He's always been a potter, meaning he's been throwing regularly for his whole adult life. His work is fine and angular, crackle-glazed and functional. He sells pots in semi-regular sales online, where hundreds sell out in minutes, and he also makes lucid and instructive videos on his YouTube channel, detailing everything from how to throw various forms to the more tedious aspects of potting like clay reclaim and packaging.

I take a trip out to his studio in a block of former factory units and converted industrial spaces hidden behind a loop of terraces in north London. He says it's not his ideal studio, but it seems dreamy to me, a clean and light former industrial space

with skylights between steel beams, with two kilns and a broad waist-high plywood table dominating the space. The table is covered with neat rows of pots waiting for their unfired glaze to be checked for dinks or bubbles before going in the kiln. It's a job that will take him the whole of the next week or so, he says. Tucked in around this are smaller tables and a wheel, which crouches in the middle of the space.

All along the walls, running up to the ceiling, are shelves of pots in his signature palette of crackle-glazed cumulus greys and the colours of lakes under storm clouds that break in dark lines on fine edges where glaze meets clay. There are glossy vases and rows of mugs; elegant pourers he says can be awkward to make. Everything is neat, aligned, tidy – even the tubs of grout and paint in the studio bathtub are neatly stacked, and the handles of the mugs on the shelves all face the same way. His work is, he says, 'strict and cylindrical', and he trims dried pots a lot after throwing to get them really light.

We sit down for tea from one of his teapots and matching mugs. Mine is feather-light, with a handle that balances it in the hand. As a solo studio potter, throwing is only part of his regular tasks, along with marketing, selling, endless cleaning, trimming, glazing and firing. Right now, he is about to announce his memoir, *By My Hands*, which has taken time away from throwing, but with so many years at the wheel behind him, prolonged periods away make him feel like something's off, 'to the point where I even feel like I get more argumentative, or stressed', he says.

Gadsby's first experience with clay was making models to put in the bread oven age five or six at his Steiner school. He had his first go on a wheel age fourteen or fifteen, but it took a teacher

pushing him back towards it for it to click, when he realised he could take home and use what he was making. He did ceramics throughout his GCSEs and A levels, and a placement at the Leach Pottery in St Ives, before studying in Ireland. At this point, higher education ceramics teaching in the UK was at a low ebb (in many ways it has not fully recovered) – he remembers a visit to Stoke-on-Trent, where even in this city built and named on the back of its potteries, the teaching wheels were stacked up and gathering dust.

I ask him about the teachers he had: how they translated the physical gestures into verbal instruction. One of them didn't: 'In Ireland, I had a teacher who would sit next to you, lean her body on your knees and touch your hands,' he says. 'It was very intimate, but she put your hands exactly where they needed to be; put your fingers to the pot and showed you exactly how much pressure you needed.'

After this, he apprenticed with renowned British potter Lisa Hammond, who gifted him a flight and an arranged apprenticeship with Ken Matsuzaki in Mashiko, Japan, where he used a manual kick wheel for the first time. On an electric, you don't really use your legs except on the accelerator pedal, but on a kick wheel, the foot turns a wheel that in turn rotates the platter on which you throw. Gadsby says that Matsuzaki's kick wheel held very little momentum, so he learned that he needed to engage not just his hands but his whole body. 'You've got to be upright, you've got to be kicking,' he explains. 'It was incredibly mentally and physically draining – I was teaching myself a new skill. I knew how to throw, but then I had to learn how to pair that with my legs.

'On an electric wheel, you push the accelerator pedal down, and the motor is constantly spinning the lump of clay. So you

don't have to think about the wheel losing speed, whereas when you're using the kick wheel, especially during the beginning stage, when you're centring and opening up, you have to do so much kicking. But it's more like "Kick, kick, kick – centre – kick, kick, kick – open up."'

Matsuzaki complimented him on having good rhythm, 'which is funny, because I can't dance to save my life', he says. Ten hours a day on the kick wheel gave him what he describes as the potter's equivalent of tennis elbow in his leg. 'It's hard work,' he says. 'But you know, when Ken does it, he makes it look easy.'

He now uses an electric wheel again, but misses some of the rhythm and possibilities the kick wheel offered. Its direction is reversed with a single kick, whereas on an electric the wheel must be stopped and a switch flicked. This apparently simple difference offers a massive range of possibilities, particularly with brushwork decoration of pots, for example.

'Throwing on the wheel is incredibly complex because you're having to manage pressure with your hands; how fast you move them upwards; movement from your arms; wheel speed; water usage – it can't be too wet or too dry. All those things have to work in harmony. That is incredibly difficult – it's not just one or two processes, it's five or six things working in perfect unison to throw the pot. And that's mysterious.'

Gadsby works hard in his instructional videos to explain processes in detail, often breaking down each step into discrete videos and giving a complete analysis of steps within steps over the course of twenty minutes or more. 'I spend a lot of time thinking of a descriptive word or analogy that makes what I'm

actually explaining make perfect sense,' he says.

'With ceramics, cooking analogies work really well. Or driving a car, where pedal usage relates so closely to the pedal on the wheel . . . Frankly, describing the process of pulling up the walls of a pot to someone who's never seen it or done it is really hard. But it's so simple for someone who's been doing it for so long.

'At the beginning, I remember feeling so clumsy. You're doing things with your hands, like pinching a rim, but it just doesn't feel right, you feel awkward. Then give it five or ten years – suddenly you don't even think about it, and it's completely subconscious. The hand gestures themselves become almost a way of speaking.'

The wheel is where he describes finding something that sounds like flow state. It is a mechanical process for him, but when throwing, he's working mostly with his hands and water, and very few tools. 'I do sometimes wonder what happened – three hours pass, and I literally can't remember doing what I've done.'

He loves throwing, he says, because even within its constraints, there are so many possible routes to the same forms. 'People use different hand gestures for every single stage of the process,' he explains, 'yet they can throw a pot that looks identical. I find that fascinating.' It appeals to him as a technology that has barely changed in its principles since it emerged, and that will remain the same into the future. 'You're using the same techniques, more or less, that people have been using for thousands of years.'

Some of the earliest known depictions of pots being made on some sort of rotational device are in Ancient Egyptian reliefs. Wheel-like devices are pictured on the walls of the tomb of Ty at Saqqara, and at the tomb of Ptah Shepses at Abu Sir, dated to around 2500–2300 BCE. The wheel is also at the centre of one

Egyptian creation story, which tells how the ram-headed creator god Khnum was a divine potter who worked on a wheel. At the Roman-era temple of Esna he was celebrated at a festival of the potter's wheel as a 'lord of the wheel' who fashioned gods and men. His celestial potter's wheel turned every day. In some texts he is said to make all the bodies of earthly creatures; in others he is restricted to objects, or royal bodies.

In a relief at Dendera, he is shown as a ram-headed man with long horns. He and the goddess Heqet appear to be creating a small boy on a wheel or rotational device. The boy is Ihy, a god who plays an instrument called the sistrum. The mud that Khnum threw with was thought to be from the seasonal deluge he oversaw from his main sanctuary on the isle of Elephantine in the Cataracts. This deluge was what made the 'fertile crescent' fertile, but also what brought the clay deposits used in pottery to the region, and in this way the clay and fertility became symbolically bound.

In more general histories, the potter's wheel is often presented as an invention that simply happened, and then spread as a technology and technique that sped up pottery production (for example, in Emmanuel Cooper's history of world pottery from 1972), but it is no longer clear that this is true. Current scholarship states that it is in no way obvious that the wheel made things faster, or that it was used as such. This simplified narrative also presupposes a definition of the pottery wheel, but what do we even count as a wheel? Is it anything at all that rotates, or does it need to spin fast enough to throw an entire pot from centring to trimming?

I call up Valentine Roux, an expert in the earliest known uses of the pottery wheel. She tells me that the first evidence we

have of people using a wheel is from the fifth millennium BCE, in the region around present-day Jordan and Israel. What was being made at this time was just one type of small bowl, used in burials or found inside houses, some of which still contain soot in the bottom, evidence that suggests they were used as some sort of lamp.

These bowls were handbuilt, then placed on a basalt wheel to be finished – this means they are 'wheel-made', she says, not necessarily 'wheel-thrown'. Her research is focused on the techniques that were used, as in tandem with these small wheel-made bowls, utilitarian pottery was still being handbuilt. 'My whole hypothesis was about the conditions for the emergence of new techniques,' she explains, 'which marks a real rupture with previous techniques – with the potter's wheel you introduce a new source of energy, kinetic energy, and because of this, you have to develop specific skills.'

The earliest wheels were stone turntables, or stones set in pivots, perhaps greased with wet clay or oil. Roux thinks that they were used by the same handful of itinerant potters – maybe even a single potter – who would travel around the region finishing pots begun by locals on a wheel carried by a pack animal.

'The question is why [this technique] was not borrowed to make other vessels,' she says. 'It appeared very clearly that it takes – not only for the potter's wheel, but for any new technique in rupture with previous ones – millennia or centuries before a technique associated with a type of object can be transferred to objects which do not have the same function. The transfer to utilitarian vessels took a huge amount of time and required new social and economic conditions.'

The purpose or symbolism of these wheel-made bowls and

what it signified for this society to leave a wheel-made bowl with their dead are questions that can only be speculatively answered, because when this society collapsed, the wheel and associated skills disappeared. It then took until the second or third millennium BCE for the wheel to be used again in pottery production more widely.

These stone wheels pre-date cuneiform writing, temples and money, and notably, also pre-date the use of wheels on wagons or any other transport. Rotational energy was very much in use, for drilling, spinning and other tools, but it is not totally absurd to suggest that the wheel was invented by a potter.

<p style="text-align:center">*</p>

Much of what we know about how early pots were made remains unknown, or is still being debated. It's only relatively recently that advanced imaging techniques have allowed us to look at a pot and work out how it was formed. The implications of this are making some questions around ancient pottery hot topics again in the research community, along with the development of experimental archaeology. In some cases, the presumptions of some archaeologists about how a pot was made are being fundamentally overturned.

One of those researching this subject is Ina Berg, a senior lecturer in archaeology at the University of Manchester. She is an expert in prehistoric Greek pottery, specifically the use of the potter's wheel and how techniques like throwing were applied. She's not a potter (she tried it, and quickly discovered she was terrible at it, she says), but she works directly with potters to ascertain whether her theories about the way something was made align with how they would make a pot. She also X-rays pots to

see how they were made – sometimes herself, sometimes with a scientist or external lab.

Because early stone pivot wheels didn't gain much momentum, they would have slowed down or stopped before a pot could be thrown, but Berg says it's probably not that simple: there may have been people whose job it was to keep a slow wheel turning, for example. There's also a question over what we count as throwing, and how much rotational force – known as rotational kinetic energy – a platter needs for a potter to throw. There might be lots of things that turn, but are they turning enough, and being used in a way that we can think of the pot as being thrown?

What Berg has often found in her research, as with Roux, is that pots were made on early wheels in hybrid techniques – a vessel might be coiled, then put on the wheel to be made uniform or appear thrown. When sent in for X-ray, it's often the biggest or most complex shapes that reveal the most secrets about how the wheel was used thousands of years ago, because they required a combination of different techniques. 'I looked at some Mycenaean pottery where the assumption was always that it was wheel-thrown, because you can see the rilling' – the horizontal undulations left on the pot surface where pressure is exerted onto the clay by the potter when forming on a wheel. 'Once we knew what we were looking at, it turned out it wasn't wheel-thrown at all – it was a hybrid technique,' she says. 'It caused a bit of a stir amongst us as archaeologists, as we realised that what we had taken for granted just wasn't the truth.'

Fundamentally, the question of how a pot was made has typically fallen into second place behind studies of its decoration – this seems remarkable to me, but Berg says that, until relatively recently, there were either assumptions or gaps in the literature

about the production techniques that had been used, and because scholars thought an object was wheel-thrown, they were unaware of any gaps in their knowledge. It was presumed, for example, that clay for throwing might need to be processed so was finer than clay used for handbuilding, but it's no longer clear that this is strictly necessary. Technologies like X-rays, microscopy and computer tomography can show marks that indicate whether something was thrown, slab-built or coiled. 'Depending on your forming technique, you'd leave different fingerprints behind in that shape,' she explains. 'If I'm lucky, they might give me clues as to what the technique was.'

The application of these technologies, in tandem with a greater emphasis on collaboration with professional potters, is regularly updating what we know. In the past there was far less communication between archaeologists and potters. Berg tells me a story about a workshop where a potter was asked by some archaeologists to show how different kinds of shapes were thrown. When they came to the Greek kylix – a wide, shallow drinking bowl with handles and a short stem – the potter showed how the bowl and the stem were thrown separately, then joined. 'The archaeologists said "What?! You don't throw the whole thing at the same time?!"' she says. 'There was a lot of naivety about potting amongst archaeologists, and it's really only with us drawing on the help of potters and some of us learning how to pot ourselves that this has changed.'

Museums and galleries provide almost no detail in the information cards about how a vessel is made, but what I didn't understand until talking to Berg was that, in some ways, this knowledge is still being built, and there are new discoveries all the time. 'Even I'm surprised that we still have stuff that we haven't

discovered,' she says. 'There was an assumption that we thought we knew it all, you know? We'd seen the pots: there was some rilling on the surface so it must be wheel-thrown. Only with the arrival of technology like X-radiography was there a greater awareness that there aren't just two techniques: wheel-thrown and everything else.'

I look up M.C. Richards again, to see what type of pots she threw. She was about as concerned with professional production as I am (which is not at all) and I want to know whether she threw well. Jenni Sorkin, an art historian who has written extensively on Richards, writes that she 'embraced the role of enlightened amateur', giving away her pots, or selling them for very little. I'd read letters in her archive where she wrote to ask a friend if the Stockhausens had received their cups, and of a dinner set she made for John Cage as a birthday gift. But there are just a handful of images of her work online, some thrown, some handbuilt, like the three-eyed beast she met in a dream. The Getty has her papers but not her pots. Her tendency to give her work away means there's not a huge amount of her pottery in places you can see it, and certainly not enough for me to get a handle on it.

Then, quite out of the blue, a piece appears. I had met a group of friends for lunch with the composer Annea Lockwood, who was visiting from New York. Annea asked what I was working on, and I explained that I was struggling to find pots by Richards in any institutions. 'I've got one,' she remarked quite simply. 'A mug with a lid: perfect for soup.' It was given to her by her friend, another remarkable character called Jean Rigg, who (among many other jobs, from taxi driver to lawyer to originator of the annual New Year Stein readings) was manager of the Merce

Cunningham dance company in the 1960s, bringing her into contact with Black Mountain College. Annea thinks Richards must have gifted the piece to Rigg directly.

When she gets home, Annea asks a photographer friend, Bill Hart, to take photos of the cup and send them to me. It's thrown: country-style cobalt over milky white, a large teacup with a neat handle in a grogged clay that has turned roasted caramel on the footring. I can see the shadows of neat rilling on the inside, narrow and regular. It is in pleasing proportions: not heavy or bulky, but not delicate either. There are iron speckles on the white, and the cobalt is brushed on in a wide stripe. There are half-moon notches in the glaze around the bottom of the cup – the shape of Richards' fingers when it was dipped in glaze. The lid is thrown and turned, and fits snugly on the gentle flute of the rim, the knob a caramel colour that sets off the white and blue. There's a small chip in the lid, and instead of a maker's mark, 'MC' has been scrawled on the base in oxides; more of a reminder than an assertion of authorship.

It's useful, but also fairly unremarkable until you take a closer look – the marks of its maker are left in the scallop of the finger, her throwing lines, her scrawled initials. It's outlived her, and has been passed on through friends, used by people. I'm entranced by its simplicity, but it's far less 'special' than thousands of cups in museums and galleries. Her throwing is good, and the cup is practical, not luxurious or even particularly desirable, except for its lineage. Its value is untested because it was never given a price (at least we don't think so), so its worth has come from being used and passed on by the characters who have owned it, from Richards to Rigg to Annea. It's a resonantly appropriate way of encountering a thrown piece by Richards, who in teaching

pottery and talking of centring, as Sorkin writes, 'returned clay to its roots as a pliant and connective material, as a way of joining students to each other'.

This is particularly resonant in terms of the wheel; of Richards' lifetime of thinking about what it means to pass on knowledge of a creative act. This passing-on of her soup mug is her sort of communalism in and of itself, a long-form participation in the life of an object, which becomes significant because it is about centring and about how we teach one another to centre. It is a teaching that requires a sort of poetry in its verbalisation or articulation, whether the metaphors and similes Gadsby leans on around cooking or driving, or the spiritual metaphor Richards takes from the notion of getting the clay to the middle of the wheel.

Months later, I receive two boxes through a friend, left for me by Annea. Inside, I find Richards' cup, generously gifted to me, making me its next keeper. It is bigger than I expected, and the throwing is finer. It instantly becomes the most valuable thing in my house, a route to my own centredness and a source of inspiration. Richards herself drew much inspiration from a memory of watching her first teacher, Robert Turner, throwing at the wheel in the shop at Black Mountain College, giving a demonstration: 'He was centring the clay, and then he was opening it and pulling up the walls of the cylinder. He was not looking at the cylinder. He was not looking at the clay. He had his ear to it. He was listening. "It is breathing," he said, and then he filled it with air.'

The Kizaemon Ido teabowl.

6
Food

Clay vessels like the soup mug I was gifted by Annea have held our food in multitudinous ways throughout human history, but clay's role in our mealtimes has not only been as a container for nourishment. Historically, clay in its raw form has also been eaten, both for its medicinal properties and to see us through famine.

The eating of clay is called geophagy, and it has been recorded in cultures and communities across the world. There is a prevalence for earth-eating by pregnant women and by people who experience famine or seasonal scarcity, and it is not restricted to the poor, the underprivileged or those without access to education as is sometimes suggested. Clay is also eaten in various rituals; sometimes taken from a sacred place and ingested for healing on the same principle as holy water is taken from shrines. Prehistoric evidence of clay-eating is scarce, but it's thought that people may have eaten clay shards in time of famine, as the low-fired pottery would have absorbed oils and juices from what had been cooked in it, and might have contained crucial nutrients.

Various forms of geophagy have been documented all over the world, although not in every country. It was often deeply misunderstood, particularly by colonial writers in the eighteenth

and nineteenth centuries, who would describe it as depraved or disgusting, despite the fact that there were societies in Europe also eating clay and earth at that time (notably in Sardinia, where peasants habitually mixed clay with their grain to make bread). In 1930, the extant literature was collected and assessed by the relatively open-minded anthropologist Berthold Laufer, who criticised those who would disparage it as uncivilised, writing that 'consuming earth, mud or clay is no more surprising than eating salt, pepper, bark, insects, snakes or monkeys or chewing gum, coca leaves, betel or tobacco'.

Laufer writes of geophagy in Malaysia, Australia, India, China, Tibet and across the Americas, and finds records of it in medieval writing. The thirteenth-century Arabic physician Ibn al-Baytar lists eight kinds of known medicinal earth, and polymath saint, composer and poet Hildegard von Bingen describes a complex leprosy cure involving clay taken from anthills. Early Chinese literature contains stories of geophagy in Taoist magic, where Taoists appear and show starving villagers beds of blueish clay called 'earth rice' that tasted like grain, which the villagers could eat to survive a bad harvest. Similar stories were found in Germany, with a clay-like material called 'mountain meal'.

The geographer and naturalist Alexander von Humboldt is said to have 'made geophagy fashionable'. Around 1800, he spent time with the Otomac, a group indigenous to Venezuela, who would 'swallow great quantities of earth', he described as 'a soft unctuous clay; a true potter's clay, of a yellowish-grey colour due to a little oxide of iron'.

Some of the reports Laufer collects are tainted by the biases of those writing, and some instances are masked by misidentification of diseases that are no longer considered to exist. Compulsive dirt-eating accompanied by various symptoms was identified as

a disease in enslaved West Africans named 'cachexia africana', although the health conditions associated with it were more likely caused by a host of nutritional deficiencies, untreated diseases such as tuberculosis, and psychological compulsions as a result of the traumas of enslavement.

In Esquipulas in Guatemala, small tablets of sacred white earth are eaten, or dissolved in water and drunk. The white clay is believed to have healing and health-giving properties. These tablets are known as *tierra santa*, and are sold as part of devotions at the shrine of the Black Christ of Esquipulas. The clay is pressed into small cakes and stamped with pictures of saints, the Virgin Mary or the crucifix of the Black Christ, near which the earth has been sourced.

The cult of the Black Christ is a syncretic Christian religion, and Esquipulas is a site of pilgrimage that was co-opted by Spanish colonisers, built on a pre-Columbian pilgrimage route that led to the Mayan ceremonial city of Copan in Honduras, which was itself already noted for its health-giving earth and sulphurous springs. The Spanish built a small Christian chapel at the site of the healing shrine in Esquipulas, later adding a five-foot-high image of Christ on the cross carved from balsam and orangewood. The wood was a dark brown colour, which was then further darkened by the burning of candles and incense in the shrine. Being built over the original healing spring, the Christ became a new focal point for devotion. The colour of the Christ was recognised as being closer to that of the indigenous population than the colonising Spanish, and became a recognised saint within the belief system that gathered around Esquipulas, gaining a reputation for miraculous cures that included healing the Archbishop of Guatemala in 1737.

A paper on this specific instance of geophagy from 1984 also describes how the white clay tablets were exported, found on sale 175 km away in Belize, bought primarily by pregnant women from the African and Caribbean diaspora. These communities had traditions of clay-eating in pregnancy that had a lineage back to the Ewe in Ghana and other areas of the African continent and Caribbean islands, taken as folk medicine, or as a dietary supplement.

This geophagy, involving the white clay from Esquipulas, was a fusion of three cultural traditions, incorporating practices from the region's pre-Columbian communities, its Christian colonisers, and the African and Caribbean diaspora. Analyses found that as a folk medicine, it provided useful amounts of calcium, potassium, magnesium, iron, zinc and selenium, and that it 'compared favourably' with Western pharmaceutical supplements from the time, especially when availability and cost implications were considered.

These healing clay pucks also have antecedents in Greece, as *terra sigillata* from the island of Lemnos (although the term *terra sigillata* now has three distinct meanings relating to geophagy and Roman or studio pottery). The reddish clays from the island were stamped into pellets and marked with the seal of the goddess Artemis. Pliny wrote of the healing clays of Lemnos, as well as those from elsewhere (although Lemnos was superior, he said), as did the ancient physician and philosopher Galen, who picked up 20,000 discs of *terra sigillata* when he stopped off there while travelling between Rome and Pergamon. Galen also described the ritual that accompanied its collection, which happened on a particular day of the year and involved the priestess of Artemis performing various ceremonial observances and sprinkling barley on the earth.

Another account from Greek physician and botanist Dioscorides described how 'the earth was found in a tunnel-like aperture in Lemnos, prepared with an admixture of goat's blood, and thereafter made up into tablets and stamped with the figure of a goat, whence came its popular name "goat's seal". It had a singular virtue against poisons if drunk with wine, and acted as an emetic when poison had already been swallowed.'

The Lemnos *terra sigillata* were said to cure everything from rabies to plagues, and to be antidotes to poisonings. Galen also used them successfully on his own ulcers. On the matter of poisoning, their advertised benefits may have had some grounding, presuming the clay could absorb some toxins if ingested – it is recorded that a sixteenth-century Polish miner had some success selling clay pellets that when tested appeared to have neutralised poisons given to dogs and one already condemned prisoner. In his survey, Laufer finds them included in Western European pharmacopoeias as late as 1848, although later chemical analyses of the pucks found that in the case of Lemnos clays, there was no identifiable health benefit from their ingestion.

Eating clays was not always healthy – if you mistook topsoil for clay, you were likely to pick up some sort of parasitic worm, among other undesirable bacteria. Clays were often eaten to ease the gastric pain caused by hookworm, although it is unknown whether the earth-eating caused the hookworm in the first place.

Despite this wealth of evidence for geophagy as a meaningful practice, one that may have had various health benefits and aided survival in lean times, there is little evidence of clay being used in cooking for its taste. If it is eaten in any quantity, it is for its minerals as folk medicine's version of a multivitamin. Its lack of flavour is usually used in cooking to neutralise, often to make

acrid tubers palatable, as it was for the Ainu in Japan. Parrots and primates have also been found to eat clay, but there is very little to suggest that anyone is doing so because it tastes good, except for one artist, masharu, who runs the Museum of Edible Earth. They collect edible clays from around the world as a gastronomic art project, and the accompanying website includes photos of gallery attendees tentatively placing raw clay in their mouths, with looks of fear, trepidation or disgust on their faces.

It is important to remember that many of the documented ethnographic examples of clay eating will have been taken from proven sources of clay known for generations. This is a very different state of affairs to digging down in any old patch of land. Even when Laufer was writing in the 1930s, the amounts of heavy metals, microplastics, and chemicals from farming that might be present in the earth were at different levels to today, although I might be tempted to try a sacred clay puck from Esquipulas or Lemnos.

When we were not eating clay, we were eating off it. Many of us drink from a ceramic mug or eat off a ceramic plate or bowl each morning. These objects are not insignificant parts of our daily lives. It matters what they look like, what they feel like, and how well they function. As the potter Lisa Hammond has said: 'Even people who don't buy hand made mugs will often have a favourite mug. You're making a decision – about the size, the form, what's comfortable – when you're half asleep. What do you want to drink your tea from or eat your cereal from?'

The sheer variety of vessels designed for specific culinary purposes is overwhelming: ceramics have fulfilled specialist functions in our eating and drinking habits far before glass and plastic were widely used. Baby bottles were made from clay as far back

as Ancient Rome and perhaps earlier. The Ancient Greeks made disposable cups from quickly thrown clay, and chai is still often served in similarly disposable clay cups in India. The shallow two-handled kylix from Greece, however, was often boldly decorated with large, cartoonish eyes around the underside, making the drinker look like they were wearing a mask when they supped. Large Minoan jars were used for transporting oil; Korean onggi are designed for pickles; medieval English harvest jugs carried beer to the field at harvest time. In Vedic literature, pottery for specific purposes is listed, such as a clay pot for boiling milk called a gharma, a clay water jar that is partially buried called a ninabya, and a pitcher for storing water called a kumbha.

What our meals are served on (and in) might often pass under our noses without much comment, but these objects often speak quietly of status, culture, aesthetics and ritual, while also being highly functional. They mean something to us, as the pot that speaks says in the *Rubáiyát of Omar Khayyám*: 'Ne'er a peevish Boy/Would break the Bowl from which he drank in joy.'

Anyone who has spent time making functional pottery and dinnerware will have also spent time paying special attention to the pottery they eat from and drink out of. For some, it becomes a bad habit: to instantly flip a plate or cup over as soon as it is emptied, to inspect the base for a maker's mark and to see how something was formed.

In my own kitchen, I have begun slowly jettisoning mass-made crockery for my own handmade plates, bowls, serving dishes, teacups and mugs. I sometimes wonder if I should be collecting studio pottery instead, but it is expensive and I am clumsy. Instead, my own work passes directly from the studio into the kitchen. It has no proven monetary value, so I feel less guilty when I break it – I can always make it again, I tell myself,

although often I make something different to replace it. This means that what I eat off is a living document of how my style is changing and my skills are improving.

There are a few things I have bought that will stay on the shelves: a set of antique pale aquamarine celadon saucers the size of my palm, bought at online auction; a white snow-glazed side plate from Japan with a single drop of blood-red iron accidentally blooming on the surface; a low-fired matte-black serving dish with lugs from a market in Colombia. They sit in the cupboard with side plates I made from flecked clay with brushed cobalt sigils; fruit bowls splashed in black slip over porcelain washes; dinner plates I hand-painted with Luke Howard's nineteenth-century cloud classifications. I am not one for matching.

It can be unfamiliar to many diners in the West to think much about the shape, the colour, the surface of the ceramics our food is served on, so I called up Casey Lazonick, a food and drink photographer, stylist, chef and now part-time potter, to ask her about how she thinks about the plates she uses. She tells me, quite to my surprise, that most of the plates you see in food and recipe photography are much smaller than they appear. 'The camera makes everything look bigger,' she says, so she uses a lot of smaller side plates, and is about to go and collect some small mugs she has made that will be useful to use for scale.

Her preference in the photography and styling she does is for muted tones, to bring out the colours of what's on the plate. In lockdown she started making her own crockery again so she would have a stock of the things in colours she most liked to use. She shows me a dove-grey side plate, and a small pale blue bowl: 'There's a lot of neutral colours I use most often, because it just makes the food pop,' she explains. 'It's really about bringing out the ingredients and thinking about where your eye is going to

go. I used to make things that were brighter, but I find it just doesn't get used.'

I ask if her work bleeds into her own routines and rituals around eating. 'Even if it's just for myself, I want it to look pretty, even if it's just pasta,' she says. 'If you have something on a really nice plate, and it's been nicely plated up, you're not going to shovel it down. It makes you think a little bit more: everything's more mindful. So if I'm buying dishes, I always want to buy something that feels a bit nicer; a bit special. Because that's important.'

Those visiting Japan are often struck by the beauty and variety of the ceramics that food is served on there, as crockery is often matched to the food. In his memoir, *A Tokyo Romance*, writer and editor Ian Buruma guiltily recounts his host having to change the plates for him and his fellow travellers, because they were so late to the meal that the light had changed. Their hostess explains 'that it would have been so much better if we had arrived on time, since the colours of the bowls and plates had been especially chosen to match the light shining through the rice-paper windows. As it was later now, she had been forced to replace the utensils with a different set to match the time of day.'

One of the most refined rituals around food and drink is the Japanese tea ceremony, where tea is prepared with prescribed utensils, actions and gestures. At the centre of this ritual is the tea bowl – the chawan.

The tea ceremony in Japan was originally part of Zen Buddhist rituals. Then, in the sixteenth century, a merchant called Sen no Rikyū (often referred to as just Rikyū) transformed it into an art practice in and of itself, one that was practised and refined by the

samurai. If it had always been ritualistic, it then became codified into a set of rules and operations.

Rikyū specified many details that are still in place today, from guidance on utensils to the proper features of a tea house inside and out. A low door forces guests to bow and – if they were carrying one – remove their swords. This was significant: Rikyū was a merchant, who were of a lower order in the social strata than other workers and skilled craftspeople at the time, so bowing was a social equaliser, and the removal of weapons a reminder that drinking tea was a time for civility and contemplation.

I once attended an introductory tea ceremony held by a Japanese tea importer in a modern studio block in west London – it was not quite the restful environment traditional tea masters envisaged, nor did I have to bow on entry, but in this busy room, teeming with imported teas, books, bowls, cups, teapots and kimono hanging from walls and clothes rails, I saw the choreography of the rituals of serving a properly prepared cup of vivid green matcha in gestures and movements laid down hundreds of years before and repeated into the present day.

In *The Book of Tea*, written for a Western audience, the bilingual scholar Kakuzō Okakura explains that the ceramics you used when drinking tea changed depending on what type of tea was being prepared: whether it was whisked powdered tea (like matcha), loose tea steeped in hot water, or (one now less familiar) a 'cake' of compacted tea. 'The celestial porcelain, as is well known, had its origin in an attempt to reproduce the exquisite shade of jade, resulting, in the Tang dynasty, in the blue glaze of the south, and the white glaze of the north,' he writes.

'[Tea master] Lu Yu considered the blue as the ideal colour for the tea cup as it lent additional greenness to the beverage, whereas

the white made it look pinkish and distasteful . . . Later, when the tea masters of Sung took to the powdered tea, they preferred heavy bowls of blue-black and dark brown. The Mings, with their steeped tea, rejoiced in light ware of porcelain.'

Matcha tea bowls are often chosen to complement the vivid greens of the powdered tea, and those decorated, shaped or glazed with non-symmetrical features should be turned by the server as part of the ceremony, and turned back by the tea drinker, so that the 'best' side of the vessel is always presented. At the tea ceremony I attended, I was given a steep-sided bowl in a rugged biscuit-coloured clay roughly glazed in a bright white, as if splashed with household emulsion. The green foam of the fresh matcha looked like a lime in a glass of milk.

The earliest tea bowls were imported from China, but the most highly valued often originated as everyday rice bowls brought over from Korea in the sixteenth century. One of the most treasured in the world is called the Kizaemon Ido, one of eight tea bowls designated as a national treasure in Japan. All important tea bowls have a name, and the Kizaemon Ido is named for its style – an ido is a form with a deep well – and its first owner, a merchant from Osaka named Takeda Kizaemon, who owned the bowl around the end of the sixteenth century. From the beginning of the seventeenth, it was passed on, from lords to tea masters to lords, but in the eighteenth it was sealed away, not because of its reputation and value, but because it was believed to give its owner boils and sicknesses, and sometimes cause death.

In 1775, the Kizaemon Ido was bought for a huge sum by a collector of tea bowls, one Lord Matsudaira Fumai of Matsue, who is said to have been so fond of it he always kept it with him, despite being twice plagued by boils. His son inherited the

tea bowl, and he too suffered from a plague of boils, at which point the family moved it into the safe keeping of the Daitoku-ji temple in Kyoto.

It takes me a while to realise I've been to Daitoku-ji. I don't remember until I look it up online and recognise the wide wooden veranda on which tourists gather to contemplate its famous Zen garden. I remember the resonant thud of socked feet on the old timber and the golden wall panels inside, but I do not recall mention of a tea bowl, because the Kizaemon Ido is not on show, despite being a national treasure. It has been effectively retired from its function three times: firstly from its original function as a rice bowl, secondly as a tea bowl, and finally, unlike many other treasures, it has been retired from public view.

Much of the information above is taken from the account given by Sōetsu Yanagi, a philosopher, writer and co-founder of the mingei movement, which venerated folk art and aimed to set a standard for beauty in Japan. He visited the Kizaemon Ido in 1931, and described the experience in what has become one of the foundational texts for the mingei philosophy, *The Unknown Craftsman*. 'For a long time I had wished to see this Kizaemon bowl,' he wrote.

'I had expected to see that 'essence of Tea', the seeing eye of tea masters, and to test my own perception; for it is the embodiment in miniature of beauty, of the love of beauty, of the philosophy of beauty, and of the relationship of beauty and to life.

'It was within box after box, five deep, buried in wool and wrapped in purple silk. When I saw it, my heart fell. A good tea-bowl, yes, but how ordinary! So simple, no more ordinary thing could be imagined. There is not a trace of ornament, not a trace of calculation. It is just a Korean food bowl, a bowl, moreover, that a poor man would use, everyday commonest crockery.'

He goes on to list the many ways in which it is worthless: it cost nothing, it was used carelessly, it could have been made or found anywhere, its maker had thought little of its form and had poor tools to make it with, and had spent even less time on refining it. (He also suggests the throwing room was dark, that the thrower could not read and was a 'clumsy yokel' who ate dirty rice and failed to properly wash their dishes after eating.) 'No one invested the thing with any dreams,' he laments. 'It is enough to make one give up working as a potter . . . But that was as it should be. The plain and unagitated, the uncalculated, the harmless, the straightforward, the natural, the innocent, the humble, the modest: where does beauty lie if not in these qualities?'

Yanagi's intention was to remake a new set of standards for beauty, and the Kizaemon Ido was plucked from the everyday and made precious. But I feel uncomfortable about the reverence the mingei movement places in presumptions around making without intention. I have a fondness, aesthetically speaking, for the folk art it so crucially promoted, but swapping one set of standards of beauty for others only replicates problems from before. Are we to understand that the person who made the Ido could not see that it had value? Is the implication that a refinement of taste and understanding is necessary to see the truth of the vessel?

In the suggestion of connoisseurship needed to see the value in the Korean bowl, I worry that this philosophy of humble beauty is just another way to exclude or create hierarchies. Pottery is art and pottery is craft. If Yanagi finds it the most perfect bowl, the next person might not, but neither must be wrong for the bowl to remain an object with value, presence and power. Like

so many of the vessels we eat off and drink from, the case of the Kizaemon Ido is not just about aesthetics and ritual, but also about class and politics.

The Imperial Porcelain Factory was founded in St Petersburg in the middle of the eighteenth century, producing hard-paste porcelain after a formula discovered by a mining engineer named Dmitry Ivanovich Vinogradov. Until the revolution in 1917, it exclusively produced porcelain for the court, supplying extravagant dinner services along with replacements for the regular breakages, as well as porcelain figurines and services gifted to other royals and powerful elites.

Then, when the tsar was forced to abdicate in February 1917, the factory was renamed the State Porcelain Factory and fell under the jurisdiction of the new Ministry of Trade and Industry. For a short period, not much changed. Many people kept their jobs and the factory continued to operate. In her definitive book on revolutionary porcelain in Russia, Nina Lobanov-Rostovsky goes so far as to say that the new ministry 'took absolutely no notice of it'.

Once it was realised that there was no need for opulent decorative wares, the workshops were threatened with closure, but were saved by a strategy that proposed they be repurposed to support the new regime's agitprop activities. Early intentions for the factory when it was reorganised were to make it a world centre for scientific innovation in porcelain production, but in practice it instead excelled artistically, employing artists to paint plates adorned with slogans and iconography of the party.

With the factory having previously churned out porcelain for the tsar, the stores were stacked with blank bisque-fired plates

awaiting orders from the court to have a particular design added. These blanks had been produced in great numbers, stamped on the base with the mark of the tsar, Nicholas II. Some blanks even had marks from two or three tsars back. It's said that Lenin himself saw these surplus undecorated plates and understood them to be an immediate and appropriate mode of communication and political propaganda when resources for other materials were running low.

The new head of the factory's art section, Sergei Chekhonin, was himself a trained artist and designer, and brought in a raft of artists to work on the project. They worked together on a long table in a former school of technical design in St Petersburg (then Petrograd), often wearing winter coats and mittens due to the fuel shortages that left the puny stove unlit. Chekhonin's designs are some of the most arresting. His 'famine series', which had been commissioned in an effort to make money to alleviate the starvation in the Volga, showed a harrowing image of a gaunt and starving Madonna and children, their faces deeply lined in black, their skin pale and sickly. Chekhonin himself felt it some of his most significant work, and took it with him when he left for Paris in 1928.

These elite wares were now – in theory – rehabilitated and reintegrated into daily life. They were painted with revolutionary slogans: hammers and sickles, red stars, hand tools and machine parts, soldiers, people in traditional folk costume, and portraits of Lenin. On a plate designed by Zinaida Kobyletskaya, 'Long Live Soviet Power' encircles a red star styled as a blazing firework that spews forth suns and spangles. On one by Piotr Vyechegzhanin, 'COMMUNE' dances across a plate in angular lettering, electrified by red lightning bolts, framing a hammer and sickle. Others by Chekhonin read fairly threateningly when read in the

present. One series included slogans: 'He who is not with us is against us' and 'He who does not work does not eat' (co-opted from the Bible), both decorated with scattered flowers and leaves turning from green to brown. One of the most brilliant and best-known designs is 'The Telephonist', by graphic designer Maria Lebedeva — on a large oval plate a Russian peasant stands in green leg bindings and a fur-lined jacket. He has a telephone held to his ear, and its black wires frame him in busy twists and loops like a ribbon dance while behind him gold biplanes soar above a pink and blue cityscape.

Later in the 1920s, a suprematist line emerged in the factory, with artists like Kazimir Malevich designing with a vocabulary of circles and polygons floating in the infinity of a white background, some suggestive of Soviet symbols. Malevich later designed porcelain wares from scratch, notably a supremely impractical sculptural teapot meant to look like a train but whose lid did not fit.

Because nothing from the original Imperial Porcelain Factory was ever sold, there were no outlets for this new revolutionary dinnerware, so a former porcelain shop in the city was turned into a showcase for the reinvented wares. It was relatively expensive, but sales were good, although the high turnover in difficult times led to the suspicion that the pieces were being bought up specifically by foreign collectors — not by the proletariat they were intended for.

It is not clear that anyone was ever using the State Porcelain Factory's plates to eat off, nor whether they were ever supposed to have been used as an actual dinner service in the homes of workers. The plates were significant as vehicles for writing; the tsar's opulence co-opted into objects for the everyday, which carried messages from those in power to the people. They disseminated

the values and principles of the new state, by being a material on which the State Porcelain Factory's artists could write, recording the slogans of the new regime on plates originally intended for the tsar's table.

We don't often think of clay's capacity for carrying inscriptions like Chekhonin's communist slogans, but it has been a transmitter of language for thousands of years: a surface on which we have written since records began.

King Ashurbanipal's Flood Tablet.

7
Words

I have a photo pinned to the wall above my desk, printed off the internet. It shows a road sign, although there is no road in sight. Behind the sign, emerging from the earth in the middle ground, is something sunk in the landscape. At first glance it's unclear what it is – a rocky outcrop, sand-coloured like the foreground – but look closer and you can see some of the rock faces are built from brick, two stacked pillars revealing a doorway. The road sign is blue like a motorway sign, with script in both Arabic and white Helvetica. It reads: 'The first written words started here.'

The site it marks is where Uruk once stood. Uruk is recognised as one of the first cities, centred around a monumental temple to the sky god, Anu, and the goddess of love, Inanna. It is now 39 km east of Samawah in Iraq, in a desert landscape roughly halfway between Baghdad and Basra. It is where the earliest known writing system – cuneiform – began to develop, with the first texts dating to somewhere around 3200–3000 BCE.

The characters that make up this earliest writing system, and the clay on which it was written, are not incidental to one another. The connection is symbiotic. The clay defined the development of the writing and the way it was passed around. It affected the shape of the characters and the choice of writing

tool, and is the reason we still have so many documents from this period today (even if a lot of them are ancient receipts for livestock). The one shaped the other – the mark and the material.

Cuneiform is not a language, but a system of writing that was used to write down around fifteen languages, including Sumerian, Akkadian, Babylonian, Assyrian and Hittite, which were used in an area that covers modern-day Iran, Armenia, Turkey, Syria, Lebanon, Israel, Egypt and Bahrain. It grew from proto-cuneiform that was built from pictograms: a goat head for a goat and so on. In the earliest texts in Sumerian, there were over 2,000 pictograms, and they weren't always laid down in a particular order. Over time, these symbols developed – they became abstracted, reduced and refined – and were eventually established as a wedge-based writing system by around the middle of the third millennium BCE.

Once established, the system was in use for around 3,000 years. While the handwriting, vocabulary and page orientation change over the generations – notably getting tighter and neater, and at one point shifting orientation by 90 degrees for reasons nobody can fathom – cuneiform's longevity is equivalent to us being able to recognise and partially read texts from before the Roman Empire was even formed. In comparison, the first text in Arabic is generally accepted as being from the sixth century CE. There were issues with cuneiform's longevity, as languages changed more than the writing – on texts towards the latter years of the system's use, ancient scholars copied texts but added the annotation: 'I do not understand.'

One of the biggest hauls of cuneiform tablets was found at the northern end of Mesopotamia, in the city of Nineveh, collected

by King Ashurbanipal around the seventh century BCE. The library has become the stuff of legend, but it is the incidental elements of this discovery that clay's role in transmitting the earliest known literature is revealed.

Hormuzd Rassam was a pioneering Assyriologist from Mosul in Iraq, and is a crucial figure in the early days of archaeology as an assistant to Sir Austen Henry Layard, on behalf of whom he excavated sites at Nineveh. In 1852, Layard and Rassam began excavations at a site called Kouyunjik. It had been divided in two by the British and the French: the south was given to the British, the north to the French. In initial digs, the French found little that interested them, and work in their allotted territory dwindled. But Rassam and Layard made finds that led them to believe that there was in fact something very worthwhile in the northern territory. However, the deal had been done, the division made. So Rassam secretly gathered a team and began doing covert digs at night. These digs didn't remain secret for long, as the families of the workers started to ask about the suspicious absence of their relatives, but they lasted long enough for Rassam to prove his hunch correct.

On 20 December 1853, the digs uncovered the first reliefs of the palace of Ashurbanipal, who had ruled over the Neo-Assyrian Empire 669–631 BCE. Further excavations revealed a building that appeared to be a massive library for clay cuneiform tablets. Layard later wrote about the 'depository in the palace of Nineveh for such (cuneiform) documents. To the height of a foot or more from the floor they were entirely filled with them; some entire, but the greater part broken into many fragments.' The discovery was seismic, numbering over 30,000 fragments. These were packed up and exported, some sent to the Louvre

in Paris and the larger part delivered to the British Museum in London. However, archaeology was in its infancy, practices were still comparatively sloppy, and there were insufficient records made of exactly where on site each fragment had been found, meaning the British Museum received a jigsaw puzzle, and little to guide them on where to begin.

Among the fragments Layard and Rassam sent back to the British Museum was something now recognised as one of the first known poems: the Epic of Gilgamesh. It was not actually called this, because tablets did not have titles and were instead identified by their first line. Gilgamesh's original title is usually translated as 'He who saw the abyss'. Part of the Gilgamesh series includes the famous flood tablet, an antecedent of the Bible's Noah story. When it was identified and deciphered by a man called George Smith in the British Museum, he became so excited he is said to have stripped naked and run around the room.

Now, the known corpus of cuneiform texts covers exorcisms and omens, creation stories and myths; piles and piles of financial documents – receipts for grain and estimates of the city's stores of bread and beer in case of bad harvests – and there are poems and other miscellaneous items, which include a text known as the 'Home of the Fish' that the scholar S.N. Kramer interprets as being from a fish lover to their pet fish, with an early description of an aquarium: 'My Fish, I have built a house for you', the text proclaims, going on to list the many luxuries provided in the aquarium, and the ways in which the fish should enjoy its new home.

Back when they were inscribed, very few clay cuneiform tablets were fired as a matter of course, unless they had to last.

They were more often just left to dry, which could still give them a decent lifespan. However, the library at Nineveh had been preserved, because when the city was sacked in 612 BCE, it was set on fire. The conflagration was hot enough to fire the tablets, which preserved them into the nineteenth century. Unfortunately, they had also been housed on the upper floors of a building, meaning many were smashed when the upper floors collapsed. There's a joke that crops up in Assyriology, about how the library at Nineveh is the only library in which a fire is a good thing.

Nineveh is not the only site where tablets were found. Since cuneiform was deciphered, other tablets have had their contents revealed, including the first known transcribed love poem, found in the Sumerian city of Nippur. Originally called Istanbul #2461, because nobody knew what was on it, it has since been translated and renamed 'The Love Song for Shu-Sin'. It is around four thousand years old. By today's standards it is a wildly erotic paean from a bride to her bridegroom, and may have been part of a sacred practice where a king symbolically weds the goddess Inanna. She invites her 'Lion' into her bedchamber, alludes to things 'sweeter than honey' and makes promises of physical pleasure.

While much work was done to translate and analyse what was written on the tablets, it's only relatively recently that the same attention has been given to the clay the tablets were made from. Did people make their own tablets? Was the clay dug locally or sourced from outside the city? Who collected it? Were unfired tablets recycled? No text from the time has been discovered that answers these questions, save for one school inscription riddled with the errors of a beginner, in which a trainee scribe details a trip out to the countryside to gather clay that is appeased and

purified by an exorcist so that it may be safely collected for use in the classroom. Some archaeologists have also tried to identify recycling troughs for tablets in Mesopotamian houses and buildings, presuming clay must have been reused, but conclusions remain speculative.

Scholars have known for a long time about how the size and shape of a cuneiform tablet indicate when it was written and what sort of document it is, but it has always simply been presumed the tablets were clay. No material analysis was done, and standardised museum conservation since the 1960s involved slow, low temperature firing of the tablets. It is only recently that analyses have found that some of the tablets are actually made from silt, not clay, although whether the tablet-makers knew this is another question. As we saw in the first chapter, to a potter or a scribe working by eye and by touch, if it acts like clay, it's clay.

At some point, cuneiform died out – the last known dateable tablet is an astronomical almanac from 75 CE. UCL Professor Mark Geller, in a paper charmingly titled 'The Last Wedge' writes that late-period tablets tend to indicate that cuneiform was used in temples, but not in everyday transactions. There is some evidence of cuneiform surviving into the third century CE, but by the fourth, Geller states, it was definitely dead, with three millennia of wedge-shaped writing on clay superseded by writing on leather in alphabet form.

Talking of cuneiform as a first in the history of writing is a bit like trying to pluck the first bird from the evolutionary timeline. Its development was gradual and not necessarily linear. Cuneiform, it is generally agreed, is the first *fully developed* writing system. Other cultures used pictograms, before and after cunei-

form. There were inscriptions made on tortoise shells in central China in the Neolithic; on tablets and vessels in Gimbutas's Old Europe, in the Indus Valley and elsewhere. It's unknown how old the Nsibidi script in Nigeria is – some scholars date it to the fifth century CE, others to a script found on monoliths in Ikom from 2000 BCE.

Foundational to the translation of cuneiform in the nineteenth century was the longevity of clay as a writing surface, and the conflagration at the ransacked Nineveh. As French Assyriologist Dominique Charpin points out, 'in a few thousand years, our photographs, books and hard disks will no doubt have disappeared, but our collections of cuneiform tablets will still be there'.

Words written in clay, if fired, have a longevity that guarantees they will outlast their inscriber. This is as true for the potter's marks made today as it is for the cuneiform we can read on tablets in museums, and it presents a profound possibility for an individual's legacy. At various points in the history of writing that came after cuneiform, clay as a surface for inscription preserved the legacy of individuals that was otherwise made invisible by the time in which they lived. This was particularly significant for David Drake, a nineteenth-century enslaved potter.

David Drake – also sometimes called Dave the Potter, and previously Dave the Slave – was a master potter enslaved (and later freed) in Edgefield, South Carolina, an area later known as Pottersville. His names trace a historical trajectory. He was initially just known as Dave – he had no family name that he knew or was permitted. When he was freed, he had to take a last name, and so he took the name of his owner at the time, as many

slaves did. His specialism was large storage vessels, on the necks and shoulders of which he sometimes inscribed lines of writing that included short verses and rhymes, or on which he left his signature in a big looping hand.

I had first come across a pot by Dave in the Art Institute of Chicago, when navigating from the Greek statues to the Moche stirrup vessels. In my memory, it was in a small vestibule off one of the main rooms, in sombre lighting, but when I went back to look at my photos, I found it to be displayed against bright pale grey walls. It's hard to conceive of the size of Dave's pots in photos, so I had stuck my hand in front of the vitrine for scale. I remember thinking, if I wrapped my arms around it, they would not meet. As I flick through my photos, I am struck again by the proportions, graceful and pleasing in a way not necessary for the pot to function, but which gift it a solidity and balance. The brown glaze had fired in colours from teak to compost brown. It had two lugs for handles, attached so you could lift the pot from above, and a sturdy rim around the open mouth, which was big enough to fit two hands in and pull out whatever was kept inside. This pot was not inscribed with verses, but with a name, and a date: 'Lm September 7 1857/Dave' – Lm stands for Lewis Miles, one of Dave's former masters at the Stoney Bluff pottery.

It's thought Dave was born in North Carolina in 1800, and later taken to Edgefield to work in the potteries there. His jars were some of the largest made in this period in North America. He used a hybrid method of coiling and turning, adding coils to a thrown base and then a rim, which he turned on the wheel. There are forty or so vessels with writing on, and as scholar Michael A. Chaney notes, it is the signature that stands out: 'Graphically the signature enunciates. But who is Dave?

Repeated on one jar after another, the name swells nearly to an imperative: Dave!'

It is, he says, an exclamation of identity, of 'personhood interjected'.

Looking at this pot, it's not just the handwriting that is bold but its placement. The name, Dave, with its big looping D, is not placed out of sight on the base like a potter's mark, nor on the side, shadowed in the pot's neck – it is on the widest, most prominent part of the vessel, the part where the focal point of a frieze would go; the part the eye is drawn to. There are some vessels Dave inscribed when it was illegal for him to be literate. On these, even just signing his name is an act of defiance, but it is made openly: the confident D, then a loop, scallop, loop.

Writing in cursive was a particularly dangerous skill for a slave to know, as it was considered a path to freedom. White slave owners feared that being able to write in good cursive hand would mean a slave could forge his master's signature to cash a cheque, plunder white financial resources and literally 'write passes to freedom'.

The most arresting lines Dave ever inscribed on a pot are:

I wonder where is all my relation
Friendship to all – and, every nation

These are deeply radical lines in context, a stepping out of bounds to wonder aloud where your family has gone; to point out that you have a family and that they are not with you, because of a system that has enslaved you and defined you as property. And not in fugitive margins, but prominently left on a large pot. With

these two lines, Dave inscribed an object in a way that might outlast him by many thousands of years; that would outlast the legal instruments that had enslaved him and all the paper they were written on.

In an article that addresses Dave directly, American poet Evie Shockley points to this couplet in particular as the first example of black vernacular poetry. Dave's writing, she says, comprises not only vernacular speech; it is 'a culturally specific way of representing the sounds and rhythms of your speech in writing', and we might even think of him as the first self-published poet via his medium of choice: clay.

How can this moment of inscription be understood? I can't hear it as an idle line scrawled on a slow day; it is different to other verses Dave wrote, which included rhymes about the contents and purposes of the huge vessels he made. It's also on the shoulder, symbolically the load-bearing part of a body, whether clay or human. This inscription makes him permanent, but it is daring and risky. Does that second line pull back to look beyond the current grief of separation, or does it make it safe to utter?

Much work has been done to fill in the absences in Dave's biography in recent years. It's not known who taught him to write or where he learned, although he did work at a newspaper for a period. Back in 2008, a writer named Leonard Todd discovered that his ancestors were owners of Dave, and in an attempt to make some sort of reparation, he wrote a biography of him. Todd wants to overcome the fact that the system of slavery by which his ancestors profited permits no return, but in defining humans as property, slavery has erased most human aspects of Dave's life, leaving Todd to fall back on romantic flights of imagination.

He reconstructs emotional encounters that may or may not have happened, and paints speculative scenes such as Edgefield's regular kiln firings. He imagines what Dave felt, even though a large part of what we know of Dave is because of, or contained within, the pottery he made.

Dave – and Todd's book – were the focus of Chicago artist Theaster Gates's 2010 exhibition *To Speculate Darkly: Theaster Gates and Dave the Potter*. Gates said he too found 'a whole lot of imagining' going on in the book, and said, 'I feel like I'm probably a little bit closer to Dave than Leonard Todd is. And if Leonard Todd can speculate darkly, then God knows I'm gonna.' The exhibition opened with a choir performing Dave's couplets set as compositions by Chicago musician Leroy Bach. 'I wanted to embody Dave the Potter,' wrote Gates. 'To sing his name as if it were mine; to build a noble jar.'

Todd shows Dave's writing to a handwriting analyst, who ascribes personality traits to Dave based on his inscriptions, and comes out with the rather dim idea that Dave must have been stubborn, because he persisted in writing in clay, which is 'difficult and frustrating'. The issues with this sort of speculation are manifold, not least because it is simply not the case that writing in clay is difficult or frustrating: a sharpened tool and clay dried just past leather-hard make for a deeply pleasurable writing experience – anyone who has tried knows that the right tool glides easily.

In his essay 'Writing in Clay', American curator Ethan Lasser describes Dave's writings not only as subversive inscriptions, but as 'iconoclastic acts', in that his verses utterly transform the jar:

When Dave picked up his tool and cut into the leather hard stoneware surface he did not simply put a poem on

a pot or alter the otherwise smooth surface of a plantation commodity. Rather, he radically redefined the essence of the object, transforming it from an ordinary if large scale storage vessel into an enduring substrate for his poetry, a permanent background for a text.

Dave's pots are now highly desired by collectors and museums looking to diversify their collections. Prices are rising – in one of Gates's video works that formed part of his exhibition *A Clay Sermon*, he tries to buy a pot by Dave at auction, but is enormously outbid. A stoneware 'catination' jar from 1836 was bought at auction for $369,000 by the Fine Arts Museums of San Francisco in 2022. The estimate was $40,000–60,000. The vessel I saw in Chicago was bought by the Institute for $150,000 in 2020. When I returned to the Institute and searched it out again, it had moved – it's now one of two pots that form a gateway into one of the Americas galleries, along with a large black vessel stamped with bear-claw prints by Santa Clara Pueblo potter Sara Fina Tafoya.

Dave's pots are now celebrated, but we do not know much about the act of writing on his pots except for its historical significance – what was it like for that person to make these inscriptions then? While writing transformed the jars that Dave made, and ensured his legacy, we do not know how people reacted at the time. There is no evidence that he was punished for these acts, so was he a potter so skilled he could break the rules? What interactions or discussions happened around these pots? Was there community talk about whether he should be permitted to write at all? Perhaps it was requested, like a maker's mark: provenance for the biggest, highest-quality vessels in the region (another Edgefield potter named Harry has also been

found to have signed his own work). But was there writing that has not survived, on paper, on walls, on floors? What did happen to all of Dave's relations?

We have Dave's writing because he was able and, it seems, permitted to write in clay, the same material that preserved the tablets at Nineveh. But we have little else. Like Ladi Kwali, he speaks loudest through his pots, although his pottery preserves his voice in literal, and literary, ways. I think of a young Black British electronic musician I'd interviewed about her work, responding to a formerly neglected African American composer. 'It's great that his stuff has been rediscovered but there's something sad about it when people are only rediscovering you after you're dead,' she had said. 'What does that do? Does it make a difference? I don't know if there's any redemption in it.'

Dave's inscriptions on clay asserted his authorship, and in some interpretations published his writing. In reading about others who have inscribed on clay, I become fascinated by one story that is almost the inverse. It too lacks verifiable details, but errs in the direction of myth – about a Japanese nun who wrote on clay to make her pots valuable, and in doing so managed to undermine her own authorship entirely.

Ōtagaki Rengetsu was a Japanese Buddhist nun, born in 1791. Unlike Dave, she was not a highly skilled potter – quite the opposite, in fact. She seemed to be a potter who never really improved. She is a compelling character to encounter: so remarkable as to seem fictional; a woman around whom swirl stories that sound more like myth than fact.

Reported to be a beautiful child, born at an auspicious time, by age five she is said to have been able to write full sentences,

and by six she wrote poems. As she grew up, she became adept at both calligraphy and the tea ceremony, as well as martial arts. She went into service at Kameyama Castle after missing an opportunity for a favourable marriage. In one of the few short biographies of her available in English, she is said to have hung around the stables long enough to learn how to ride a horse and began to vault castle fences with bamboo poles: 'The other ladies in waiting were appalled that one of them should be so nearly a ninja. It was a disgrace,' the biography states.

She then married unhappily; the coupling marked by the devastating loss of three children under five. She remarried, somewhat reluctantly, and had two more children. Then her second husband died, and some years later the children followed. By this time she had lost two husbands and five children. She wrote:

Smoke rises
Till the sky turns dark,
And I weep
Feeling as though the end
Will bring me no surcease

Rengetsu wrote waka, a form of poetry that according to her translator, John Stevens, expects readers to augment the sentiments in a poem with their own experiences. There are also 'season words' – mention of sakura (cherry blossom) means a poem for spring; summer in Japanese poetry is symbolised by the cuckoo. She subscribed to a poetic mode taught by Ozawa Roan, who held that poetry should 'describe something directly without resorting to metaphors or similes' and that 'poetry consists in expressing thoughts of the moment at hand, in words of one's own that have the ring of truth'.

She had promised her second husband that if he died, she would not remarry, but would become a nun. However, she was soon out in the cold again after the death of her patron at the temple. Without him, she was not permitted to stay. She left and began to teach poetry, but men came to proposition her, not to write. She began to try and make herself less appealing in order to divert attention – she is said to have removed her eyebrows and worn rough clothes, and in one horrifying instance she became so tired of constant propositions that she pulled out all her own teeth, a terrifying act of self-harm and defiance.

Pottery offered the possibility of damaging her looks further, by roughening her hands. Hands during this period were a fundamental part of how female beauty was perceived: 'Slender graceful fingers were a symbol of feminine beauty – in Edo as much a part of beauty as the face,' wrote Michifumi Isoda in his book *Unsung Heroes of Old Japan*. 'In Rengetsu's day a woman with work roughened hands and fingers was considered to have lost her looks.'

For Rengetsu, pottery offered a form of freedom. While she seemed not to improve in her making by some standards, it gave her income and independence. She made teacups and small teapots known as kibisho, and used a metal nail to incise them with her calligraphic poetry. They are often squishy-looking objects, and while some books said she had a wheel, her wares are dimpled with fingerprints or look to have slumped by being formed with clay that was too wet – one teapot looks more like a malformed pumpkin.

She would make a batch of pots and cart them once a month to a kiln to be fired, but initially her wares were so rudimentary she had trouble finding shops willing to take them: 'They won't sell,' shopkeepers warned her.

One of her poems reads:

Taking the clumsy,
Fragile things I make
To sell them
In the marketplace –
How forlorn am I!

Rengetsu's pots began to sell when she made them a vehicle for her writing. A lumpy pot was altered permanently by her inscriptions – like Dave's, but with different resonances of time, place and context. These forms, sloshed with pale glaze, come alive with her calligraphy; it is the word that elevates them, that makes them live, like the Golem in Prague. Even with a language barrier, her writing appeals: the characters dance on the pot, arranged as if blown there by a gust of wind.

As her reputation grew, she began to receive a constant stream of visitors. Her once quiet retreat, set amid fields of radish and taro, became steadily noisier, and she took to moving frequently. As a Buddhist, she had almost no possessions to speak of, and apart from some rough tableware, she owned nothing but a potter's wheel and a writing desk. All she needed to pack up and move was a single cart.

When she was almost seventy, she was still making pottery at the rate of over a hundred pieces a month, and eventually there were said to be so many of her pots in circulation that every household in Kyoto owned one. With rising demand for her work came imitators, who wanted to sell pots pretending to be hers, piggybacking on her sales. But those making fakes couldn't replicate her poetry or her calligraphy: they were often outed because they used the same poems over and over again. Instead

of facing down her imitators, Rengetsu welcomed them. Stories about her say that she would happily give bootleggers a pot to take away and copy, and instructed them to return so she could inscribe the pots for them. This was her radical act.

She was the poet, but she was only sometimes the potter. In leaving people to untangle the two, she undermined notions of authenticity in her work, by making it impossible to tell a 'real' Rengetsu from a 'fake'.

To do so was to renounce her authorship – the inverse of Dave's assertive inscriptions. At the very least, she confuses our ideas of authorship and artist. Where Rengetsu found a way to write on her pots and remove an element of herself, Dave recorded his existence by being an author writing on a substance that would outlast him. Both inscriptions afforded them a freedom they didn't have otherwise: economically for Rengetsu, expressively for Dave.

Rengetsu challenges what we think of as the artist, and together with Dave proposes an expansion of the materials on which writing is published, and what makes someone a poet or author. Her pots have a roughness of quality later lauded by the mingei movement, but that movement had an interesting relationship with 'signed' pottery as it related to authenticity, as the workaday pottery treasured for use in tea ceremonies was often not signed. At the close of *The Unknown Craftsman*, Yanagi complains of how in Japan at the time, 'second and third rate artists were selling well' because of the 'excessive admirations of signed goods'. The potter and co-founder of the movement, Shōji Hamada, didn't sign his work, Yanagi writes, because he wanted to 'make things to be used without the question of who has made them'. In some rerouting of this idea, Rengetsu is doing something similar in letting other people sign her work. There is a significant connection here, between her Zen

Buddhism and her renouncing of authorship, perhaps as a mode of denouncing ego, the self, the who of the pot.

Most of the biographical detail on her is drawn from the previously quoted text, *Unsung Heroes of Old Japan*, by Japanese novelist and professor Michifumi Isoda. How many of all these dramatic biographical details are true and how much is myth or rumour is unclear, because there is so little about her translated into English. As well as Isoda's book, I find an out-of-print monograph of her pottery, a tiny chapbook of poetry the size of a top pocket translating her deceptively plain seasonal verses, and not an awful lot more. Her calligraphy is in multiple national collections, but her pots are in very few.

I love that Rengetsu's pots were 'bad' by most standards, and I also love that she persisted. I feel vindication on her behalf that the pots she was told wouldn't sell became known and desired: that people wanted to buy her sets of teacups that didn't match; that her bumpy surfaces were held and loved. Pottery offered her independence and escape in a period where nothing else was available, and I am cheered by her lack of improvement over the years.

Clay as a medium for writing allows words, writing, poems to perpetuate so far into the future that it is a deeply radical proposition to inscribe upon it. It was both pioneering and subversive for Dave and Rengetsu. I like to think that Dave knew the profound implications of his writing. I like to think that in a thousand years' time there will be humans who know his name and looping hand. I hope there are people who read Istanbul #2461 on their wedding day in the future, or who note the turning of the seasons by reading Rengetsu from the side of an uneven teacup. I can hear Dave wondering aloud into the infinite

future what happened to his relations; I can feel something of what Rengetsu felt taking my clumsy plates to the studio sale. All these inscriptions, from the masterful to the amateur, have the potential to preserve our names and our words into the coming millennia. Let us not forget what Dominique Charpin says: that whether you are reading this book on paper, on a device, or whether it is being piped to you as an audiobook, all these methods of transmission will fail before the words inscribed on the pots by Dave and Rengetsu turn to dust. For them, did the moment of inscription carry with it this understanding of time?

Katherine Pleydell-Bouverie's collected glaze tests.

8
Colour

Where potters' marks and writing on clay ensured the preservation of makers' names and their words, the glazes our pots are decorated in carry no such information. Glazing is about colour, but it's not *just* about colour. It is about surface and texture and the transmission of meaning. It is colour as pattern, drawing, motif, or form, and is often a display of status or value.

It is not accurate to compare a glaze simply to paint. It is more like fabric or clothes. Some glazes sit thin and light like silk, some swamp the form like felt, others stretch in high gloss like PVC, or are chunky like a cable-knit sweater. Making up a glaze, however, is a bit more like baking, where various powders are mixed into liquid batters. Glazes are made from powdered clays, metals and minerals. These are mixed with water, then painted, sprayed, dipped or poured onto a bisque-fired pot, which is then fired again. This turns the glaze to glass, and welds it to the clay surface of the pot.

A basic glaze usually includes a silica, a flux, an alumina and often, a colouring oxide. Silica could make pure glass if you fired it to 1,700 degrees (most kilns only get to somewhere around 1,300), but because it has such a high melting point, you need something that brings the melting temperature down to

make it runny – usually feldspar and whiting, or a frit (frits are glaze materials that have been melted together and ground back to a powder, to contain otherwise water-soluble or hazardous elements). Aluminas stiffen the glaze so it stays on the pot, and occur in clays like china clay, ball clay, and bentonite. The ratios in a glaze mixture will affect whether it is shiny or matte. For example, more clay means a more matte surface. To this mixture you can add colouring oxides, which include (but are not limited to) tin for white; cobalt for blue; manganese for brown; chromium for green. If you fire in reduction – which is where the kiln is starved of oxygen – these oxides can produce very different colours.

Certain hues are easy to make – cobalt is such a powerful blue that even a small amount brings out strong colours. Others are far more elusive to coax from the kiln. Bright reds and yellows that pop are hard to make: for a tomato red or acid yellow, stains are needed. Bright yellows used to be made with uranium – one of the potter Lucie Rie's yellows was made with uranium, meaning these pots are now ever so slightly radioactive.

To develop their own glazes, potters must experiment, and the variables are overwhelming. It is a science that can be highly unpredictable. On a glaze workshop with expert potter and writer Linda Bloomfield, I thought I'd been mixing a broad palette of greens and blues, but a bad talc and the addition of ilmenite for a speckle had turned everything sludgy yellow and brown. In Bernard Leach's pottery book, he too describes an unsuccessful firing, where upon opening the kiln the iron glazes and celadons had come out well, but 'a few of the blues were overdone, and the cobalt in its horrible purple intensity had triumphed'.

Michael Baxandall, in his book on painting and experience in fifteenth-century Italy, writes about the many ways in which

people understood different blue pigments: 'The exotic and dangerous character of ultramarine was a means of accent that we, for who dark blue is probably no more striking than scarlet or vermillion, are liable to miss.' This sort of nuance or meaning as something lost to us now is as true of pottery as it is of painting. For example, yellow was once a colour that only the imperial kilns could fire for the emperor in China. The dragon was a symbol that had meanings lost or diluted when sea routes opened up and Chinese pots started to be exported to Europe. Nowadays, certain natural muted colourways and slip decoration might allude to aesthetics advocated by Bernard Leach, Shōji Hamada and the mingei potters in the first half of the twentieth century. The Sode-isha group, or Crawling Through Mud Association, were formed in 1948 in direct opposition to these rustic styles. Some potters now make paintbox brights in a move against their dominance: One potter I spoke to was adamant: 'I don't make brown pots!'

In 2006 a large bottle by Leach sold at Bonhams. It has a narrow neck, sloping shoulders and a stout middle, like a farmer with a fondness for ale. It is decorated in a deep black tenmoku glaze – one you could sink your hand into: a portal. It looks like it would be heavy and cool in the hand. It is solid from a distance, but zoom in and the surface is spangled like a galaxy: gold and purple and white speckles over mottled black and mahogany. Where the light catches, you can see tiny pinholes in the surface.

The glaze is listed as the 'N glaze', which stands for Nirmala – meaning it was made by an Indian potter called Nirmala Patwardhan, who apprenticed at the Leach Pottery in the early 1960s and had an acute talent for glaze chemistry. When I come across her name, I'm interested: I've not heard of her before; hadn't heard of other Indian potters apprenticing in Cornwall (although she

was not the only one to do so). I find one article in a 2008 copy of *Ceramic Review*, when potter and writer Brinda Gill visited her studio. It is one of the few places I find much biographical information.

Patwardhan was born in 1928 in Hyderabad and learned painting from several renowned Indian modernist painters. In 1957, she travelled to Europe to learn pottery in Stuttgart, where she fell in love with glazing. She returned to India with Leach's *A Potter's Book*, built herself a wheel and began throwing. In 1962, she came to England to apprentice at the established Winchcombe Pottery under the well-known studio potter Ray Finch, where she made some glazes that remained in use for years. She lived in a caravan on site, working from eight till five every day, then eating with the family. She told Gill that Finch was her greatest influence – 'Ray had faith in my glazes,' she said. He also taught her logarithms, so she could better alter and understand her recipes.

Later in her career, she taught classes, so I contact one of her students online, a potter called Martin Karcher, who types up some of his correspondence from her in the 1990s. 'In 1961 I was not good at potting but quite good in glazing,' she wrote to him, 'so my main job in Winchcombe pottery was glaze testing, as Ray never had time for this. We would sit at night and discuss the glazes and what he wanted.'

One of the glazes she made while at Winchcombe was a remarkable achievement: a chun glaze. Chun (or jun) is highly coveted – a gift from the alchemy of kiln and chemistry in opalescent blue that was first developed in China in the eleventh century. It is often seen in combination with splashes of copper, which brings out purple blood bruises on the pale blue. It's mystifyingly technicolour for its age: a glaze that looks factory-made. Compare an eleventh-century chun-glazed bowl with earthenware

made in eleventh-century Europe, and the chun looks like a precious moonstone next to a hunk of mud.

The story goes that when pots glazed in Nirmala's chun came out of the kiln, Finch took her immediately to London, to the British Museum. She recounted to Gill how Ray pointed to a chun blue pot and said, 'What do you think of that?' 'It's chun blue,' she replied. He pulled her pot from his bag and said, 'Look, this is *your* chun blue.'

She had been using bone ash in her recipes – throwing bones into the fire and then using the ash in her glaze experiments. Bone ash has high phosphorus content, which brings about the striking luminous pale blues in certain firings. Nirmala had found this out without a recipe, just with chemistry, experiments and intuition.

After two months with Finch, she joined Farnham School of Art, where she made another N glaze for the students – this time white – before spending time at the Leach Pottery, where she made her deep, rich black tenmoku N glaze.

At the Leach Pottery, she was paid £3 a month for studio work, and survived on milk, bread and sugar – her husband back in India gave her £5 a month, but she saved it to buy a kiln. There is a single photo of her as a young potter with Leach and another unnamed woman – everyone perched on chairs, Leach pulling a face, his thumbs to his ears and his palms flapping at the sides of his head. Patwardhan is off to the side at a little distance, sitting lower than Leach, her hair pinned back, a taut smile on her lips, a large shawl around her shoulders and her arms across her front. She's looking directly at the camera, confident, although perhaps a little nervous.

There is a single letter from Patwardhan to Leach in his archive. (Its tone suggests there were others, but they have not

survived). It is from the time after she returned to India. She was struggling to set up as a studio potter, pricing her pots low in line with Finch's philosophy at Winchcombe. Notably, she realised that all the glaze recipes she had developed in England needed reworking based on materials available in India, so she calculated the molecular formulas and worked backwards to design glazes for what was available there, publishing her own *Handbook for Potters* in 1984 (updated in 2005 with the intervening two decades of glaze experimentation).

Karcher has hazy memories of her studio classes after forty years, but remembers that there were 'hundreds of glaze tests strung up everywhere'. He sends my contact details to her son, who replies and forwards my email to his sister-in-law, who now lives in Patwardhan's house. She emails back to say that 'we have garlands of glaze test rings all over her house, hundreds of them, carefully numbered'.

I wonder what it would be like to live in a house garlanded with her tests. These glazes she designed – for Farnham, for Leach, for Finch and for herself – must decorate many people's pots that do not otherwise bear her name. There's something compelling about these traces she left behind; about what it means to be the technician as well as the potter.

Patwardhan left her mark in the timeline, but not in a way we can read. She is in those pots, but hidden. While there are plenty of images of the work she made online, she has been largely forgotten in other histories of studio pottery.

Potters like Patwardhan, whose glazes are perhaps more influential than their pottery, are often tangled in ceramic histories. Patwardhan is barely known, but can be found everywhere. Her art, her chemistry exists in ceramic history like fungi. The

proliferation of her glazes forms a hidden network that blooms on pots across the world: the glaze is the fungus, the pot the fruiting mushroom. I wish I could have asked her how she felt about the way glazing bore her signature, but she died in 2008. Instead, I try to track down something in the archive that carries one of her glazes.

I set off for the Crafts Study Centre at Farnham to look for the N glaze Leach used, with nothing but a photo of the pot that sold at Bonhams. There is no mention of Nirmala's name in the catalogue, but I wonder if I can pick out the glaze by eye. Greta, the archivist, shows me what's in the main store. I peer among the shelves – I can see a Ladi Kwali in one corner, some Michael Cardew among faceted wood-fired pieces: neat cups and saucers, shallow grey tumblers dripping with green glaze. None of the possibles look promising – the spangle isn't right on anything approaching a dark black-brown. We drive across town to the storage unit, where we shine torches on the tall shelves. Greta pulls down pots for me to peer at more closely. 'What makes one dark brown pot different from another?' she says after a while. It's a good point.

There is nothing in the archive papers that might help me: no recipes, nothing obvious to say what glaze was being used. Searching by eye is a fool's errand, really. Different results can come from the same glaze on the same clay body, even in the same kiln firing. I stare into the surface of a large jar with a narrow neck in a dark gloss, but all I can see is my own distorted face peering out from its pinholed surface. There is a playful futility to my quest here, but it also frames the impossibility of tracing certain material lineages. At the glazing workshop I'd attended with Linda Bloomfield, I'd seen first-hand how small differences in temperature within the same kiln, different modes

of application or minute differences in colouring oxides could not just change the colour of the same basic glaze, but alter its surface texture, its shininess, or the way it sat on the clay.

Eventually we find a probable match in a jug Greta lifts down gingerly from a high shelf. It has a tall, wide, straight neck, a slightly rounded belly, a spout pulled outwards with a finger when it was made, and a strong, lean handle. It has a faint comb design upswept from the base that has been mostly flooded by the glaze. Under a spotlight, the surface glitters in the light: a galaxy-like speckle. I look back at my photo, compare the two. The jug is a good match, with a surface that imbues it with light and frees it from the weight of its sturdy form, and it also looks most like Patwardhan's glaze.

In addition, it has the right date attached to it – it is one of three pots that Emmanuel Cooper dated to 1963, a year after Patwardhan was at the Leach Pottery, deposited in 2004 by the children of Mary 'Boots' Redgrave, the partner and executor of Janet Leach (Bernard's wife's) estate. Other Leach pots had been deposited decades before Patwardhan arrived in Cornwall.

It's the closest I'll get, I tell Greta. I'd put a fiver on it. Not fifty – but a fiver.

I had once spent a summer making glazes, sweating next to the kilns in the summer heat with Cooper's book of glaze recipes. His pots are often dressed in bright, vivid hues; there is one I think of a lot: a slab-built jug that is cartoonish in its proportions and is decorated in a volcanic cyan, as if made from raspberry-blue foam.

I was aiming to fulfil requests from other studio members, which included a reliable satin creamy white to replace the commercially bought one people had been ripping through in

the studio. I was also trying for a very matte turquoise, a royal blue, a reliable crackle. I scoured for glaze recipes online, and found the black-bronze that decorates Lucie Rie's pots and those of her imitators, running in delicate, pin-sharp rivulets of brass on the rims of her bowls.

I mixed all the white powders and oxides, and made notes in a yellow notebook. I wrote down what thickness the glaze liked to be, what it looked like on different clays. It was not just about amounts, proportions, ingredients, but about these sensory elements of mix and surface, too:

OATMEAL AND MILK SPECKLE: Can 'curdle' when applied too thick. Very small red/brown pin prick speckle. Has classic 70s look. Reasonably well behaved. Best when sprayed in <u>three thin layers</u>. Mix medium-thick.

CAROL'S 238x: Even at low 1,200 firing a pure royal blue, when on thick it sits denser and darker. Edges show through on single layer. Satin surface.

Reading through them, I remember each one vividly: the texture, the way it would smother a form or run leaving fine edges bare; what its surface felt like under my fingertips. When I started making again after lockdown, I had to start from scratch, because my new studio fired higher and I had changed the clay I used. I was reminded of this the hard way, by dunking a few tester pots made from a buff-coloured body in a grey-blue glaze that came out purple on the pink blush of the clay beneath. Not quite the 'horrible purple intensity' that Leach had complained of, but too purple for me. The glaze itself was fine; it was me who had made the mistake.

When we talk about how a glaze sits on or wraps around a vessel, this is known as glaze fit. It's like dressing a person – what swamps them? What's too tight? What accentuates the good parts: the shoulder, the waist, the belly? It's also more complicated than putting clothes on, because the body being dressed and the clothes being put on it are going to be subject to intense heat that will make them both expand and/or contract. If the fit is bad, it often causes faults.

The science of glazing involves a precise understanding of chemistry – how different materials react with one another, and how they react to applications of heat. But even with all this knowledge, there is an element of the unknown. The faults all have names: crazing and peeling, shivering and shelling, blisters, crawling, pinholes, dunting. The curdling in the cream glaze I described is better known as crawling, where a glaze globs together and folds back on itself, leaving a landscape of bald clay and topographic islands of glaze. It is usually caused by the glaze not sticking to the clay correctly, in one way or another. It is sometimes called butterflying, rolling, or less commonly, ruckling. Occasionally it can be intentional or exploited – as in the work of the artist Takuro Kuwata, who cultivates these so-called faults to create vessels decorated in glossy globules of colour. Shivering is where the glaze is too big for the clay and shears off in chips and sheets as it tries to shrink around the body but can't shrink enough. Crazing is a less serious, often pleasing outcome, which causes a shatter effect across the whole glaze. Pinholes usually appear when something is over- or under-fired, but can produce a tactile orange-peel surface. 'Clay Fail! A Pottery and Ceramics Shit Show' is a Facebook group that contains a litany of these glaze failures at their most disastrous, along with cracks, drops and other explosions. It's a good place to go when the kiln gifts only disasters.

*

So as not to constantly ruin good work, when potters mix new glazes they make small tests, like those that still garland Patwardhan's house. These are applied to bisque-fired test pots or tiles, to show how a glaze sits on a body. In my old studio there were garlands, too: flat cards of clay with stamped flowers; round biscuits with lines combed in; tiny bowls pinched and painted to see how colours would run and pool.

Glaze tests are miniature bodies of work in and of themselves, but it's rare that you see this working-out that has gone into making some of the most famous potters' wares. In the V&A there is a vitrine showing Emmanuel Cooper's glaze tests, and I'd been dreaming of Patwardhan's house, but neither of these can be touched or handled, so I headed back out to Farnham, where they have tests by Lucie Rie and the English ceramicist Katherine Pleydell-Bouverie.

Greta and her assistant, Chloe, pull some of Pleydell-Bouverie's tests from the storeroom and line them up in front of me on the desk. These small pots are carefully finished; even stamped with her maker's mark. Some are turned and trimmed, meaning they were thrown, left to dry, then put back on the wheel to be tidied up – significantly increasing the time committed to these items that were 'just' tests.

There are twenty-nine miniature pots in the archive, from a thimble-sized lavender-grey jug with handle and throwing lines to a pot as big as a grapefruit with an incised frieze in florals and Greek key design. Each has a number in Roman numerals, to match it to the recipe in Pleydell-Bouverie's assortment of postcard-sized glaze notebooks. There are annotations with the recipes ('I should have left it on to soak for half an hour – try that next time', reads one) along with strange little glyphs that

it takes me an hour to realise must be illustrations of firing cones. I cross-reference the numerals to find glazes made from laburnum, cedar, box, holly, and horse chestnut ash. CLXXIII is apparently inclined to run, a red with blackened edges that has a surface like a wet window pane; LXII is very matte, like stone or fine-grained concrete. She said she wanted her pots to make people think of 'things like pebbles and shells and birds' eggs and the stones over which moss grows', and these tests are a compendium of the British landscape in their ingredients as well as their muted earth tones.

In comparison, Lucie Rie's glaze tests are wildly varied and feel less like a contained body of work. I'm somewhat cheered to find how many failures there are here – it's not what I expect from a potter whose forms have such levitational poise. Three miniature vases in white with an oxide stripe are all failures – the white has crawled or shivered terribly. There are tiny shallow dishes, light as a feather but in a blue that has bubbled ugly like honeycomb where it sits too thick. Others are rough experiments in oxides and blue glass, which is blobby and gaudy, which does not feel related to her finished work. Wrapped in white tissue paper are two chocolate-coin-sized white clay discs, with oxide washes licked on the rear, and there's a glaze that's slouching on a dark sandy clay. There are successes too, instances where matte barium glazes sit cool and flat, but I am interested in the dead ends just as much as the successes, and it is a privilege to encounter them. You can see the intent in these experiments: she's looking for certain textures, finishes and surfaces – exploring the way things mix, hang on edges, or sit on a form. More than anything, I am thrilled to touch these surfaces in a way not permitted in museums and galleries; to weigh the forms in my hand, inspect the bases, feel the decoration made in relief or stroke the soft surface of a chalky glaze.

COLOUR

*

It takes a lot of looking at pots to get your eye in, but once it's there, you'll not only be able to know a Pleydell-Bouverie or Lucie Rie glaze, you will also be able to spot a pre-mixed glaze a mile off, and arguably, a really good potter will have glazes that are as distinctive as their forms. Florian Gadsby's grey-green crackles and pale rainy greys are a good example.

But developing glazes takes time, space and some understanding of basic chemistry, so many part-time potters use factory-made, pre-mixed glazes. (Professional potters don't often use these because they are not economically viable when making large batches of work.) There are a handful of companies making glazes like this – Mayco and Amaco in America, Botz in Germany – and their ranges have expanded enormously over the last decade. While they are expensive inch for inch, these pre-mixed glazes are also precise, reliable, and can produce special effects that were previously difficult to achieve. Now, you can buy a plastic tub of glaze off the shelf that gives you crystals and crackles, hare's fur and oil spots that otherwise require specialist firings. Largely, these glazes are an express route to an exact colour and surface without stopping at the testing phase: a glossy forest green, a crystalline ivory, a stony matte grey, a foggy celadon; even a speckled violet called Purple Haze.

Some baulk at this as cheating, but the first glaze I ever used was a Mayco glaze off the shelf – a stoneware colour called 'Blue Surf' that was deep sapphire where thick and broke sea green where it was thin. I feel some attachment to these quick-fix glazes because of this, and I'd always been curious about how these companies were overcoming the usual hurdles of glaze chemistry. How were they guaranteeing that all these colours came out right? Who was using them? What does a glaze factory look like anyway?

Mayco's factory and offices are in the Midwest, in Hilliard, on the outskirts of Columbus, Ohio. I drive there from Chicago, and the route is all blank fields, strip malls, fast food joints and the occasional signage reminding me that hell exists, as does Jesus. The factory is a blank, low-slung building behind a baseball field and Franklin County Fairgrounds, near Hilliard's old town.

It was founded in 1954, and now has a catalogue of hundreds of glazes, adding a handful of new colours every year. What they make is largely aimed at hobbyists and part-timers like me. They have volcanic magma glazes, fluxes, crackles, washes, crystalline glazes and a 'mudcrack' that shatters like a dry lake bed over a contrasting base. They also produce Stroke & Coat – a paintbox of colours made with stains that paint-your-own-pottery shops use, because they are like poster paints and look roughly the same colour raw as they will fired.

I get a walk-through of the factory, past bottling stations where 8 oz bottles of Gray Hare Stroke & Coat are rattling through a machine; and trays of crystals are waiting to be fired in big kilns along a back wall. These will be crushed and added to Jungle Gems crystal glazes. The company also make their own test tiles – called chips – that are stuck on marketing boards and sent out like tactile flyers. I am shown round the 'heavy' side of the operation, where the glazes are milled and mixed. There are big opaque plastic vats with numbers scrawled on the side, a grinder and giant mixers: big barrels in cages that turn like tumble dryers on their side, which are full of ceramic pucks that crush the dry glaze materials. There is also a mixer like an industrial KitchenAid, splattered with paint like a Jackson Pollock custom job. There's a lot of chemistry going on in Mayco's glazes, but this intensive milling of raw ingredients (in combination with various suspending agents

like gums and bentonite) stops the glazes settling, and helps keep things stable.

I'm met by Colleen Carey, the bubbly CEO, who puts in an order from a local BBQ joint for everyone's lunch before showing me round the rest of the operation. She introduces me to Todd and Sally, who are part of the Mayco design team. Todd is quiet in a baseball hat; Sally is relatively new to the company, dressed in a vintage jumper, with cropped hair and bright eyes. She shows me cups she has made to test out new glazes, and a rack of slip-cast teardrops in a spectrum of colours and surface effects for a trade show display. I find the sea-blue glaze that was the first one I used, and ask if they have favourites too. Todd points to a super-matte glaze that looks like the surface of a grey pebble. Sally shows me a melty dragon skin of lime green and red – this has a stiff glaze on top of a more fluid one, meaning that when the base layer moves during firing you get these reptilian patterns breaking across the surface. Carey points to a mauve she likes, which has a furry softness: 'It's yummy,' she says.

In the lab she introduces me to the director of technical services, Steve Kutney, a ceramic glaze engineer who has been at Mayco for twenty years. Outside of work he keeps bees and chickens. In addition, the quality and new product development is done by Ben Post, who is a chemical engineer. They won't tell me anything about their recipes – they are proprietary secrets – but they do a lot of testing, most of which is quality control, but which also includes leaving a new glaze in the back of someone's car for a month to see if it changes. New colours and surfaces come from educated guesswork and testing, but there are also happy accidents. I ask about materials: are they even using the same ingredients as other potters? 'We have a common set of materials the studio potter would recognise,' says Kutney. 'But

it's weighted towards frits, because we grind everything down.'
Post says they're primarily looking to use raw materials that will
be stable – that will not continue to react inside the glaze once it
is mixed. It doesn't always go right – one recent test glaze turned
to concrete after a fortnight. He says it's usually about stabilising
a glaze, which might mean 'making a red pigment, figuring out
how it will survive, and giving it a chemistry with a backbone
that can coddle that pigment at higher temperatures'.

Over sticky BBQ sandwiches in the canteen, everyone has
stories about unusual customer requests. What's the weirdest
request you've ever had? I ask. 'Tell her about the cat,' says Sally.
'Sure,' says Kutney. 'Someone wanted to know if we could make
a glaze within which they could inter their cat.' In theory they
could, but whether any of the cat would survive in the glaze once
it was fired was another question.

I ask if there's anything they still haven't been able to make as a
stable glaze, if they have a Holy Grail? Kutney says a replacement
for lead oxide: 'It used to be a really important part of glazes
because it acts as a flux, so it affects the movement of the glaze,'
he says. 'Everyone had to stop using it because it's so toxic.' Post
chips in with a better answer: 'Fuchsia! Hot Barbie pink! It's
impossible! It's now a joke between distributors. At trade shows,
the first thing we ask each other is: hey, made a hot pink yet?'

As everyone returns to work, I head back to the parking lot, past
some of the longest-serving receptionists I've ever met. Carey runs
out to hand me a stack of their catalogues, and two small purple
bottles of Stroke & Coat – the new colours for this year, she explains.

At various points of the tour, Carey had said she wanted to
help potters 'find their joy' – it sounds insincere on paper, but
she genuinely meant it. Pre-mixed glazes are modern shortcuts for
people without the resources to take the long route, which was

me when I first started making. They're like stabilisers on a bike, getting you to the next stage until you're ready to go it alone and make your own from scratch. 'We're not trying to diminish the work of studio potters,' she says. 'We just want to open up the possibilities so people stay engaged.'

On the way into Mayco, I'd been thinking about how many pots Patwardhan had glazed by proxy in her time designing glazes at Winchcombe, Farnham and with Leach. I wonder how it stacks up next to Kutney and Post's output. Back at home, I pull a small blue cup from the cupboard – the first I ever threw and glazed. How should I understand this pot? I made it, I chose the glaze, but that glaze came from Kutney, probably. He's had a hand in this cup – or at least Mayco have – just like Patwardhan had a hand in the Leach bottle that was sold at Bonhams. But neither of their names appears, and largely they are both lost, as unnamed contributors to a huge body of work that cuts across continents.

Glazes clothe the vessels we make, are vehicles for meanings diluted and remade, but we so rarely know who dressed a pot if it is not the maker themselves. Glazes carry meaning and the hues are manifestations of technology, chemistry and testing. But no matter how controlled or expert you are at making glazes, there will always be an element of alchemy in it: a turning of wetted powders into precious colours. The unknowns, the failures and the possible transformations increase its mystery even further. This description – that it is alchemical – is largely metaphorical. It's in the search for another ceramic material that it becomes a more literal description.

Bird designed by Johann Joachim Kändler, Meissen, 1740.
Residenz museum, Munich.

9
Sound

I'm up early to catch a 9 am flight to Dresden, to see an impossible menagerie made 300 years ago for Augustus the Strong, Elector of Saxony. The animals are not alive and never were. They do not claw or scratch or peck and they never needed to be caged, because they are cast from porcelain. Porcelain is a difficult material: difficult to work with and difficult to write about. More than one potter, when I asked if they worked with porcelain, practically screamed and ran away. Others fall under its spell completely.

For those who find an affinity with porcelain, it offers something entirely other to the hand and the eye than most clays: it has a paleness not found elsewhere; a fineness unachievable with common stoneware. Its value and its history are tied up with this whiteness, but it is not a clean story. It is muddied early on by distortions and refractions that complicate notions of authenticity. It is a ceramic material that has been perhaps more imitated than any other, and formed into objects more desired than most.

It's hard to know where to begin with such a material. What can you do with porcelain that you can't do with other clay? What makes it special? Clay can be dug from a riverbank, but a

porcelain clay body has to be made, created by the combination of kaolin (China clay) and petuntse (feldspar, mica and quartz). The kaolin is key; the petuntse may be exchanged for feldspar and quartz, or other feldspathic rocks. Porcelain has enormous capacity for fine detail; for the light it carries in its density. It is like bone, and it is like glass. When fired, it sometimes seems as if it may float. In 851, an Arab traveller named Suleiman wrote that 'They have in China a very fine clay with which they make vases which are as transparent as glass; water is seen through them. The vases are made of clay.'

There is also a description that circulates, mostly unattributed, of the qualities of early porcelain from its de facto world capital, Jingdezhen: 'white like jade', 'bright as a mirror', 'thin as paper', and 'sounds like a bell'.

Contemporary artists working with porcelain often lean into these properties. In his diaristic book on his obsession with porcelain, the writer and artist-potter Edmund de Waal writes:

Pinch a walnut-sized piece between thumb and forefinger until it is as thin as paper until the whorls of your fingers emerge. Keep pinching. It feels endless. You feel it will get thinner and thinner until it is as thin as gold leaf and lifts into the air. And it feels clean. Your hands feel cleaner after you have used it. It feels white.

For all its supposed purity as a material – which has at least something to do with complicated associations around 'whiteness' – tracing even a rudimentary history of porcelain involves a knotty back-and-forth between Asia and Europe. It is a bifurcated history, which binds the two continents in a story thousands of years old on one side and just hundreds

on the other, which contains chapters on cobalt mining in the medieval Islamic world and sea voyages to East Africa, and which means we can trace a tangle of connections from a plate in Tang dynasty China to a piece of chintz in a charity shop window. However, despite its sprawling geography, the history of porcelain is also more contained than other histories of clay, because it is a material that is made not mined. Perhaps because of this, as well as the drama in the stories of its manufacture, it has spawned more writing than any other zone of ceramics, from catalogues of factories and makers' marks to modern literature and non-fiction by authors like Bruce Chatwin, Janet Gleeson and de Waal.

It's years since I've thrown with porcelain – I had a go early on, after being warned off. 'It's too difficult!' I was told. 'You won't like it!' people said. In that early experience, I remember realising that, unlike impressionable stoneware on a wheel, porcelain talks back. It has a character, and just like people don't get along, porcelain doesn't get along with everyone. But throw small, throw like a firm handshake, and it might assent to coming your way. Think hard about the form you want, and pinch the clay decisively. Do not show fear. It likes control; it likes you to be sure.

I have thrown with it only briefly. I kept a small cup that was later swamped by a heavy white glaze as if covered in fondant icing, which turned out to be perfect for mezcal. I made a dipping bowl that I laboured over, turning it to a crisp shallow form lifted on a footring, with a love-in-a-mist swirl over a pale satin white. I made some small sculptures I treasure. I liked it, but the expense (it costs roughly double a basic bag of stoneware clay) and practicalities (your workspaces must be totally clean or only white

to maintain the purity – often difficult in a community studio) mean it remains, for me, a largely unexplored territory. To begin bridging the gap in my experience of porcelain, I head to Dresden.

I land in the city in the late morning. Across the wide Elbe, banked with meadows, is the old town. All of it was obliterated in the Second World War, but you wouldn't know it – it was rebuilt accurately enough that if you look through a large steel picture frame erected on the banks of the river, you can still see a skyline of Bernardo Bellotto's 1748 painting *Dresden From the Right Bank of the Elbe Below the Augustus Bridge*, the image only altered by twenty-first-century cars, electric trams and a couple of cranes.

I first go looking for porcelain in the Old Masters Picture Gallery. Stalking the vast corridors and grand rooms, I find a painting of a table heaving with luxurious foods: apples, pears, yellow peaches, artichokes, a pheasant, grapes, figs and a slaughtered deer in the centre of the frame. The fruit is all on what looks like blue and white porcelain. It might be Delftware – the Dutch imitation of porcelain; it was painted in the 1650s by Antwerp artist Frans Snijders – but whichever it is, it *means* porcelain, which means luxury. There's more blue and white in a Vermeer and in a painting by Jan Davidsz. de Heem of a still life with a lobster from 1669.

When Europeans began sweating over how to make porcelain, China had been making it for over a thousand years. It emerged out of high-fired stoneware, which had been made since the middle of the Shang period (*c.*1600–1050 BCE) in southern China. By the time of the Han dynasty, 'proto-porcelain' was being made, which had a greyish stoneware body, and later in the Eastern Han dynasty (25–220 CE), porcelain proper emerged.

These developments – so many hundreds of years ahead of much of the rest of the world – were possible because of the high temperatures that could be achieved in Chinese horseshoe kilns. It was these high temperatures that made fired ceramic produce a 'crisp metallic ring' when tapped, writes porcelain specialist Lili Fang. She estimates that the technology to make proto-porcelain was achieved somewhere around 2000 BCE, with the earliest known pieces, found in Xia in 2012, dated to around 2070–1600 BCE.

In China, porcelain emerged from the confluence of clays and high-firing kiln technology, which outstripped almost all others in the world at that time. The north and south of the country were divided in their development: high-fired glazed stoneware was already being made in the fifth century in the north of China, and grew rapidly in the sixth. The first true white porcelains, as we might recognise them now, emerged in the late sixth to early seventh centuries.

It wasn't until the tenth century that the south caught up, and started to dominate the trade. White porcelain from Hsing kilns developed in part because of patronage from high society, which put it hand in hand with the emergence of tea-drinking culture, where the translucent white porcelain cups were treasured as being 'especially suited to the drinking of red tea'. Later, Qingbai wares emerged, which had a blueish tinge, and Jingdezhen was transformed into a sprawling industrial complex. It was a strictly controlled operation, with official quality control around the three grades of porcelain that were produced, and it was international and multicultural, with sizeable exports to the Arab world. When a porcelain bureau was established there in 1278, the first supervisor was Nepalese, with successors coming from Persia and Mongolia.

From the fourteenth century, the making of blue and white porcelain was mastered, following the import of cobalt from Persia. It was already being used there on tin-glazed wares, on which it tended to bleed, but the Jingdezhen porcelain could be painted on in exquisite detail. At the time, Persian artisans called it 'lājvard', in reference to lapis lazuli. The English word for cobalt derives from the German *kobald* – 'goblin' – because smelting of the ore produces toxins that miners in Saxony saw as evidence of malevolent subterranean spirits. The earliest dated blue and white porcelains (although not the earliest) are from 1351. These two tall vases are known as the 'David Vases', with elephant-head-shaped handles, decorated with bands of cobalt, plantain leaves and dragons in flight amid foliage and clouds around the narrow-shouldered forms.

This material exchange, between China and Persia, influenced what was being made in dramatic ways. Chinese potters brought in tight, busy patterns influenced by ornate Persian designs, and made large dishes suited to the communal eating practices of the Middle East. 'By the middle of the fourteenth century, large dishes were densely decorated in geometric patterns better known in Islamic metalwork or architecture than in Chinese ornament,' explains professor and curator Shelagh Vainker. They were almost exclusively for export: only one large dish of this style and period has been found within China. The domestic market had mixed reactions to the blue and white wares – they thought they were garish and alien in comparison to the subtlety of Song dynasty wares. An early Ming connoisseur's manual called the *Gegu Yaolun*, from 1388, praises monochrome porcelain, but notes that 'the blue and white (qinghua) and the multi-coloured (wuse) specimens are vulgar in taste'.

Following a rebellion in the middle of the century, blue and white fell away, until the Hongwu emperor ascended in 1368 and

restored the imperial kilns, filing orders that included masses of white porcelain roof tiles for his palace in Nanjing. Gradually Chinese blue and white began to reflect Chinese aesthetics, incorporating imperial symbols – the dragon and the phoenix.

Export trade was enormous. In 1403, when the Emperor Yongle ascended the throne, previously restrictive overseas trade reopened. Two years later, the first of the Ming voyages set sail – a wildly ambitious set of seven journeys led by Zheng He and spanning twenty-eight years, with 27,000 men visiting over thirty countries in Asia and East Africa, sent out on trade and diplomacy missions loaded with Chinese-made goods, including porcelain. The distances they travelled were astounding. I trace the routes in felt tip onto a map – they form looping necklaces around the Indian Ocean, through the Arabian Sea, the Bay of Bengal and the South China Sea.

The earliest documented piece of porcelain to make it to Europe is thought to be what was later named the Gaignières-Fonthill vase – the Fonthill vase for short. It is thought to have been made in Qingbai around 1300–1340, and was presented to Charles III of Durazzo by Louis the Great. It was passed on and around, eventually reaching a collector and writer called William Beckford, who kept his collection in his home, Fonthill Abbey, a large Gothic-style country house that gave the vase its name.

The Fonthill vase is not, by my estimation, a beautiful object. It is fussy. Edmund de Waal went to see it in person, and called it a 'flummery of ideas'. He describes foliage and flowers, balls and swags in relief under a grey-green glaze, and calls it 'the most irreproachably aristocratic, double-barrelled porcelain object in Europe'. It is a shape, he says, that is all wrong – it bulges, has no grace.

When the Fonthill vase arrived in Europe, nobody was making porcelain outside Asia, and nobody knew how. As imports increased, desire for this hard white translucent stuff grew. With desire grew mysteries around its manufacture, which were transmuted into myths about its properties – it was said to be able to reveal a poisoned drink. Marco Polo wholly inaccurately described how in Jingdezhen:

> the people of the city gather mud and decomposing earth and pile it up in great mounds which they leave undisturbed and exposed to the wind, rain and sun for 30 or 40 years. After sitting all this time the earth becomes so refined that the bowls made from it have an azure tint and a lustrous shine and are unparalleled in their beauty.

The sixteenth-century French potter Bernard Palissy spent his life trying to discover how to replicate a 'white enamelled cup', which is generally accepted to have been a piece of Chinese porcelain. He worked without success, 'like a man who gropes in the dark'.

There was little knowledge and lots of presumption in early European attempts to make porcelain. Europeans had not realised the importance of kaolin – named after the white clay hill called Kao-ling outside Jingdezhen where it is found – and kiln technology was too rudimentary to achieve the heat that was needed. Porcelain fires at around 1,300 degrees Celsius, and European kilns just couldn't get there, even if someone had worked out that it was necessary.

Most early European theories presumed the inclusion of glass. In the sixteenth century, Francesco de' Medici tried mixing sand, glass and rock crystal, but the resulting Medici soft-paste porcelain could not be thrown with. It was rolled

into slabs, put into moulds and fixed together, and was highly friable. Only twenty-six pieces survive, one of which is in the V&A, but you can see it's not right – the form looks like a body squeezed into a too-small dress. Its tiny looped handles accentuate oddly bulbous hips. Other pieces have glaze defects, or cracks. A seventeenth-century potter named John Dwight in Fulham also took out a patent on porcelain, and although there's no evidence of him producing anything in any quantity, some more recently discovered potsherds suggest he might have had some success. The Duke of Buckingham set some resources towards the discovery of a recipe too. In France, the Rouen pottery made a few scant pieces of soft-paste porcelain from the 1670s (only a handful of which now survive), and from 1702 at Saint-Cloud, 'a distinctive paste made of strange ingredients' was produced, which was a decent imitation of true porcelain.

Porcelain takes its name from the Italian *porcellino*, the name for the piglet-like shape of translucent cowrie shells. When it began arriving in Europe, it stood out against other wares and looked advanced enough to be a different material altogether, but nobody knew how to make it. While detailed writings on porcelain production were published in China, some of the key texts did not appear until the middle of the eighteenth century and onwards. Three of the best known now are the *Tao Lu*, the *Tao Shu* and the *Tao Ya*. Also notable are works by the famous Tang Ying, superintendent of the Imperial Porcelain Factory, whose reputation spread into work songs sung around Jingdezhen. One recounted in Joseph Needham's definitive tome, *Science and Civilisation in China*, explains the pounding of the porcelain stone:

CLAY

The mountains' stony body gives out clay
Water powered trip hammers pound it in mountain streams
If the workshop boss says it's not OK
It won't get parcelled up and shipped away

The *Tao Lu* is a compilation of stories and descriptions written
by a scholar native to Jingdezhen, Lan Pu, who died before it was
finished. The *Tao Shu* came earlier, in 1774, and the rather argu-
mentative *Tao Ya* was published in 1906, written by Chen Liu,
'an avid porcelain collector and a self-professed lover of alcohol'
whose entire porcelain collection was comprised of wine cups.

However, these were all published after the earliest first-hand
accounts of porcelain production made it back to Europe, written
by a Jesuit priest called Père d'Entrecolles, who was stationed
in Jingdezhen. His two detailed letters, sent in 1712 and 1722,
comprised the first-ever accurate and comprehensive descriptions
of the manufacture of Chinese porcelain that the West ever
received, and they paint a vivid picture of a city aflame with
industry. He describes street scenes and factories, and tells of how
the fires burn eternally from the kiln chimneys: 'whirlwinds of
flame and smoke rising in different places make the approach to
Jingdezhen remarkable . . . During a night entrance, one thinks
that the whole city is on fire, or that it is one large furnace with
many vent holes.'

He describes men striding through the bustling streets carrying
planks loaded with porcelain (if you bumped into them, you paid
for whatever was broken), and kiln stokers putting salt in their
tea, to better cope with the intensity of the heat. It was a tightly
controlled place, with streets and communities barricaded at
night and strangers not permitted to sleep in the city overnight
without permission.

Most importantly for those who received his letters, d'Entre-
colles transcribed the recipe that had eluded the West:

> It is from kaolin that fine porcelain draws its strength, just like
> tendons in the body. Thus it is that a soft earth gives strength
> to petuntse, which is the harder rock. A rich merchant told
> me that several years ago some Europeans purchased petuntse,
> which they took back to their own country in order to make
> some porcelain, but not having taken any kaolin, their efforts
> failed. Upon which the Chinese merchant told me, laughing,
> 'They wanted to have a body in which the flesh would be
> supported without bones'.

The first European to make a porcelain body where the flesh was
supported was Johann Friedrich Böttger, just a few years before
d'Entrecolles' letters were sent. Böttger was a skilled chemist
and alchemist who – at least to begin with – appears to have
genuinely believed that transmutation of matter into gold was
possible. Born in 1682, he trained under Johann Kunckel, an
alchemist in Saxony in the 1670s who had been refused a salary
by the court because, they said, if he could turn metal into gold,
he had no need for one. Under Kunckel, Böttger became obsessed
with finding the alchemist's arcanum.

In 1701, after five years of grinding pills at the apothecary –
and presumably a few years of fruitless alchemical experiments
– he started holding secret demonstrations, where he performed
a trick so flawlessly that his friends were convinced he was the
real deal. Janet Gleeson, in her biography of European porcelain,
thinks that Böttger actually believed he had made a true alchemi-
cal discovery, despite the fact that he must have been performing
a sleight of hand. He turned metal into gold in front of an

audience on the condition his guests kept his discovery a secret, which they did until his master at the apothecary – a chemist named Zorn – attended the show, and could not resist writing to a colleague in Leipzig about the miracle he had witnessed. From there, news spread. It was reported in the newspapers, the philosopher Leibniz heard about it, and it reached the King of Prussia, Frederick I. A man who could make gold was a valuable asset, and so Böttger was summoned. Evading discovery, and in the process putting a price on his own head, he took flight and headed into Saxony for protection, where word of the alchemist reached Augustus the Strong, who whisked Böttger away to Dresden. It was partly a rescue, but largely a kidnapping, and it led to Böttger's effective imprisonment for most of the rest of his life, his freedom offered in exchange for the secret of transmutation.

Augustus suffered from what began to be called *Porzellankrankheit* – porcelain sickness. In *Porcelain for Palaces*, Oliver Impey describes him as an 'accumulator', rather than a 'discriminating collector', of porcelain. He had agents buying for him in Holland, acquired entire collections at once, and in one often-retold story of his unquenchable appetite for the white stuff, he once exchanged a regiment of his own dragoons for twelve large porcelain jars.

Böttger regularly promised Augustus gold, but year after year failed to produce it, until it seemed likely he would be sentenced to death. But he had impressed an older chemist named Ehrenfried Walther von Tschirnhaus, who was, among other things, investigating porcelain. Tschirnhaus had warmed to Böttger and admired his knowledge of chemistry, and so saved him from execution by co-opting him into his quest to find the secret of porcelain production. Böttger soon realised it

was not glass that was needed but different clays and more heat, and he began to make progress. He first made a red porcelain clay, but it was when white clay came in from Colditz that he got closer than ever.

Gleeson describes how during one set of experiments, a filthy subterranean inferno raged in the kilns constructed for Böttger in the Jungfernbastei on the banks of the Elbe. For six days and nights the kilns were stoked. The burning floor blistered the workers' feet in their shoes; the air was so hot it singed their hair. City officials became so concerned by the heat that the Dresden guards hosed down the exterior walls. Augustus arrived to see the kilns for himself, accompanied by one Prince von Fürstenberg. He walked into 'a hellish scene', greeted by a soot-blackened Böttger. The stoking was halted and the kilns opened – Böttger's assistant reported that the Prince 'repeatedly said "O Jesus"', but Augustus just laughed. A teapot, glowing red, was pulled from the kiln and plunged into a vat of water. It hissed and emitted a loud explosion. Augustus remarked that it had broken, but the teapot, miraculously, had survived.

It did not break because this early porcelain was technologically tougher than its contemporary Chinese porcelains. Made by adding small amounts of calcined alabaster and quartz to china clays, it needed temperatures of 1,350 degrees Celsius or more and had a particular resistance to thermal shock. A year later, in March 1709, Böttger had fine-tuned the firing and materials enough that he confidently proclaimed to Augustus that he could make 'fine white porcelain'.

On day two in Dresden, I feel acutely underqualified to handle the history of this most eminent material. I'm a hobbyist trying to get to grips with something that has made emperors rich and

bankrupted kings. People have handled and worked this material from childhood till death, and I've made a couple of dipping bowls. Porcelain contains a density of meaning that requires several tomes, not a few thousand words. It is a lifetime's work, a religion, a sickness.

To house his swollen collection of hoarded porcelain, Augustus began renovations (which were never completed) of one of his palaces in Dresden, which he intended to turn into a Japanese palace. The baroque facades were going to be held up by chinoiserie caryatids and the collection was to be displayed in massed arrangements: one drawing for the palace shows 'tiers upon tier of plates, saucers and vases . . . around pyramid like etageres supported by lion figures or around plaster or giltwood medallions'. These massed porcelain displays popped up in palaces and estates all over Europe at that time. It's thought Augustus saw the porcelain maximalism at the Charlottenburg Palace in Berlin, where blue and white porcelain is used like paint and wallpaper, and was probably also influenced by the ceiling at the Santos Palace in Lisbon, which layers plates like fish scales ascending into a peak.

In Dresden, Augustus planned an upper gallery for the Japanese palace that would house a menagerie of life-size animals made entirely from porcelain: there would be 'all kinds of birds and beasts, both wild and tame, made entirely from porcelain and in their natural colours and size', writes Gleeson. Across the other side of the world, lifelike animals were also being made in Jingdezhen – d'Entrecolles wrote about how 'the workers make some ducks and turtles that float on water. I have seen a cat painted naturally, where one had put in its head a candle of which flame would form two eyes and they assured me that during the night the rats were frightened by it.'

However, porcelain is not a material best suited to making large sculptural objects, and especially not the Meissen porcelain that Böttger had developed, which was prone to cracking in the kiln. Sculptural weight poses a serious challenge – how might a bird hold itself up on porcelain legs?

The menagerie was a nightmare commission for Böttger's new Meissen porcelain factory – a ridiculous request and a misunderstanding of what the material did best. At first, under a stone-carver named Kirchner, it went very badly. He failed so completely, he was widely ridiculed by his colleagues, and the few pieces that came out whole from the kilns were rejected by Augustus for being too posed, static and dull. He took it badly and began frequenting taverns and brothels, eventually getting such a bad STI he had to have weeks off work, after which he was fired and returned to stone-carving.

In his place came a sculptor named Johann Joachim Kändler. He was well educated, from a clerical background; his father was a pastor and noted his talent for art and preoccupation with antiquity. Gleeson writes that he had 'a round intelligent face, a mischievous smile and an affable manner'. He took easily to the porcelain, and within weeks had created an eagle with outstretched wings, based on a heraldic design. Within a year he had made two life-size ospreys, a sea eagle, an owl, a hawk, a heron, and a St Peter for the chapel. 'Porcelain had never come so close to imitating the essence of life itself,' writes Gleeson.

After wandering halls, rooms and corridors of plates, vases, cups and bowls, I round a corner and find a gallery inverted. Instead of white walls for coloured objects, these rooms are rich in golds, purples and reds, and the porcelain menagerie is almost

all in white. They sit on golden rock formations under purple and red parasols, or lounge by the doorways on plinths. It is easy to spot Kändler's animals next to the few that survive by Kirchner. There is in the former's work a combination of executive precision and an imaginative twist – his animals are expressive, unusually but naturalistically posed. Fur may curl, lie flat, stick up stiffly like a brush. Birds' feathers may be slender and fine, or stubby and fluffy. A macaw has been sculpted hanging almost upside down from its perch, as if to pick up seeds from the ground. The feathers on its neck are scalloped and smooth, the muscles and joints on its wing are taut, its long primary feathers drawn upwards into an elegant point, each barb picked out along the quill.

I'd been thinking about the fragility and difficulty of porcelain: the way it transmits light, and how this makes it suitable for silk, hair, feathers, fur, but it's when staring at the detail on a cockerel's tongue that I realise I've been missing something. The tongue is picked out in such detail that it is not just as if it is alive, but as if it is mid crow. I realise that Kändler has made his menagerie real by making it sing, screech, snarl, honk and caw. His animals are cacophonous. With this, porcelain lets me in.

Porcelain is defined by the sound it makes as well as what it looks like: 'white like jade', 'bright as a mirror', 'thin as paper', and also that it *sounds like a bell*. The ringing that defines it is the sound that checked its veracity – it rang when struck, more clearly than other ceramics, and this was also used as an indicator as to whether it had been fired properly.

As well as his menagerie, I find that Kändler also made a glockenspiel, which was finished and assembled in 1737 and can

still be seen in the Zwinger palace complex. As I head out of the galleries into the sun, the Zwinger bells are ringing, high and pure, like porcelain.

Tomoko Sauvage is a Japanese sound artist living in Paris. Her work involves the playing of large bowls of water – most of them porcelain, but some glass. The water tunes the bowls to particular pitches, and in them she submerges hydrophones – underwater microphones – which amplify the chimes, rings and other rippling sounds she gathers and manipulates by rubbing the surfaces of the vessels, dripping water into them, tapping them to create chimes and manipulating audio feedback – an acoustic phenomenon that occurs in the interactions between microphones and loud speakers. On her album *Fischgeist*, she evokes whale song and the trilling of underwater creatures; on *Musique Hydromantique*, water drips become the slow awakening of a gamelan. Her performances and installations often happen in resonant spaces, which are activated by the frequencies she amplifies from the bowls and the movement of water; lights cast shadows and project watery refractions on these towering architectures, which have included churches, galleries, and a water tank in Berlin. Mostly she's making porcelain ring 'like a bell', with a usual set-up of five or six porcelain bowls, and one glass for visual effects.

When I call her, she explains that her playing on water-filled bowls has a lineage in an instrument from southern Indian Carnatic music, called the jal tarang, made from porcelain bowls of various sizes filled with different amounts of water. 'It's percussion you hit with sticks,' she explains. 'It must be quite primitive, so I'm really interested in the hidden story of this instrument.'

The *Tao Lu* references something similar, stating plainly that 'water cups are musical instruments'. 'Our forefathers made them of potsherds or earthenware,' it says.

'In Ming times a musical expert planned to make them of iron instead; but failed. So he bought food vessels that gave out a musical note, acquiring several Ch'eng Hua porcelain pieces made in the palace factory. These were divided into high and low, thick and clear, according to whether the water in them was deep or shallow. A horn spoon was used to strike them. There were eight vessels in all completing the scale.'

Few recordings of the jal tarang are available as compared to other traditional Carnatic instruments, but it poses an interesting historical puzzle. India did not make porcelain at this time, so the bowls must be imported. At some point there was a glass version, referenced in the Kama Sutra as one of the things women should learn. Père d'Entrecolles also lists many porcelain instruments ordered by the crown prince:

> a kind of little organ called 'tsem' which is nearly a foot tall and made up of 14 pipes, of which the harmony is very agreeable . . . sweet flutes, flageolets, and another instrument is called 'yum-lo' . . . composed of diverse little round plates . . . one hangs nine of these in a frame in different rows that one plays with mallets like a dulcimer; it makes a little carillon which accompanies the sound of other instruments and the voices of musicians.

Sauvage first came across the jal tarang at a live performance by Anayampatti Ganesan, one of its masters, in Paris. 'I was studying Indian music, but it totally blew my mind when I saw this instrument,' she says.

'I was totally, totally mesmerised and fascinated by the sim-plicity of it, but also the sound – I just had an epiphany. I immediately started to imitate it in my kitchen with the bowls I had and some water, doing some kind of improvisation. I had no intention of doing something serious with it, I was just having fun. Then one day I heard about hydrophones. I bought one and it changed my life. I was *swimming* into these bowls. That was eighteen years ago, and little by little I developed this instrument.'

Sauvage's bowls are doubly tied to sound – they are an instrument, a modern take on a jal tarang, but they are also cast from bell moulds made by the ceramic research centre in Limoge (CRAFT). 'They had done another project making porcelain bells, with some precise research on sounds, dimensions and form, and had some moulds,' she says. 'As my project didn't have much money, they decided to recycle these moulds by cutting them into bowls for me, so my bowls are really bells.'

They made her a set of twelve, which she still uses now. Before this, she often used ordinary bowls. 'I'm not even sure if they were porcelain,' she says. 'You can find them everywhere. Sometimes I toured with nothing and would buy them in a local Asian grocery shop, then give them away at the end of the concert. They sounded good, too, they were just smaller, so the pitches were more limited.'

In Sauvage's music, there is a lineage back to China, through India and France. It is a history of a material, and a history of trade. 'I'm Japanese, and people might think that what I do is quite Asian. Some people, especially Japanese people, tell me that it sounds like suikinkutsu – the sound decoration in the garden where a ceramic vase is buried underground and drips into the empty hollow of the vase,' she explains. 'So, of course, when I

play with water drops into the bowls, it might sound quite similar. But actually, my practice is nourished in Europe. The porcelain comes originally from China, but mine are European-made. And I really developed this instrument in European spaces.'

Her work contains within it the sound and the object, and a tangle of questions about this supposedly pure white porcelain material. It might be a human-made clay body that suggests a more compact lineage than most clays, but its whiteness hides a history infiltrated by imitators; by the movement of objects and centuries of trade; by desire; by music. Little about porcelain is authentic – its history is more interesting cast as a story that is rooted in inauthenticity. It is bought, sold, copied, replicated.

Blue and white porcelain in particular is significant for the history of the world at large, and perhaps has more to tell us about the way trade and economies have developed than any other type of pottery. Porcelain is said to feel weightless, but it is also a material weighed down and complicated by its glorification of whiteness, which symbolised purity and imbued it with value. It is in its sound – that it rings 'like a bell' – that I find a through line from the early tests of its purity to how it is sounded by Sauvage and others now. There is a quote I come across by founder of Taoism, Laozi: 'The vase gives form to the void, music to silence,' although with Sauvage's porcelain, it is the vase that gives form to the music.

I get home to a bag of porcelain. I clean the worktop down, wedge up a small ball of clay and thwack it onto the wheel. I think of the void I will shape, not the vessel. After a few tries, I begin to harmonise with the sticky porcelain. I manage a bowl. I leave it to dry, and trim it down. I fire it a few weeks later, finishing it

in a glassy transparent glaze. I set it on the table, half fill it with water and tap it with a fork. It rings clean and clear, high and proud like a bell. It announces itself: an accomplishment.

The rear of a Keymer tile, with handprint visible.

10
Shape

Ceramic tiles are ubiquitous in urban and suburban life: on roofs, floors and walls, in kitchens and bathrooms, hospitals and train stations. They might be made into murals or mosaics, be protective or decorative, or both. Tiles have practical application in places like metro stations, where they are robust and long-lasting. When glazed, they are hygienic because the impermeable glaze absorbs no dirt and can be washed clean.

The possibilities offered in the face of a freshly made tile are near enough infinite. What is its purpose? Where is it going? Will it be viewed close up or from far away? Will it be glazed? Will it tessellate? Will it form a pattern? How will multiples fit together? Does it need to speak, like the calligraphic friezes on mosque walls? Or is it functional, like the tiles on the London Underground?

There are countless tiles being made in myriad styles, sometimes by people better known in other zones of craft. One of those is the German-British potter Hans Coper, who began a little-known commercial project at the close of the 1950s, designing clay cladding and acoustic tiles designed to mop up noise.

Coper is best known for his vessels and sculpture inspired by archetypal forms from Mycenaean and other ancient pottery.

At the beginning of 1959, he joined the artist community at Digswell House in Welwyn Garden City, beginning a phase he later referred to as his 'architectural period', where he tested out principles from the Bauhaus school: that form should follow function; that materials should remain true, simple and effective; that there was no boundary between artist and craftsperson. He had received a grant from the Maidenhead Brick and Tile Company, and used it to design and produce ceramic wall cladding and acoustic bricks. In his monograph on Coper, the noted ceramics writer Tony Birks explained that the clay-based cladding tiles were to be designed on the principles of eighteenth-century mathematical tiling (laid on timber buildings as cladding) and allow the 'infilling of prefabricated structures with overlapping tiles', which would produce 'varied surface texture and pattern from a very limited number of units'.

Coper produced six or seven designs made by extruding clay in various shapes, some of which were glazed, others just biscuit-fired. The few promotional photos of the tiling show a school and sports hall wall, and expanses of tiled surfaces shot in high-contrast black and white, where the ridges and curved surfaces of the extruded tiles create patterns of light and shadow that might be designs pulled from the bold abstractions of Anni Albers' textiles. They came on the market in 1961, and were advertised fairly widely, but fell foul of more competitively priced concrete materials. They were discontinued some years later, even though (according to Birks) they were successful and well liked where they were installed.

The design patents are apparently still held by the Keymer Tile Company, which has been manufacturing clay tiles since 1588. Writing in the 1980s, Birks is hopeful that the uptick in the cost of concrete might drive people back to clay and bring Coper's

tiles back to market, although it hasn't happened yet. Instead, I head to see the tiles Keymer is still making by traditional means, which pre-date Coper's designs by hundreds of years.

In the time since Keymer was founded in 1588, the factory has moved a few times, once because their clay pit was exhausted, and in 2015 because they were bought by a big Austrian company called Wienerberger. The new owners have largely left the business as it was, except for improving health and safety, so now the two businesses operate on one site in Surrey, using the same clay pit. Keymer makes tiles primarily by hand, Wienerberger mass-produces with modern technology, firing uniform building bricks in a football-pitch-sized hangar, in a kiln that is never switched off and runs the length of the building. I'm here to see the much smaller Keymer factory, to understand something of the way tiles have been handmade in the UK for the last 450 years.

At Keymer, tiles and bricks are made to heritage and traditional designs. There is a library of traditional brick moulds, and tile moulds so old nobody can date them. Most of the manufacturing processes are based on these simple wood and metal moulds, meaning that the company can often reverse-engineer any unusual bricks or tiles that can't be sourced elsewhere for heritage projects.

I'm shown around the factory by Keymer's manager, Alan Jupp. He walks me to the far end of the site to show me what looks like a muddy field and a fort-like mound of earth but is the clay from which everything here is made. All of it comes from their quarry, which lies behind the treeline and is 101 years old and roughly 55 metres deep. Once a year they 'win' the clay from the ground, and stockpile it nearer the factory in the open air, where it will start to break down. Then it is processed, milled

to break it down further, and mixed with a little water. It's not filtered for debris or bigger lumps at all. 'What we expect from the stockpile is a hundred per cent pure clay – what we're digging out of the earth has been there since time began,' explains Jupp, 'so except in a few rare instances, nothing has really been able to get into it.' Different colours of clay come from the quarry, but all of it – whether it's yellow, brown or blue – will fire to an orangey terracotta.

The clay is then processed into slabs, which are extruded (forced through a slab-shaped die) by a machine and coated in a little brick oil (which is now organic, but in previous centuries was made from linseed and diesel oil). This stops them sticking together when they're stacked on top of one another. After this, everything is done by hand until a tile goes in the kiln: stacking and unstacking, moulding, stamping, loading and unloading.

The slabs are stacked on trolleys and taken to one of the five workstations, which are metal booths with a hand-operated mould and a trough of rough sand. Jupp introduces me to Alex, who he says is not just the fastest but the best tile-maker they have, which seems to be an accepted fact by other workers we bump into on our tour. I watch Alex's movements: the rhythmic sequence of throws, slaps, stamps and shuffles before a finished tile is slid onto a tray. Each takes around eight seconds. 'That's slower than usual,' Jupp says, because these are the more architectural forms. The simpler ones take half that. 'All the tile-makers work at a different pace, and they all have their own techniques,' he explains. 'The way Alex slaps a tile is different to Jack over there – Jack is quite heavy-handed, Alex is a bit lighter. When you get trained up, you will be shown how to make the tile, and encouraged to watch the others and see how they do it, then you can develop your own method.'

Alex shows me how he makes a tile. First, the top slab is taken from a stack and coated with handfuls of sand. The mould is brought down onto a plate and the sanded slab slid into the frame. It is then slapped down with the palms, to make sure it's totally flat. The stamp is brought down hard, once. This imprints on what will be the rear of the tile, punching holes for the roofing nails and Keymer's logo, as well as a colour code, the maker's code and a Braille-like set of screwhead dinks that show the month and year the tile was made. Then the palm is slapped down again on the clay, leaving a clear handprint on the surface, which is not smoothed off. This takes me by surprise – it does not happen on most other tiles, says Jupp, but it marks each tile that comes from this part of the factory. It means that every single Keymer tile has the whorled fingerprints of its maker on the back.

Alex invites me to have a go. I sand the slab, slip it in the mould, slap it, stamp it, leave my handprint. When I slap my handprint on the clay, I am congratulated by Jupp and Alex on the force I deliver. Alex gives me a nail to sign my initials. It is fun: the mould and my hands make a percussive rhythm, but my hand smarts from the impact just making four, albeit with gusto. I look at Alex's hands, callused on the palms – more from handling the rougher tiles, he says, than making like this. I ask what I could improve on. No notes, he says – but he makes 2,200 tiles a day on an 11-hour shift with 2 half-hour breaks. I would just have to make 2,196 more today to be any good at this job. I think I might enjoy the rhythmic repetitions to begin with, but after a while, my energy might start to wane. I cannot fathom what it would be like to have over 10,000 tiles pass through my hands in a week.

Once formed, the tiles are sent to a drying room for sixty hours, then moved again into fireclay cassettes – open-sided

boxes that are stacked for the kiln. There's no more finishing, no smoothing of the edges. Any rough edges, called skirts, are left on – they will not be seen when they are laid anyway.

The kiln is roughly the size of a shipping container – and there are two of them. It is the biggest kiln I have ever seen, although Jupp says it is tiny compared to the ones next door in the brickworks. The tiles are fired to 1,050 degrees Celsius, but extremely slowly – three days up, then three days down. When wheeled from the kiln, each one is unpacked by hand, and every single one knocked against a ceramic block to check its sound – if it rings, it is good; any dullness means an impurity, an internal crack, and it goes into wastage.

The tiles Keymer makes are regional by design. While much regional specificity in construction has been overtaken by stand-ardisation in the last century, the tiles produced here can still be found on older buildings particularly in Kent and Surrey. The 'Kent peg' tile they make has square holes made specifically for the wooden nails that they are traditionally held in by.

The tiles are all the same, but are not quite uniform, just as a factory-produced mug will be uniform in a different way to a run of identical mugs made by a studio potter. They might weather, and a few might need replacing, but generally speaking you should be able to take these tiles off, rebuild a roof structure, then put them back on. 'A Keymer tile has to be easily laid, it's got to withstand the life of the building,' Jupp explains. 'Their water absorption and flex strength is phenomenal, but you will still get these little idiosyncrasies: different surfaces and curvatures of tiles as they dry and fire.'

Jupp jokes that he is a bore on holiday, looking at all the bricks and roof tiles instead of the scenery, but as I leave with a stack of their tiles, I see the appeal of this sanded red surface,

and I start doing the same. I drive away down Surrey country roads and stop for lunch to inspect the village roofs, wondering if they are each hiding a few thousand of Alex's handprints. The prints, the maker's mark and the date have made me see these tiles afresh – these are not just coverings, not just functional, but in the whorls of fingerprints on the back, the repeated form and the dance that makes them, I find more similarities between Keymer and the craft and art makers in this book than with the machines that the company shares its clays and site with.

Tiles can be made in moulds or presses; by rolling or slabbing clay. They can be cut to size with moulds, templates or cutters. Making batches of tiles presents a specific set of challenges, when you don't have a production line like Keymer. While a single tile can be made easily, making uniform tiles by hand requires skill and attention to detail. To make tiles is easy; to make a good tile is hard, because clay remembers, clay is malleable, clay moves, and, most of all, it often doesn't seem very happy about being in a neat geometric shape.

Most methods of making tiles involve some sort of stamp, mould or guide: a mould might be used to make a flat tile to be stamped in relief; a tile might be stamped then cut out with a guide. In different cultures and different time periods, there are different moulds, guides and templates. Some methods use a tool called a clay harp, where a large bow-type device made from bent wood and a wire is used to cut even slices from a large lump of clay. The girih tiles in zellij mosaics – stars and polygons that adorn mosques – are traditionally cut from pre-fired and scored tiles, before each is chiselled out using a sharpened hammer and bevelled on the reverse so that the coloured glazed front face shows a crisp edge, but they can be fixed with a dollop of mortar

on the back. Skilled craftspeople can cut 400 of these pieces a day – the smaller the piece, the more difficult it is to cut, and the more expensive a finished arrangement is.

The first known instance of massed tiling is from Uruk in Mesopotamia, where sun-baked mud and straw columns were tiled in red, black and white cone-shaped tiles. The cone bases were painted, then the pointed end was pushed into a wet layer of clay. Mosaics, on the other hand, are made of marble, glass, ceramic or stone (most Roman mosaics are made of naturally occurring coloured stones). It's possible to stumble upon them in cities all over the world – facades rendered brilliant by known and unknown artists; murals made by locals; tiling to keep a place locked to its history. I still remember a first encounter with a series of quietly astonishing mosaic panels of William Blake's artwork made by the London School of Mosaic, found under a dank bridge behind Waterloo railway station in London. The panels show some of his best known works: *Nebuchadnezzar* and *Songs of Experience* rendered in ceramic and glass and stone. Coming across them in the dark was like finding a pearl in an oyster – luminous and surprising.

On a trip to LA, I'd driven out on a pilgrimage to the Watts Towers, its webbed peaked spires an outsider architecture and folk art landmark in the deprived southern part of the city. It was built across three decades, beginning in the 1920s, by Sabato (also known as Simon) Rodia, an Italian construction worker. In photos you can't tell quite what it's made from, but up close, the metal and concrete structure is mosaicked messily in broken domestic wares: shards of blush-pink plates, imitation blue and white, broken green tiles with art nouveau designs, but also glass bottles, shells and other found objects.

Rodia made Watts Towers with his bare hands in his spare time, sourcing the shards of atomic-bright dinnerware from nearby factories. It aspires towards a permanence that the fragility of the rusting structure denies, but has echoes in Gaudí, who also used this method – called trencadís tiling – sourcing his tiles from a factory called La Rajoleta, the Pujol i Bausis factory in Catalonia.

I'd found the Watts Towers deeply moving – Rodia's structure has left an important social legacy in a deprived part of the city in the form of the Watts Towers Arts Center, built next to the landmark and opened in 1970. 'I wanted to do something big and I did,' he said. If Rodia was an ambitious architectural outlier, he remains part of the history of tiled exteriors, the apex of which can be found in medieval Arabic architecture.

From where I live, the most easily accessed and impressive example of the massed geometries and patterns of Islamic architecture is the Alhambra palace in Granada, Spain. It is considered a high point for the golden age at Al-Andalus (a kingdom that occupied the Iberian peninsula from the eighth century), where arts and sciences flourished. Building began in the thirteenth century under the first Nasrid emir, Muhammad Ibn al-Ahmar, and intensified into the fourteenth. Alhambra means 'the red fort', a reference to the iron-rich clay used for the original rammed earth walls. Inside and in its courtyards, its tessellated tiling is mostly in a limited palette: white and black; yellow, emerald and cornflower blue. I'd been twice, once with a French exchange family as a teenager, another time with a group of friends when the colours were competing with the bright russets and ambers of a Sierra Nevada autumn. I remember the cool quiet within its walls; the sharp lines of light

and shadow; the way decorated surfaces revealed their detail as you approached.

Tiled friezes in sacred Islamic architecture include ceramic calligraphy, and the walls of the Alhambra are covered with inscriptions that make the walls speak. The tiled geometric patterns are like its melodies and rhythms. In Syrian national poet Nizar Qabbani's 'Granada', he speaks of the decoration that he 'almost hears pulsing' in the Alhambra, as the call from the ornamented ceilings grows. Victor Hugo wrote that the palace was 'gilded like a dream' and 'filled with harmonies'. Massed tiles create an ecstatic music, but the possibilities gifted by their modularity and practicality extend far beyond these spaces into advanced geometry.

On a holiday to Uzbekistan, a Harvard scientist called Peter J. Lu became transfixed by the geometric tiling on a wall. In the US, he was a researcher in attractive colloids – looking at how specific types of mixtures acted in zero gravity. On his return home, he began picking through images of other tiled surfaces and saw something he recognised: a pattern that had a logic, was crystalline, but which didn't repeat.

The pattern is known as Penrose tiling, named after mathematician Roger Penrose, a Nobel Prize winner in physics for his research on the formation of black holes, but who also designed a mathematical tiling system that is aperiodic – meaning it does not repeat – and that has a fivefold (or pentagonal) symmetry (which is often associated with sacred and mystic beliefs). What Lu had noticed was that hundreds of years before Penrose 'designed' this pattern, it was in use by Islamic architects. He began looking deeper into other medieval Islamic art and architecture, and found tiling dated to the thirteenth century, then showed that

by the fifteenth, these complex tessellating tiles were being used to construct 'nearly perfect quasi-crystalline Penrose patterns, five centuries before their discovery in the West'.

Previously, girih tiles – networks of geometric stars and polygon shapes, often with strapwork (working lines left on shapes and incorporated into the design) – were thought to have been made by designers in far more arbitrary ways, by criss-crossing lines made with ruler and compass, and this more free-form nature of production was the reason the patterns did not repeat. Lu and his colleague, Paul J. Steinhardt, proved that these were in fact complex geometries that were designed and planned, then executed by labourers. Similar simple tile shapes are shown in the extraordinary Topkapi scroll from the late fifteenth or early sixteenth century, which is a catalogue of both early geometry and advanced interior decorating in medieval Islamic architecture, containing 114 geometric patterns for walls and ceilings.

Lu found that there had been a definite mathematical breakthrough in the twelfth century. He identified five types of girih tiles that allowed for complex decagonal (ten-sided) motifs: a regular decagon (a ten-sided shape where each corner has the same angle); a standard pentagon; a rhombus (a sloped square); an elongated hexagon with two long parallel sides; and a shape that Lu and Steinhardt describe as a 'bow tie'. Straplines drawn on them are 'girih lines', from the Persian word for knot. These lines create shapes inside the edges of each tile – a bow tie inside the rhombus, a star inside the pentagon – and provide the pattern's complexities. 'Each girih tile is decorated with lines and is sufficiently simple to be drawn using only mathematical tools documented in medieval Islamic sources,' their paper stated. 'By laying the tiles edge-to-edge, the decorating lines connect to form a continuous network across the entire tiling.'

These particular girih tiles opened up extraordinary possibilities for enormously complex patterns, most importantly, 'a nearly perfect quasi-crystalline Penrose pattern'. The only reason they're not perfect quasi crystals, Lu told the *New Scientist*, is because of human error – around eleven of the tiles were laid the wrong way round.

A similar case of installation error was recounted in an article on Penrose. 'My favourite anecdote is of Penrose inspecting a new tiling being laid out on the concourse of some university,' remembered the writer Philip Ball.

'Looking it over, he felt uneasy. Eventually he saw why: the builders, seeing an empty space at the edge of the tiling, had stuck a tile in a place which was neat but incorrect there that didn't respect the proper rules for their assembly. No one else would have noticed, but Penrose saw that what it meant was that "the tiling would go wrong somewhere in the middle of the lawn". Not that it was ever going to reach that far – but it was a flaw in that hypothetical continuation, that imaginary universe, and for a mathematician that wouldn't do. The tile had to go.'

Early Islamic tiling emerged around the eleventh century. A crucial early example is the Great Mosque of Herat, in Afghanistan, whose blue and white tiled arched facades seem too rich and decorative to be on the outside of a building. It's often said that figurative images are banned in Islamic art, hence the geometry and calligraphy, but this isn't quite true. Figurative ceramics – often people and animals – are abundant on domestic items. It is only on sacred and religious sites and structures that we find no images of God, people or animals. In Islamic religions, the word is the gift from God, whereas in Christian religions it is Jesus, the son, who is the gift, and the decoration of sacred spaces in these belief systems reflects this.

The massed geometries of Arabic architecture represent an apex of possibility for the ecstasy of pattern on and in architecture. As I zoom around photos online and pull library books with duplications of tiles, I first see the patterns, the awe, but I am still struggling to get my head around the geometry and the maths that is inherent to them. I can see something of the patterns online and in books even if I can't fully experience them, but I want to understand more about the geometry that the designers were working with; what the labourers made and assembled.

I take myself to see an artist-geometer I know called Leila Dear, who I hope can explain something of what is happening in these tiled facades. 'Are you familiar with Platonic solids?' is her first question. 'Familiar' would be a stretch, I say. We're in the bowels of Somerset House on the Strand in London, where Leila is a resident artist. She asks me what I want to know – what brings me to geometry? It takes me a while to formulate, but there is something I am grappling with, which is about what it means to take the amorphous thing that is clay and to make it into these highly geometric patterns that are mathematical, infinite and precise. I am interested in the imposition of order and form onto an otherwise unruly substance, one I associate with the organic, the messy and the irregular.

Leila studied with Keith Critchlow, a radical and influential Western geometer who was once commissioned to build a temple for the guru Sai Baba that involved the application of sacred geometry. While studying with Critchlow, she travelled to Iran, where half of her family is from and where she lived off and on as a child. There, she found her old colouring books – all of it was geometric tiling, she says; it's what they gave to kids in Iran. Studying with Critchlow, she became obsessed. Her final project

was a tiled fountain, with geometric designs based on the shapes made on Chladni figures (patterns created by sand when metal plates are vibrated by certain sonic resonances) and glazed in lapis, turquoise and white.

We sit down to draw with a compass and ruler. There are different schools of geometry that teach different ways to begin, but Leila tends to start with a circle. There's a spiritual significance to this – everything is one, whole, in the beginning. She walks me through a sequence of steps where we split the circle with a compass, connect interstices, use what we've drawn to find the measurement for the next step, until a rosette is revealed on the page – a circle turned into a flower that unfurled on the paper in front of me.

I expected this to be like doing engineering drawings – process and measurements – but it's a flow that leads to a page that blooms in shapes that weren't there before, every step representing a calculation done without any unit of measurement, just the circle we began with. I begin to understand something of the sacred, spiritual and ecstatic potential of this stuff.

There are only three regular tessellating shapes, she explains – triangles, squares and hexagons. Most tiling is based on the interplay of these basic shapes. The debates in this field of Islamic geometric design are largely about differences in schools of thought: about whether you begin from the circle and divide it, or use the polygonal method Arabic geometers would have been using in medieval times to create elaborate tiled, painted, carved surfaces and non-repeating patterns like the girih tiles Lu identified. A tessellating pattern can become infinite, revealing a layering of shapes, strapwork and infill.

Previously I had looked at these patterns as arrangements of shapes, but in drawing just a simple rosette, I was required to make

further shapes within the shapes – an effective layering through these working-out lines, through the strapwork: pentagon on pentagon; the creation of rectangles. I had executed calculations through a purely manual process: the realisation of mathematics into a real-world context. I think of myself as a words person, that I have come too far away from maths to get back. I can't even split a bill any more. But this opens something up.

When I go back to my books and photos of mosque tiling, I begin to see the shapes differently: I can find the pattern and understand something of what the strapwork is showing. I can understand why Leila – and others for thousands of years before her – has become snagged on the possibilities of creating like this, with nothing but a straight line and a compass. The geometry of the tiling on the Islamic architecture manifests fundamental facts *about* the world, and yet it contains little we recognise as being *of* the world.

Tiling at its most intellectual and ambitious is a handshake between mathematics and the craftsman, but tiles as material – whether custom-made or repurposed from the waste piles of broken pots – can be easily applied by almost anyone with a bucket of grout and a blank space to fill.

Inspired by Keymer's moulded tiles and Rodia's improvised mosaics, I design a project that is at the other end of the spectrum from the complexities, precision and significance of the shrines and mosques I've been looking at online. I decide to tile my shed.

It is a single-skin two-metre-square brick structure with a pitched roof. I design a tile that allows for variations on a set of rules: each will be made from a single rectangle combined with a raised circle. I allow that the circle can be used whole or split in half, and can be placed anywhere on the length of the tile. I measure the space, and work out that I'm going to need 150

tiles – which would take Alex half an hour or less, but will take me weeks. I choose grogged red clay, fired at the top end of its capacity so it turns from flowerpot orange to an autumnal red.

I have no mould, and I'm not chiselling out from fired clay. I'm going to cut my tiles from slabs rolled out on a slab roller – a device like a giant mangle – and then stick the discs onto the damp tiles with gluey slip. As I put the first batch in the kiln, I say a little prayer: I want them to have something of Coper's about them; for the raised discs to reference the fired cone mosaics that decorated Mesopotamian palaces. I want there to be pattern; I want to look out from the kitchen window and watch the sun cast geometric shadows on the wall. I want the brick surface to become a mural, an artwork, a surface with form, function and beauty.

In tiling, I find a form of clay work that is all about its capacity as a vehicle: for ideas, for worship, for value, symbols, design and handprints. The patterns in Islamic architecture have sometimes been discussed as being possessed of a sort of *horror vacui* – a fear of blank space – but encounters with massed tiling are often more about awe than fear. The Alhambra begs for both close and full-field viewing. It is not a single image that we are confronted with in these multitudinous surfaces, but the possibility of an infinite number of images. It is a sacred experience whether you're a believer or not – a metaphor for us within the world, for a creator and their creation; the possibility of being a small part of a much bigger whole.

All the same, there is something I struggle to articulate about these surfaces, made up of many pieces of clay. They represent the sacred but say something about the way the world actually is. Keith Critchlow connected geometry and being; said that the one

is required for the other: 'Right at the very beginning geometry had to be established for there to be being,' he said, pointing to the DNA helix and the structure of cells. 'Everything in our universe is based on geometry. The biggest tragedy of nature is that everything is revealed to us, but we cannot see it.'

I grew up with a Catholic image of a deity in the form of an old man who represented the divine, but the geometries of the sacred patterns that decorate entire buildings not only dwarf my body and intellect, but also manifest something real. It feels significant that this is so often made in clay: that the humble earth can transcend and speak to us like this. I find an echo of this in my discovery at Keymer: that each tile in the thousands it takes to roof a single building contains a handprint of its maker on the reverse.

In these tiles and their interlocking shapes – some small enough to fit in the palm of a hand and others covering the exteriors of monumental architecture – I find something of the world around me. But clay has much wider applications in the built environment than just these tiles, however ecstatic they can be, because supporting these tiled walls and roofs are entire structures. I had been looking at massed surfaces and flat geometries, but there is more to be understood about the possibilities for clay as material in which we live, worship, work and play.

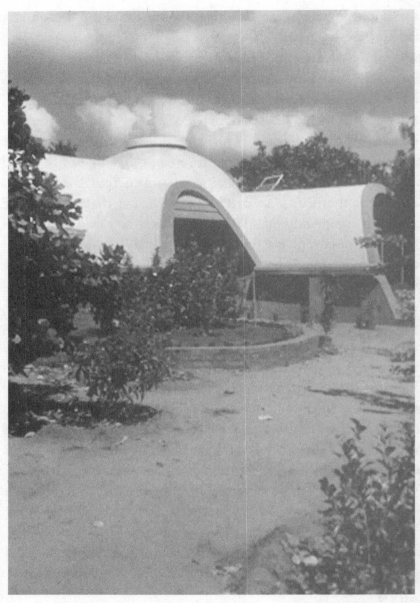
Ray Meeker's Agni Jata house (also known as the Mallika House). Built in 1988 and still standing, in Auroville, India.

11
Walls

On 24 January 1980, the night before the election of the first president of the Islamic Republic of Iran, an architect named Nader Khalili lit a fire inside a clay-built house in a small farming village outside Tehran. 'The torch is ready for a match,' he wrote, 'and the country is burning tense.'

The fire burned all night inside the empty house. By the morning, it had been fired. It was the first demonstration of what Khalili called his 'Geltaftan' ceramic house method, in which he fired houses built from clay from within. The name for the technique was a composite Persian word, derived from 'gel' meaning clay and 'taftan' meaning firing, baking or weaving. The words had been used for two thousand years in Persian, and Khalili hoped his houses would stand two thousand years into the future.

Nader Khalili was a radical architect who developed not just ways of constructing ceramic houses but also a method of forming domed structures from tubular bags filled with earth. He translated Rumi's poetry, was consulted by NASA for ideas on how to build on the moon, and dreamed, a lot. He grew up in Tehran and trained as an architect in America before returning to his home country to realise his vision of homes that were like

giant pieces of pottery. Later, he moved to California, a natural home for an idealist and a radical thinker like him, who in his writing often reasoned away problems as blessings in disguise. Once in California, his ideas became even more ambitious: he and a student made serious plans to halt coastal erosion on the West Coast by glazing and firing the cliffs themselves, using trash for fuel.

Khalili opposed the mass uptake of concrete and steel constructions in Iran when it was a country looking to modernise its architecture and building practices, instead dreaming of houses that reflected the colours at sunset. 'My ultimate goal,' he wrote in his memoir, *Racing Alone*, 'would be to fire the raw earth and make colourful rocks in the form of shells.' He wanted to 'build a house out of earth, then fire and bake it in place, fuse it like a giant hollow rock. The house becoming a kiln, or the kiln becoming a house. Then to glaze this house with fire to the beauty of a ceramic glazed vessel.'

He hoped to decorate the structures so they would be glazed and tiled, glittering upon the landscape:

> I used to imagine going to the desert where the beautiful sand dunes lay, and freezing them into a town, leaving every curve and edge made by the wind untouched . . . I used to imagine covering all the curved roofs with colourful glazed tiles. A colourful city with the shape of sand dunes in the midst of a grey and sandy desert.

Crucially, Khalili planned to build on foundations of sand – the rigid ceramic dome dwellings he designed would move, rather than cave in. He hoped to alleviate the heavy death tolls from homes collapsing when the ground shook in Iran's earth-

quake-prone regions. More than anything, he wanted to build low-impact, low-cost housing that would change the lives of the rural poor, so they would have earthquake-resistant housing made from material that was free, local and abundant.

After running his own architecture practice specialising in high-rises, he returned to Iran on a personal quest, motorbiking round the countryside to villages too small and isolated to have their names mapped beyond their government-designated lot numbers. He and a young assistant began by building walls in the desert. They failed time after time: walls fell down; were trampled by animals. He persisted, chasing institutional support that was promised but never materialised, but then in 1978 he was galvanised to continue by a 7.4 magnitude earthquake in the central Iranian city of Tabas, where he saw steel and concrete houses reduced to rubble in the urban zones, and raw clay houses that had crumbled in the city's rural outskirts.

Getting nowhere on his quest to fire a house on a sand foundation, and feeling despondent, he describes a revelation he had encountering an old kiln by the side of the road – built from clay bricks, it was itself fired by all the firings it had held. This kiln had survived longer than any other structure in the area – had even survived earthquakes – and he realised that he need not look for a new idea. The route to his fired houses was right in front of him. Basing a technique around the idea of a clay kiln also meant that, in theory, a pre-existing clay house could be fired and could also be filled with bricks and other ceramics that would be sold afterwards, effectively covering the cost of its own creation. He stopped off at a kiln to shadow one of the labourers who was firing bricks. 'I explain to him what I am going to do,' he writes. 'I am going to bake houses the way you are baking this kiln.'

CLAY

*

The first house Khalili bakes is in Ghaleh Mofid, a poor village twenty-six kilometres outside of Tehran, on the night of the election. The houses are made from mud, but there are no resources to maintain them, so in heavy rain they often cave in, occasionally killing people as they sleep. In bad weather, people are afraid to sleep inside.

The night of the firing, Khalili describes how:

There are two oil barrels sitting over a tall base on the roof of Mash Safar's house in Ghaleh Mofid village, ready to be filled and flow to the two torches sitting cold under the next door house. The two room house is all walled in like a kiln and is ready to be set on fire. Inside the room several hundred adobe are sitting around the torches to become brick. We will bake the room and the bricks; children have even made small statues and pots and left them in the room.

They light the torches at 10.30 am, and a woman rushes in with esfand (wild rue) seeds 'to blind the evil eyes and give us success'. The torches settle into a steady roar that can be heard all over the village. Fairly early in the firing, the mice and other pests flee the house, the villagers chasing them out with brooms and spades. Later, the roof gets hot enough to cook a pot of potatoes, as steam rises from the building.

They shut the torches down at 3.30 am after seventeen hours of firing. Peering into the peephole, Khalili sees:

one of the most beautiful sights I have ever seen in my life: the dying of a high-fired space. Since the torches are off, there is no fuel and there is no fire, but the room is itself emitting

204

fire. The walls seem to be shooting fireballs at each other. A fired room doesn't die all at once; it plays a lot before its death. The whole room after a while starts glowing in deep red colour, then adobe blocks of the walls and the ceiling become amber colour, while the mortar lines between them change to pure gold nugget.

After the firing, the house is left to cool for a few days. Khalili and his kiln master Ali Aga – an expert in managing the fire that sets the house – leave for two days until it is safe to open up. On their return, the house is already open, the walls are chipped, the hand-moulded clothes hooks are snapped from their places on the walls, and rubbish is spread across the floor. Khalili is devastated by the villagers' disrespect, but a farmer, afraid of what their reaction might be, explains that as soon as it was cool enough, the locals were impatient to know if it had worked. They had barged in, chipping at the walls to test their strength, while the children snapped off the coat pegs as souvenirs to show their teachers. Once it was clear that firing had worked, some of the villagers slept under the fired roof – none had wanted to sleep under their own unfired roofs in the heavy rain that had fallen.

At this explanation, Ali Aga and Khalili erupt in happy laughter. 'My anger and worried feelings change into joy and fill the room with a roar of laughter,' he wrote. 'The answer to our work as far as it's being a success or not is already here, before we even ask it: they have tested, accepted, and dwelled in it before we have even permitted them to do so.'

Afterwards, every family in the village wants to be next to have their house fired; a farmer even wants his cowshed fired, in the hope that it'll clear a persistent infection in his animals, as the pests

being driven from the structure made them realise that the fire also effectively cleansed the structure.

The second house is glazed on the inside. They spray a yellow base using sprayers that the village's farmers use for pesticides. A turquoise blue and a purple are used to write on the interior walls. They write in Arabic, lines from Persian poems and the Qur'an, including the line about humans being created from clay. The villagers then add their own names. Children commit their clumsy handwriting to the walls; one girl who has just learned to write paints the names of her mother and sisters who cannot, and her mother asks her to add their father's name, who died some years before. When they set the fire, nobody knows what will happen. Will the colours come out? Will the glaze crawl or pucker? Will it shrink around the walls and damage the form?

When Khalili again peers into the house towards the end of the firing, he is ecstatic:

The word WATER is shimmering on the wall, it looks as if it is melting. The words EARTH, AIR and FIRE too are shining and emitting light. The picture of the dome and the vault and the word Geltaftan stand out with dark and spangling outlines. I have a glimpse of eternal beauty. I kneel on the roof as if in front of an altar, looking through the vast horizon under a full moon, then gazing through the roof into the room and devouring with my eyes all that I can behold. My dreams have come true. My dreams have come true.

Twelve more houses in the village were fired; nine by the villagers themselves. Reading Khalili's memoirs of this time, you are swept up in his quest, as he writes poetically of his ambitions. It is a story of community doubt converted to faith; of people coming

together to make a home that will last indefinitely, the walls carrying their prayers and the names of their deceased. It is not so much a home as a shrine that he fires.

I don't know whether those first houses still stand – I cannot be sure I have found Ghaleh Mofid on a map. There is just an old, blurry photo, shot in low light, that shows a streak of an Arabic character on a fuzzy wall.

Khalili was well aware that he was doing nothing new; that his dream of ceramic housing was rooted in a tradition of kiln building that had been employed all around the world. Others had thought to live in these spaces too. In 1990, the *LA Times* covered a disagreement between the authorities and a Vietnam veteran and Rastafarian convert called Joseph Diliberti, who had found solace in living off grid in a fired dome house he had built from the clay on his land and fired for thirty-six hours (it has since been demolished). The same article also outlined Khalili's system, but in a letter responding to the article, Jean-Louis Bourgeois (son of the artist Louise Bourgeois, who also wrote a book on mudbrick architecture and is a specialist in adobe and mud building) outlined the limitations of the technique.

Bourgeois points out a number of problems with Khalili's system. Firstly, the firing will only affect the inside of the house, so the outside will still need regular repairing or resurfacing. If firing pre-existing buildings, there are risks concerning other materials that might have been used to build internal structures: just like my raw clay from Chapter 1, if mud walls contain rocks or other debris, they may crack and explode under a firing. Wooden beams within the structure may also burn out, collapsing the house.

The final issue, which is more pressing now than it was in 1990, is the cost of the fuel, and the fumes pumped out by such a lengthy

firing if rolled out on any sort of scale. Bourgeois writes that this is an insurmountable hurdle, for while the materials and the labour might be reduced to almost nothing, even when building from scratch, the fuel needed to sustain the duration of the firing (Khalili uses kerosene) is wildly unaffordable for the rural poor.

Much later in my research, I discovered by chance that my friend Jane – the gardener who gave me her take on clay for Chapter 1 – was working with earth-building specialist Paulina Wojciechowska, who had trained with Nader Khalili. I email to ask her what he was like.

Paulina spent time at CalEarth, the institute that Khalili and his partner, Iliona, set up in 1995. She stayed on site alone for three months, building her own earthbag structure. 'Nader used to watch me build and told me that the dome I was building was the holiest dome,' she writes. She remembers him as a storyteller, 'someone who was very passionate about simplicity and earth', who was charismatic and would 'put people in a trance listening to his optimism on how you can just build with earth . . . any earth . . . even on the moon'.

She also found him egotistical, and reminds me that he was just one half of a team at CalEarth with his wife, who had studied at the Architectural Association School and was the daughter of the architect John Outram. 'His ego was very big . . . like most who work relentlessly to get known . . . Maybe that was the shadow side,' she writes. 'Or maybe it was necessary for him to create the centre.'

I am entranced by Khalili's idea of living inside a kiln or a terracotta pot – I imagine it as smelling like baked earth in the summer when the sun hits the outside walls, and of petrichor drifting through its rooms in rainy seasons. There is something

radical, daring, impossible about firing a whole house – we think of pots as being big, maybe big enough for a human to fit inside, but not big enough for us to live inside. It's a scale that undermines our assumptions about what we can do with clay, lending a magic to the possibilities of living. The added benefits – that firing a house would rid it of pests; that you could glaze the walls; that you could fashion handmade sinks, seats, tables from the fabric of the house itself – make it incandescent with possibility.

The Casa Terracotta in the mountains outside Bogotá claims to be the largest fired house in the world, although having visited the site, it's unclear whether it actually is fired or not (the challenges of modular firing and the presence of electrics pose questions nobody from the house would answer). Whatever the case, the imaginative and design possibilities of handmade clay architecture are also offered by unfired clay. Clay in its raw form has been used to build floors, roofs and walls since the earliest civilisations – you just have to have a strategy for dealing with the rain, or have very little of it. The largest extant mud building is the iconic Great Mosque of Djenné in Mali, whose mud facade and minarets are dotted with wooden pegs that not only are structurally and aesthetically striking, but also act as long-term scaffolding for the regular repairs and maintenance it requires.

In some periods, clay was a material that spoke of privilege and power. Istakhrī, a tenth-century writer and traveller in the eastern Islamic world, wrote of a region called Khazar and its capital Itil (or Atil) which was on the Silk Road near the Caspian Sea. There, clay was treated as a superior building material. He described how most dwellings were felt tents, except the king's, whose palace was the only building permitted to be made from baked brick.

Clay was not just a foundational building material for tenth-century Atil, but remains in use today, often chosen by architects looking for sustainable building methods. Sri Lankan modernist architect Minette de Silva hired artisans to fire clay tiles based on ancient designs for her first house, the Karunaratne House (the first to be designed by a woman in Sri Lanka). More recently, architect Francis Kéré, who runs a practice between Burkina Faso and Germany, often uses clay due to its ability to regulate temperature and provide cool spaces, making it a focal point of some of his designs in Gando, Burkina Faso. He is doing some of what Khalili imagined: using locally sourced clay and labour, keeping costs low and providing employment. The colour of the local clay and the landscape are incorporated into his designs, and so his buildings – which often have a community or social function – operate as *part* of a place and a reflection of it, rather than being an intrusion into it.

Thinking beyond buildings to bricks opens up another wide-reaching history within architecture. The Tower of Babel in the Book of Genesis was made from brick and burned thoroughly. The Great Wall of China also has sections made of clay bricks, which were fired in kilns dotted along its lengths that have only recently been discovered. Bricks were fired for the building and repair of the structure, fixed in place using various types of mortar, one of which was made from sticky rice and lime, and was so effective that weeds still do not grow in the cracks.

The Ziggurat of Eanna at Uruk, constructed roughly 4,200 years ago, uses a combination of sun-dried and fired clay bricks. When historian Dan Cruickshank visited the site, he found that while most of the kiln-fired bricks had been taken years before, the sun-dried bricks had remained and survived. The few kiln-fired

bricks he does find are still remarkably sound, some imprinted with the names of Mesopotamian kings, and mentioned in Gilgamesh. 'Gilgamesh realised that his name stamped on hard bricks "where the names of famous men are written" meant that his creations and his memory would last forever,' Cruickshank writes. 'The kiln-dried brick was the passport to immortality, a guarantee that your creations – and your name – would live forever.'

Ray Meeker is a potter in Puducherry, India, who also fired a series of ceramic structures from the 1980s onwards, in more technical, and possibly more successful, iterations than Khalili. Meeker studied architecture for a few years at college in America, but ended up graduating in ceramics, leaving him 'eminently qualified to do absolutely nothing', he tells me. He had met his partner, the ceramicist Deborah Smith, in the pottery department. She got a job in Japan, translating for the potter Susan Peterson who was writing her book on Shōji Hamada, and from there went straight to India. Ray took the overland route to meet her, arriving a few months behind her, in early 1971. The ashram they joined wanted a pottery set up, and Smith agreed to start one, so long as Meeker could come on board to build the kiln.

A few years later, in the mid seventies, a woman in nearby Auroville got hold of Khalili's memoir, *Racing Alone*. Her boyfriend, an English ceramicist, glommed on to the idea of fired houses and joined with a student of Meeker's to begin building a small structure. It was finished but never fired. The project was delayed by a family bereavement, and destroyed during monsoon season. But Meeker picked up the idea and ran with it. 'I saw what they were doing and thought, well heck, I'm going to do that,' he says.

Auroville – an experimental city designed around sacred geometry in Tamil Nadu, on the far south-eastern edge of India

– became the site for many of Meeker's builds. Designed as a utopian 'perfect city', it has since become a centre for visionary architecture and alternative ways of living – including specialising in earth architecture.

On a trip back to the states, he and Smith attended one of the CalEarth workshops, but Meeker already knew how to build kilns and did not find the course particularly enlightening. 'I told Nader: I'm just going to go and do this,' he says. They were joined in India by a couple of Dutch potters, one of whom was the ceramicist Jan de Rooden. 'He was a bundle of nervous energy,' says Meeker. 'I remember thinking, God, how am I going to take care of this guy? I know – I'll start firing houses!' He laughs. 'So that's what we did.'

Meeker wrote de Rooden a grant proposal for the Dutch government, so he could go to Egypt to learn from architect Hassan Fathy about the construction of Nubian vaults. Then they built and fired an experimental structure, which would be the first of nineteen fired buildings Meeker worked on. In the 1980s, a couple from Auroville called Dhruv and Mallika asked him to build them a house made of earth. 'I said, I'll build you a mud house, but if I'm doing it I'm also going to fire it.'

That house was the first Meeker made for someone else, and the first that was explicitly designed to be lived in. It was called Agni Jata, which means 'fire-born' in Sanskrit (although is more often referred to as the Mallika House), and it was centred around an impressive five-metre-high dome, with four vaults leading off it, each three metres wide. The total floor space was around eighty square metres. 'There was plenty of room to walk around,' he says. 'There was a high vault and a sleeping loft. A five-metre dome – that's a lot of air in there . . . As a house it's not that big, but as a kiln it is huge and that affects the firing: you don't want to blow anything up.'

Meeker effectively constructed a giant kiln, which would sta-
bilise the mud structure, making it water resistant, if not totally
waterproof. The domes and roof vaults were only six inches thick,
so these were fired all the way through, helped by a combustible
layer added to the outside, which began as insulation to stop heat
escaping and then, once temperatures reached 600 degrees or so,
would burn. 'The vaults and domes are really well fired through,'
he explains, but he says that because the walls had to be thicker,
he took to building an exterior fired brick skin over an unfired
brick interior skin. He was not planning to reach temperatures
required for most glazing, and as such, the walls remained porous,
designed to be plastered or coated after the fact.

He and a team of labourers wood-fired the Mallika house to
980 degrees. It took three days, for much of which Meeker didn't
sleep, constantly monitoring pyrometers, dome vents and fires.
When the firing was over, the house was sealed, and left to cool
for another three days.

The structure also doubled up as a literal kiln, where, as Khalili
had also planned, clay products were fired inside the vaults to be
sold to offset the cost of firing. 'It doesn't ever quite work like that
though,' Meeker laughs. 'Part of the problem is that you're not
firing the product, you're firing the house, so while the products
are always really well fired, it's also a pretty inefficient kiln.'

Doing this also impacted enormously on how long the project
took. Meeker spent four weeks effectively single-handedly loading
the structure with 60,000 bricks and floor tiles intended for the
house, as well as toilet pans and other pottery.

Following the Mallika house, Meeker worked on a number of
further projects, most of which were intended to improve the kiln's
efficiency and lower the cost even further. He would aim to get

started in February and finish before the bad weather kicked in again in October. He completed two projects focusing on low-cost housing; watchmen's houses for a factory complex; a small administrative structure, a pottery and three private houses; as well as a large project building a group of four family homes, five apartments, a laboratory and an office for a subsidiary of the Indian Tobacco Company. Much later, he also designed a temple for dancer Protima Gauri's dance village, Nrityagram, which is still being used today.

Most people were happy with the houses, he says. 'There are some problems with them. You have to maintain them like anything else – you really have to keep your eye on leaks – but I think Mallika lived in her house for twenty years.'

With his fired housing projects two decades behind him, he says he feels he did prove the idea was viable, across a range of low-cost, corporate and individual builds. 'I didn't want to do it for the rest of my life,' he says when I ask why he stopped. He also realised he had developed the technique to the point that it required an understanding of how all the parts needed to work together – he was part architect, part mud builder, part kiln master, and part project manager. 'I'd shown it could be done, and I was perfectly happy to help anyone who wanted to take it up.'

Nobody did, except one Auroville architect called Anupama Kundoo, briefly. She worked with him and wrote a PhD on his work, but ultimately had a broader set of methods and materials she wanted to apply in her practice. I ask Ray what he thinks drew him to firing houses in the first place. 'It was something different, I guess,' he says. 'I can't throw cups and bowls all day.'

In houses across Europe and the UK, clay is often present from the tip of the house to its foundations. It will be in the chimney pots and roof tiles; in bricks, bathrooms and kitchens. It may be what some

of the pipes are made of, if the house is old enough, and depending on where it is built, the foundations may be sunk in clay soil.

Khalili and Meeker's fired houses, however, are singular visions and remained maverick one-offs: kilns for living in, in India and Iran. The image I kept coming back to was Khalili's impossible one: of the roofs of houses glittering like polychromatic shells in the desert sun. I live in a house made of brick, but what if that brick was not uniform, not grogged and shaped into blocks and fired, but clay that had been moulded in undulating curves; arches and openings across the landscape – what could life be like under a roof like that?

While Khalili wanted there to be more fired houses, ultimately it has remained the province of wild ambition and artist-architects striving for a radically new way to live. Meeker was more successful in proving the concept, and many of his structures still stand. However, talking to him tempered the enthusiasm I had been swept up in when reading Khalili's memoir. It was clear why these ways of building had not caught on.

Both Khalili and Meeker built houses out of clay and fired them, and in doing so they ignited the possibilities of individual ceramic buildings, and also found their limitations. Meeker had talked in passing about how one of the key considerations was to have good brick clay on site, which was key to the economic viability of a project, as importing clay made costs rocket. He had found that while there is earth under our feet, it's not always the right kind of earth to make a house with. I realised that in this, I was being drawn back to the mud I had started from, and that I needed to think about clay not just as a literal building material, but the material around which communities are built as well. What does it mean for the fabric of a place if it has not just been built *with* clay, but also around the industry of clay?

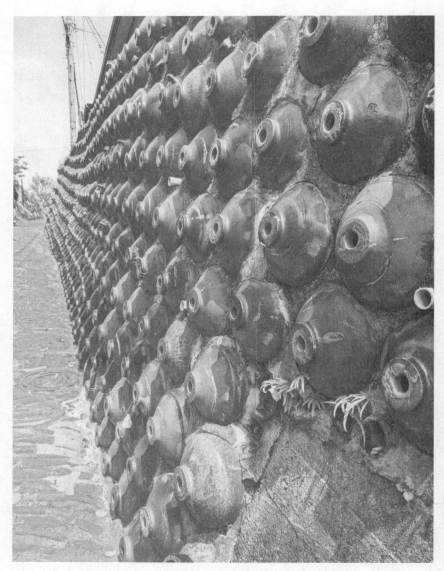

Tokoname pottery path, Japan.

12
Cities

After talking to Ray Meeker, I want to know not just about clay architecture, but about clay cities and towns. I want to know what it means, what it looks like, and how it affects and influences a place when it is built on and around clay.

Most countries have a pottery town or city – regional centres where there are specialists and knowledge, or a distinctive style or technique: blue and white tin and cobalt ware from Delft; turquoise tiles from Isfahan; tin-glazed faience from Faenza in Italy. Khurja in Uttar Pradesh is one of the oldest and most prolific sites for glazed pottery in India. Ráquira is sometimes called 'the pottery capital of Colombia', for its terracotta production.

I spent an afternoon in Ráquira in late 2022. It is a few hours' drive outside Bogotá, in a region dotted with pottery towns, all known for making terracottas. Nowadays, it is mostly a tourist town – the streets leading off the main square are stacked with its mould-made pottery, which is mostly low-fired and painted in crude paintbox-bright enamels. Some shops have small amounts of Colombia's more traditional black pottery, but the shops were largely selling wares I associated more with garden centres: figurines and odd ornaments; Disney and Marvel characters painted and varnished; plantpots small enough for seedlings or

big enough for trees. It's not what I had expected – these were wholly modern forms, often replicas of cartoon characters from global TV franchises.

In a walk around the edge of town, I saw stacks of moulds, kilns firing, open workshops with corrugated roofs and rows upon rows of characters waiting to be fired before being painted in enamel and sent down into the tourist shops. This was a form of mass production, but in a similar way to Keymer, and was far from a mechanised factory production line. I was struck by how little there seemed to be about heritage in Ráquira despite its rich history, but I realised I had arrived with expectations around what 'tradition' looked like. I had expected to find something that had not changed in generations, probably in a palette of muted natural tones, with traditional designs painted or carved by hand. This latter at least is true – I see one shopkeeper painting fired pottery at a cash desk.

I had found these multiples of Disney and plasticky enamelled painted pottery disappointing. But more than 80 per cent of the inhabitants of Ráquira make a living from pottery, and if pottery is the main source of income for most people, it is not so much about tradition as about maintaining livelihoods. My taste has little to do with what makes this town successful, or a destination for tourists, and more to do with my own personal dislike of a coquettish Homer Simpson figurine, cast from a terracotta mould and staring up at me from the shelves. When pottery is a business, it often changes and evolves.

Japan's oldest pottery towns are known as the Nihon Rokkoyo – the Six Ancient Kilns. They are Bizen, Tamba, Shigaraki, Echizen, Seto and Tokoname. The grouping and naming of them was effectively a post-war invention, to acknowledge important

sites for production in a country where pottery had been made more or less continuously since medieval times. It was a term coined by ceramics scholar Koyama Fujio around 1948, although sites were only formally recognised as official heritage sites in 2017. All the Six Ancient Kilns are in hilly areas, with abundant sources of clay and fuel for firing. Tokoname is the easiest to access, and is thought to be one of the oldest, if not the oldest, with pottery being made there since the eleventh century. An eighteenth-century Owari samurai named Naitō Tōho wrote that 'The four Tokoname villages have produced pottery since ancient times. It is the first location to have done so.'

I caught the Shinkansen from Osaka and changed trains for a line that runs from Nagoya to the Central Japan Airport. Tokoname is near Ise harbour – and now the airport. It has always been well placed for export, and even early pots made there can be found across the country. Much of the town is elevated, its steep pathways built from, paved in and walled with pots, saggars, pipes, bottles and tiles. It once produced a huge amount of industrial ceramics – piping and drains – rolled out as part of Japan's modernisation.

Like Ráquira, Tokoname has also transitioned largely into a tourist destination to buy and browse pottery from individual makers, and to take photos in the pottery-lined streets. The tourist office gives out maps to show the route along the 'pottery path', which itself is built from the materials the town produced – jars and vessels stacked on their sides and filled to make a steep walled footpath. Koji Takahashi, a former Muji product designer and director of a heritage project around Japan's ancient kilns, moved there to work on the project. In a report produced to promote the sites, he writes about living in an old rented house in the area, where 'the window next to the bath opens up to a wall of

giant clay pipe piled onto each other . . . Defective clay pipes and shochu (Japanese liquor) jars have been put into use in public works projects. There is an abundance of clay pipes within the town, to the point they are seen used as grave posts.'

When I visit, the small houses and steep, tight streets remind me of a Cornish fishing village. The exterior walls are patched in colours like the clays that are used – there are blacks and rust reds, a corrugated-iron rectangle gone ochre yellow, next to wood panels splashed loosely with pale grey paint. Walking from the station takes you past the precipitous cast-concrete walls of Maneki Neko – a street named for the ceramic cat reliefs that decorate the walls. I wonder if the height comes from a thousand years of rejects, a ceramic midden made destination. I wonder what it would be like to stand on the highest street and dig down, to take a core sample like a scientist takes from glaciers. What would be underneath? What pots, what kilns, what lost work, what rejects?

Most potters in Tokoname are now studio potters making tableware: sake cups and bottles, bowls and platters, and often the exquisitely made teapots that the region is known for. There is no set style or form: I even see a run of fish tanks in one particularly experimental maker's store. The first shop I visit has a cash desk, wheels in the corners, and shards of broken pottery for a floor instead of gravel. The step up into the wooden structure suggests they may be a foot deep or more. This roughness underfoot contrasts with the delicate teapots on display.

In one shop, I pick up two white bowls for soup, which have orange flashing that suggests they were touched by flame. I wait to pay, hovering on the edge of a sectioned-off workspace until the potter lifts his head from a focused task smoothing over

delicate edges of some small handleless teacups in dyed porcelain. I have learned the words for electric, for wood and for kiln, and I ask, roughly, if these white bowls are wood-fired. Yes, he says. I ask where. Ten minutes away, he says, by car – doing the hand gesture for steering wheel. He built the kiln himself, it took him a year, and when he fires it, it takes three days. It's not a community kiln, it's just for his work, which means he either has help or stays up for seventy-two hours straight. It looks big. He brings up a video on his phone of the brick chimney, with flame spewing from the mouth like a caged dragon licking the sky.

Another place has half a shop of electric-kiln-fired ware while the other half is wood-fired. In yet another, red teacups are slipped in black, so only a fine red line shows through on a sharp rim. They are tiny, more like big thimbles than small cups, and will hold just a sip of tea. Elsewhere there are goblets, dipping bowls, a bowl with a Miffy face planted up with two cacti for her ears, and endless chawan. There is a shop full of hand-sculpted animals; a shop where there are smooth redware teapots in an upstairs gallery. I pick one gently from the shelf. It is buffed to a high shine and small enough to sit neatly in my palm. It feels no heavier than a sheet of paper in the hand. The decoration is limited to just the tiny pinch marks around the handle and spout that have been left visible from where they were connected. Stores here also hold taster sessions for people wanting to try their hand at throwing. I walk in on two parents watching teenage siblings at the wheel. The boy, maybe fourteen, can't even get a saucer going and is poking at a wobbling disc of clay. The girl, his younger sister, has made two large bowls already.

Things seem priced not necessarily for their function or size. The expensive items are often those where something happened that cannot be repeated, or which take longer to execute. The

chawan with the surface that was not intended is more expensive than the plain, if the effect is particularly pleasing. A vessel might have been stained by smoke, bubbled, rippled or pinholed. A thick sake cup, monstrous and fungal in the hand like a meteorite coated in curdled yoghurt, with pink flashes pushing through the cracked mush, is double the price of a smooth black clay cup in a mottled green glaze by the same maker. The fungal monster is unreproducible, the green glaze and black clay cup can be made again, more or less.

Scholar Yoshiharu Sawada writes that vessels from old Tokoname are some of the first to be identified by their locality – as pots that bear the name of the place they were made in their form. At Tokoname, they were closely linked to the Buddhist institutions on and around Mount Hiei, where locally made jars were used as sutra containers. This meant they had to be a particular shape to hold the scrolls encased in bronze canisters and placed in the pots, which were then lidded with a large shallow bowl. Earth was then mounded on top to create sutra mounds. Some also have marks or seals. These pots were high-fired, a practice that comes from the Buddhist idea of purification by fire, and their shape, too, was derived from Buddhist concepts: 'the sharp edge of the lip, the powerful swell of the body' have 'a naturalness . . . in the way the hidden vitality . . . comes naturally but inescapably to the surface', writes Sawada.

Early glazing was in wood ash glazes that ran in watery green rivulets down the shoulders and around the neck of the pots. Sawada gives a striking description, glorifying them as being like the idealised male bodies of warriors. They have 'a masculine strength in their magnificently swelling shoulders, powerful lips and rugged clay surfaces', he writes. 'Particularly with the

occurrence of a flow of a natural ash glaze from the shoulder, these old Tokoname works truly possess the very essence of the Kamakura warrior.'

Production and prosperity accelerated in Tokoname in the nineteenth century, when the town began to mass-produce mould-made construction materials needed for Japan's modernisation: pipes, drains and other bits of infrastructure to move water and waste in and out of the cities that were being expanded. Before this, ceramics was a secondary job for farmers, who fired in a common kiln. Work by the whole community was fired together, and profits were divided depended on how much you put in the kiln.

The pottery path is still dotted with kilns, some roofless ruins, one larger kiln maintained as a museum piece, where you can stand inside and inspect the now empty arches and watch a video about the town. It feels somewhat funereal, with a slideshow of feel-good images from the tourist board, alongside elegiac piano music. Sawada writes about how, having counted 1,016 visible kilns, many of them in clusters of 40 or more, he found that in old Tokoname they were also placed based on astrological and directional divination.

The old climbing kiln, Tōei-yō, was built in 1887. It is twenty-two metres long with eight chambers. There were sixty of these in Tokoname at one point, but this one is now preserved as a monument within the town. I climb the steps around the outside, with warnings of mosquitoes among the wildflowers and weeds. I poke my head through an opening, into the covered arches outside each of the firing chambers. The smell is still like baked earth; heavy dust rises to my nostrils from under the corrugated roof.

The town's history is everywhere: messy and dusty, adjusted

for tourists and shoppers but still working, still functioning as a pottery town. I come across one storeroom-type shop, heaving with pots. Two small rooms are crowded with work, the walls flanked by large jars. On the next chicane of the path, above the two storefronts, is a warehouse with row upon row of work stacked up the walls and on boards, inside and outside. It's many kilns' worth of work, all wood-fired, all touched by smoke and ash, with red blushes and black clouds, patches of charcoaled and bare skin, and all looking like the same potter's work. I shout into the gloom – but nobody is here.

Heading back towards the station, the pottery path climbs before it sweeps you back down the hill. From these vantage points along the highest paths, the view of the town is dotted with the evidence of its industry and output. It is a landscape populated by old kiln chimneys – towers of square brick that stand sentinel across the landscape, some overtaken by vines, some crumbling. One has a tree sprouting from the top like smoke, the new growth on the old showing stark across the blue sky, like a visual metaphor for the decline and regeneration that has happened here, as the independent artist potters flourished in the transition away from industry and towards craft and tourism.

In Stoke-on-Trent, there is similar evidence of the pottery industry imprinted on the skyline in its iconic bottle kilns. But the pottery industry also built the place in more literal ways, with roads actually constructed with wasters from the kiln. There is some circularity to this use of clay in the Potteries: in earlier periods potters were said to have dug clay from the roads so as not to impact farmland, which some sources claim as the root of the term 'pot holes'.

Tokoname's industrial output receded to make way for the rustic pathways around independent studios making pots by hand in old timber buildings, but Stoke has not experienced the same craft-centred revival yet. Its industrialisation was sometimes described as a vision of hell, where bottle kilns literally spewed fire into the night sky. George Orwell thought Hanley and Burslem 'the most dreadful places I have seen', and could find nothing to redeem the 'tiny blackened houses'. In his diary while on the road to Wigan, he described the bottle kilns 'like gigantic Burgundy bottles buried in the soil and belching their smoke almost in your face'. J.B. Priestley hated the region too. In his *English Journey* from 1934, he describes it as 'extremely ugly', and finds the buildings and the people embarrassingly small and runt-like. 'It resembles no other industrial area I know,' he wrote, and was 'at once repelled and fascinated by its odd appearance'. He finds it 'mean' and 'dingy' and writes of how 'the small towns straggle and sprawl in their shabby undress . . . they are neither old and charming nor bright and new, but give the impression of having been hastily put up like frontier posts or mining camps and then left to be sooted over'. He finds the distinctive bottle kilns an eyesore, calling them a 'monstrous Oriental intrusion upon an English industrial area', despite the fact there was nothing Oriental about them. 'That anything even vaguely decorative should come from these places seems a miracle,' he wrote.

Wedgwood biographer Tristram Hunt writes of how Arnold Bennett, the de facto Potteries novelist and omelette namesake, was frustrated that nobody cared or was romantic about the Potteries and its history. Nobody 'takes a conscious pride in the antiquity of the potter's craft nor in its unique and intimate relation to human life', he writes in *Anna of the Five Towns*,

although in other accounts Stoke was regularly denigrated for its landscape. 'Unless you are prepared to take a deep and lasting interest in what happens inside those ovens,' Priestley wrote, 'it would be better for you to take the first train anywhere.'

When I asked around, I found multiple friends who had family – in some cases entire branches – who worked or had worked in the Potteries. My friend Andy's grandad was a bander – meaning it was his job to paint the banded lines on crockery. He lends me a very old book about the Potteries he found in his father's attic, written in 1907 by a journalist for the local paper, *The Sentinel*. In it, there are descriptions of how the pottery industry had formed the place in literal ways similar to Tokoname: a cottage garden in Sneyd Green had boundary walls built from saggars, many of them dated to a time when salt glazing was common, and the same can be seen in Burslem. One street was once a 'shord ruck' – a pottery waste ground for dumping wasters and broken moulds – and it is written that Longton, Fenton, Hanley and Tunstall's clays and coals have been excavated so much it is suspected their centres are undermined. In one recollection, the writer also describes the types of pottery businesses that preceded the factories, laying out a single bucolic scene of a potter at work in the 'old way' in 1856: 'Here might be seen on fine days, in the open, the thrower seated at his work with his attendants . . . On sunny days, as occasion might require, the wheel and its box were placed on the [river]bank and the operatives went on with their work in the open.'

Like the kilns in Japan, the Potteries were not just built on the back of the seams of clay, but also on the means to fire it with coal from the Spencroft and Peacock seams. It is thought there

was probably a flourishing medieval pottery industry around the area, and in Sneyd Green, kilns have been found dating to around the thirteenth century.

Of the six Potteries towns, it is Burslem that is talked of as the mother, and where the majority of potworks were found in the early days of the industry's growth. It was the home of Josiah Wedgwood, a village on an 'elevated patch of moorland' made up of 'small thatched tenements', although by the late seventeenth century it had grown to seventy houses. Before the pottery industry picked up, it had 'one church with only a half timbered nave and thatched roof, the roads were packhorse tracks, the streets were dotted with mounds of ashes and shard rucks, made up of broken pots and spoilt earthenware; there were neither schools nor news sheets, but entertainment was to be found in bull baiting, cock throwing and dog fighting'.

By the early eighteenth century, Burslem had grown into a village with fields and lanes and around thirty small potworks. It also had four smithies, two butchers, a joiner, a cobbler, a bake-house and a barber, as well as an impressive nineteen alehouses, which may have some relation to the fact that when Reverend John Wesley went to preach there in 1760, someone threw a clod of earth at him and made contact with the side of his head. In her history of the Staffordshire pottery trades of the seventeenth and eighteenth centuries, Lorna Weatherill shows that between the 1740s and the end of the 1750s, the number of potteries in north Staffordshire more than doubled, with Wedgwood responsible directly or indirectly for much of the later growth and innovation.

The development of the Potteries was helped by factors like roadbuilding and improved communication networks. Crucially, in the same way that porcelain uptake had been fuelled

by tea-drinking culture a thousand years before in China, tea drinking in Britain drove the pottery industry in Stoke.

Andrew Popp, a business historian and professor of history at Copenhagen Business School, has written extensively on Stoke in the second half of the nineteenth century. His research there began with a degree in the 1980s, then he stayed on after he finished. Eventually (though only after having moved away) he completed a PhD on the industrial history of the city. He remembers that the pottery industry seemed marked on every inch of the place, from the literal shape of the landscape through clay mining to the bottle kilns on the skyline and the plaques and statues around the city. There was one regular walk he took past a still operational factory, where he remembers being blasted with hot air from the kilns as he passed by. As students, they were never short of crockery. 'There were huge, huge tips of spoiled pottery, vast hills of spoiled ceramics,' he says. 'We were poor students, so we would go there, and if you spent enough time rooting around, you would find plates and other things that were not broken – the glaze might be imperfect – but we got all of our tableware from tips.'

Stoke always had a distinctive regional identity, he says, as it was relatively isolated from great centres of industrialisation to the north and south: Manchester and Birmingham are both roughly fifty miles away. He sent me a long quote from Arnold Bennett, who had floridly summarised what he saw as the character of the region (Bennett always called the Potteries the Five Towns, omitting Fenton, whereas the official agglomeration is six):

From the north of the county down to the south they alone stand for civilization, applied science, organised manufacture and the century . . . They are unique and indispensable because

you cannot drink tea out of a teacup without the aid of the Five Towns; because you cannot eat a meal in decency without the aid of the Five Towns. For this the architecture of the Five Towns is an architecture of ovens and chimneys; for this its atmosphere is as black as mud; for this it burns and smokes all night . . . for this it comprehends the mysterious habits of fire and pure, sterile earth; for this it lives crammed together in slippery streets where the housewife must change white window curtains at least once a fortnight if she wishes to remain respectable; for this it gets up in the mass at six a.m. winter and summer . . . for this it exists, that you may drink tea out of a teacup and toy with a chop on a plate.

During its boom times, there was surprisingly little migration in and out of the Potteries. One of the things that struck Popp early on in his research was how names had persisted – he noticed that he was seeing the same names in his historical research as those he was meeting in and around the city. 'These were unusual names anywhere else in the country, that were really common in Stoke. It's the first time I'd really thought about the depth of the continuity there,' he says. There were also other distinctive customs of work and leisure, dialect and diet, as well as common diseases specific to the industry, like silicosis, which affected those working in factories. There was also a holiday known as potters fortnight, where everyone took two weeks off. It originated from the time of coal-fired bottle kilns, which had to be emptied and cleaned each year, but this had persisted into the twentieth century despite the decimation of the pottery industry and a move to gas firings. There was specialist language from the industry; one often-quoted job advert asks for 'saggar makers' bottom knockers', which Popp says he sees regularly referenced because it sounds so ridiculous to outsiders.

*

Potters in Stoke also had their own beliefs about clay. 'For example, that it connected them to the Creation – or that some people were innately "true potters",' Popp says. The notion of a true potter was a term that emerged around the 1870s, when after a hundred years of growth, the industry began to slump, triggering a prolonged period of crisis. 'One of the things that industrial districts are meant to do really well is circulate ideas and resources that support a flourishing ecosystem,' Popp explains, 'but Stoke had become so good at supporting an ecosystem that the industry was being flooded with very small manufacturers who were trading on incredibly thin margins.' Equipment or a potbank (a pottery factory) would be sold on when a small business failed, to another start-up that often met the same fate, bought up by people who had the skills to make pottery but not to run a business. 'They would think, well, I'll give it a go, on the basis of the fact that they knew how to make pots, but they didn't necessarily have the business skills,' he says.

Under these pressures, businesses in Stoke also failed to set up any collective bodies to mitigate against the downturn. The bigger firms at this point were both mass-producing wares and also making the highest-quality goods, but when they began to worry that their businesses would be affected by the churn of failures, the notion of a 'true potter' began to emerge, which was, in effect, an attempt to import a test of legitimacy into the industry and question whether you belonged. Being a true potter, Popp explains, had nothing to do with your ability to make pottery, and everything to do with whether you knew how to run a business.

Potting skills were widely dispersed, and the region was built on these skills, so they were nothing special. Where other industries had been enormously mechanised in the previous century, manual skill had not been so displaced in Stoke. The true potter was instead based around notions of 'fair competition', in opposition to 'ruinous competition', which was mostly about pricing wares too low to make a profit and dragging other prices down with you. 'It was also in some way a community, and therefore you didn't act to undermine the community,' Popp explains. 'So they thought the competition should be with foreign makers, not amongst themselves.'

Popp has written of how, in 1884, *The Pottery Gazette* exhorted people to remember the 'pioneers of British commerce' and the methods by which they laid down the foundations for the businesses that were to come, as well as that 'The true potter will always be an artist; but the manufacturer, who caters for the greater number of people rather than the artistic few, will ever be driven to bow to the god of cheapness, not necessarily to worship, but at least to serve.'

The idea was to establish a principle by which art and commerce could be claimed and combined by certain players – and was meant to exclude the flood of small start-ups that were destabilising the industry. It also emphasised the role of the larger, established firms, some of which remain familiar names today, like Wedgwood, Spode and Minton. The notion of the 'true potter' was about fusing an 'authentic' notion of craft with capitalism, and was a way for the people living and working in the Potteries to claim a place for themselves, explains Popp, while at the same time assert that they were representatives of that place.

Potters in Stoke also had complex spiritual beliefs about clay, he says, recalling a quote from the trade press in 1910 that con-

tained an evocative description of Adam's creation from clay in the Bible, suggesting that Stoke potters' skilful handling of clay brought them close to God by being close to man's creation, but also close to the ground. 'It was all connected to those really primal stories about our human origins, and human society,' he says. 'I think it was part of the industry trying to say, you know, we're the roots of humanity here, through clay. It's very basic, mucky, unglamorous stuff, so there was a kind of humbleness in that.'

He reads me a quote he has found while doing research, from Wedgwood to his business partner Bentley. 'They must have been talking about London and fashionable society,' explains Popp, 'because he writes, "Alas, I must be content with fashioning my clay at a humble distance from such company, and live, breathe and die amongst animals, but one remove from the earth."

'There's a real sense to me in this that fashioning clay is a very humble task that connects you to the earth and to nature and to animals . . . I think this primitiveness of clay did matter to Stoke, and was connected to that idea of the true potter.'

Clay formed not just the geological and material identity of Tokoname and Stoke, literally building the roads in both places; it also affected their character. In writing histories of these towns and regions, we might trace transactions and money, economies and equipment, output and profit, but when a place is built from a particular industry, that industry embeds itself into the fabric of a place, and makes it in ways that are both absolutely literal and largely intangible, as well as the source of much metaphor and stereotyping, and occasionally superstition, as in the case of clay objects being embedded in house walls in the Potteries. One of the oldest houses in Stoke, the White House, was found to have

the handle, the spout and a fragment of the body of a teapot in the wall near the chimney breast, apparently there since the house was built in the eighteenth century.

In sites of intensive ceramic industry, whether factories or individual studios, each piece of clay contains a rich history in and of itself – one that begins when it is pulled from the ground and which passes through hands and tools and kilns that have defined generations of people's lives, permeated even more fully in the everyday than it might be elsewhere.

And here we come back to the start, because these places were largely formed by the clay on which they sat. Or rather, they formed *because* of the clay on which they sat, as well as ready access to wood or coal. This manifests in the pots and objects these places make – their very beginnings filtered and captured in an object that, whether you realise it or not, contains something of the beginning of the world and the stories we tell about the origins of life.

That is what you're looking at when you look at anything made of clay: you're looking at a history of ourselves, whether it is in something as basic as a roof tile, or a paper-light teapot. Clay is at least a small part of the everyday for the majority of people on this planet. But are we the only planet where clay is found? If future generations leave Earth, will we ever pinch a pot or band a plate again, or will this craft die a death in the vastness of space?

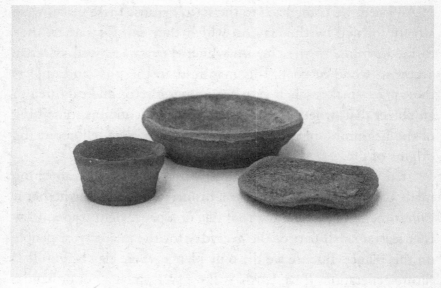

Mars tea set made by the author.

13
Space

The most unexpected fact I learned while writing this book was that Earth is not the only planet where we know clay is present.

There is clay on Mars, and it is not all red.

The story of how we came to know this is tied up with not just what we know about life on other planets, but what we know about the earliest iteration of our own planet, too.

The first thing from Earth to touch down on Mars came from the Soviet Union. Two probes in 1971: Mars 2 and Mars 3. Mars 2 was the first human-built craft to reach Mars, but it crash-landed and was lost. Mars 3 may have landed, but it too was lost after 110 seconds on the surface, suffering a catastrophic failure for reasons unknown. It is not thought that its rover ever touched down, but it survived just long enough to transmit a single image: scrambled strata of grey, white and black stripes, about which there is debate (and plenty of internet lore) as to whether it is in fact a photo of a landscape or just pure noise.

The first craft to send a postcard back to Earth was NASA's Viking 1, minutes after it landed on the surface in 1976. That image, the first one we have from the red planet, is a black and white photo of what looks like rocks on sand, and Viking's own

foot. It is not a mistake. The first image was never supposed to be a landscape, looking outwards, but a shot of the ground, because the first thing the team back on Earth needed to know was exactly what the surface was made from. The answer was solid geology.

Eight days after Viking 1 touched down, mechanical arms on the lander scooped soil samples from the surface for analysis, and confirmed that clay minerals were present in the near-surface environment of Mars.

For the first time in human history, this confirmed the existence of clay on Mars, although the news at the time was more excited by the fact that we were closer than ever to ascertaining whether there was in fact life on the red planet. Admittedly, clay is far less exciting than little green men, but its existence at all tells us a number of things about the past (and perhaps future) of Mars. Clay was important, because clay meant weathering, weathering meant water, and water might mean life.

I arrive at the Natural History Museum on a busy day in spring. Javier Cuadros meets me at the visitor entrance, a calm, smiling man who ushers me through throngs of cacophonous school holiday crowds. We slip in through a side door, past the entrance to the new Titanosaur display and along a corridor of antique vitrines housing taxidermied birds from around the world – an eagle, lovebirds, a hawk. We turn a corner and slip through a side door, down a narrow stairwell to the basement. Along this corridor there are much older specimens: rocks on pallets; a lump of something huge and green; a wall-mounted case of crystals; and a bank of hundreds of small wooden drawers with neat brass handles that hold rocks collected a century ago or more from locations all over the world.

Cuadros is a geochemist and a senior researcher here. He specialises in clays, with a particular interest in the chemical processes that form them. If clays were crime scenes, he is a detective, deducing the conditions and events that led to the formation of their crystalline structures. Particular structures are produced under certain conditions, so the minerals contain geological markers for our most distant past.

His research is not just about terrestrial clays. In recent years he has become an expert in extraterrestrial clays too. The discovery of clay on Mars was a 'big surprise', he says. It was originally thought that Mars might just be dead dust like the moon because early images showed a similar-looking surface full of craters, and the dust indicated that it might be dead dust, without any water activity. This all changed when the water was found in the form of hydrated minerals. This isn't water in the visible sense, he explains, but minerals that contain water in their structure somehow. There appeared to be a lot of these hydrated minerals on Mars, meaning that at some point in its history, there was enough water to *create* them.

'Clay is always the product of a reaction between water and silicate rocks, and the chemical conditions in which clay forms also require liquid water,' he explains. This is significant: not just water, but *liquid* water. The presence of clays that formed through reactions with liquid water means that the temperatures on the planet must have been above zero at some stage. 'The pH of these waters was near neutral in many cases. These are all conditions that pointed towards the possibility of the existence of life – because these conditions were similar to what we find in most places on the surface of the Earth.'

Scientists now don't think there was anything like the amount of water on Mars that is found here on Earth. Less water means

fewer mineral transformations, which means there were probably fewer chances of life forming. Exactly how much water there was, and how much clay there is, is hard to say. We have a view of the surface, but we do not know much about what is buried under it. Wind-swept dust covers much of the rock, but further down there may be thick layers of clay. So far, we can only stick a pin in a few places on the planet and peer below. 'Even so, some global studies suggest that there is clay in many places of the very ancient crust of Mars,' says Cuadros.

For geologists and geochemists, what was exciting about these discoveries was not only the possibility of life on Mars, but also the knowledge that Mars was a planet that had experienced a geological evolution – that it was not like the dead rock of the moon that had been born, seen some volcanic activity and then been bombarded with debris from the forming solar system. 'You have transformations, you have minerals that can evolve from the original composition of the rocks, then form new minerals and rocks, in a long and bifurcating sequence – this all adds richness to the planet and makes it a more interesting place to investigate,' he says.

The life that the presence of these conditions makes possible is not little green men. Mars has been a very inhospitable place for a very, very long time. There is nothing alive on the surface of Mars. The thin atmosphere and the lack of a magnetic field means that there is little to filter out or deflect the powerful radiation from the sun and the rest of the galaxy, so its intensity is murderous. The type of life that scientists are looking for is that which is sufficiently small to find protection underground and evolve to survive in extreme conditions, like we now know happens on Earth. We have found life in the deepest seas and

darkest crevices, in the most toxic places and under the most extreme temperatures: in volcanic springs, buried in ice, or in vents on the seabed under enormous pressure.

The hope for evidence of primitive life on Mars focuses deep underground, in places currently inaccessible to the rovers taking samples on the surface. 'Underground it would be protected from the radiation; protected from drastic changes in temperature,' Cuadros says. 'There could be some liquid water – even at the interfaces between ice, or permafrost, and the rock. These are extreme conditions in which we now know that microorganisms live on Earth.'

Another caveat is that, realistically speaking, the search on Mars is not for any living microorganisms, but for the remains of life: of something that lived, died, decayed and left a trace. Unfortunately, that is a bit like looking for a shadow of a micro-organism on a needle in a haystack that's the size of a planet. 'It's not even fossils, it's the remains of organic matter,' Cuadros says. This may be an organic compound that is adsorbed – whereby an extremely thin layer of molecules adheres – to the surface of a rock. 'We're talking about parts per million – something you wouldn't see with any microscope but has to be detected through other means.'

He doesn't think it will happen in his lifetime, but if it did, the secrets such a discovery might unlock are enormous. If past environments on Mars were habitable by some form of life three to four billion years ago, they might be able to tell us something about the way life began on Earth, and about the early chemical reactions that made something living from inert matter. On Earth, much of our earliest geology has been erased by the movements of tectonic plates as they are swallowed and remade. On Mars, there are no tectonics, so its rocks and minerals are

considerably older, and might hold secrets about what the early geological life of our planet might have looked like.

One great hope for pulling in information like this is from the currently delayed European Space Agency rover *Rosalind Franklin*. It will use a much longer drill than the current rovers and should be able to access deeper zones that might reveal information from further back in the planet's history, and which are much better protected from the impossible surface conditions. 'It will be very difficult to find,' Cuadros says.

'Life is really miraculous – you know? In the biochemical reactions that are necessary to stabilise a living organism you need hundreds of them at once. Some reactions are controlling other reactions to establish the perfect balance. One reaction alone could run until it destroys the cell. So *all* of these reactions should run to a certain point that is beneficial, and then stop. It's a tremendous balance, and unless you have this self-controlling system – which is already extremely complex – there is no life, and there's no possibility of life.'

The crust of Mars is covered by a fine dust, like talcum powder. The crust itself is solid rock, thought to be a mixture of silicon, oxygen, iron, magnesium, aluminium, calcium and potassium, elements that are dominant in igneous rocks. Beneath this, the planet's mantle, 10–100km below, has a similar composition, and is probably more plastic than the crust because of the higher temperatures and high pressures down there – it may have the consistency of soft rocky paste.

A variety of clay minerals have been identified on Mars. There is kaolin in some places, and the most common is rich in iron and magnesium. Is this what makes it red? I ask. Cuadros laughs – I've made a common faux pas. 'No,' he says. 'The clay itself is usually white. It needs to have a lot of iron to have some colour.'

The planet's red colour comes not from iron but from iron oxides – the pigments used in oxblood painting. These oxides are very fine, mixed in with the dust, and are airborne on the surface of Mars, blown about by the hurricane winds and deposited across the planet. While there are countless particles of this iron oxide, there's not that much of it, relatively speaking, but the colour is still intense, and it covers the entire surface. This reddening has taken place mainly in the most recent part of Mars's lifetime – the last three billion years. 'That is the main mineral transformation that has been taking place,' says Cuadros, 'and because the particles are so tiny it's very mobile and it's transported everywhere. It's tremendously windy there, and you have global storms that cover the entire planet.'

Most of what we know about clay on Mars has come to us through remote sensing, which is, as Cuadros explains, an indirect science. 'What we get is spectroscopic data [from probes revolving around the planet], which you then have to compare with spectra from Earth.' The shapes of these spectra then have to be matched: peaks with peaks; troughs with troughs; slopes with slopes. 'In most cases we find what we find on Earth. But you may find compositions that are slightly off,' he adds, explaining that sometimes what looks like anomalous spectra are not further investigated. However, these may hold important clues, precisely in their unfamiliar elements. Complex clays on Earth need to be studied to widen the range of clays that we can identify and 'read' on Mars.

Just as there are no humans going up there yet, no clay is coming back from Mars either. The rovers are out there for life. That's not to say we don't have any material from Mars, though. About 200 meteorites have been found that are known to have come from the planet, but as samples they're effectively a biased

group, and can only give us a limited amount of information. Clay is soft, but meteorites are largely made of hard rock and so there is not much clay in them.

Clay minerals and geology on Mars are also exciting because Mars is a planet that exists in a state comparable to a much earlier version of Earth, before iterative tectonic processes produced a crust chemically differentiated from the mantle below, and before the atmosphere became rich in oxygen. Because of tectonics, much of Earth's earliest geology has been swallowed at plate edges. Mars' lack of tectonics means there are rocks there that date back to the earliest life of the planet, and scientists expect these rocks to be similar to the rocks that made up early Earth. 'Most of the crust we know is very ancient – and still preserves the signature of the very early geology over there. So, in a way, Mars is telling us how the Earth was at the very origin,' explains Cuadros. It's a question that currently hangs in the balance: a huge unknown that is not so much about the origin of life or life on other planets as about the origin of our entire planet; not just the beginning of all living things, but the beginning of everything.

Clay on Mars is not just interesting for scientists. Its presence remakes the aesthetic possibilities of how we might live on another planet. What if we no longer have to be housed in silver and glass hi-tech homes when we leave Earth? What if we could house ourselves within the clays of Mars? We could build homes, cathedrals, monuments in clay; eat from clay pots; paint with it, make art with it. These ideas have been picked up by non-scientists, because if there is clay on Mars, can we not make things with it?

I'm not the only one to have followed the thought this far. I come across a pottery supply company in Seattle that has made its own approximation of a Martian clay body. Shipping to the

UK, given its weight, is about as easy as bringing some of the real stuff back from Mars, so I call them up and chat to Tyler Didier, the technician who had been inspired to make it.

Didier is an enthusiastic 27-year-old technician and potter. He originally took pottery because he heard it was an easy art credit, and there was a girl he liked taking the same course. He completed the first and second level, but by the third, he'd forgotten about the girl and was obsessed with clay. 'I realised I was actually in love with clay,' he laughs. He carved out a path towards the chemistry of clays and glazing, and built his own software calculator to help him develop new recipes. He has made a black clay, a speckled gold clay, an improved air-dry clay, a whole raft of glazes and, perhaps most notably, his Martianware body. 'I was reading C.S. Lewis's Space Trilogy and it talks about inhabitants on Mars . . . so I started asking questions, which culminated in: is there clay on Mars? I thought, if there's inhabitants on Mars, they must create art,' he says.

He started looking into the science and chemistry of it, and found that a lot of Martian soil had similar basic elements to clay – it blew his mind to think about the possibilities, and he started designing a formula. 'I knew that people would want to throw with it, it couldn't just be a dead body,' he explains, so he made some allowances for water content and its workability.

'It was very difficult to make it plastic, so I had to use certain clays. One of the things I ended up doing that's not traditional in your usual clay body is putting salt in it. Efflorescence – the salts coming out to the surface – is usually considered a bad thing in ceramics, but the Martianware body had it to such an extreme that people were having salt crystals slowly grow on their drying pieces – it was really cool.'

These salts also mean the clay hardens quickly, and it should be low-fired to about 1,000–1,100 degrees. How long you let the pieces dry affects the efflorescence, which in turn affects how they are fired. 'So if you took a piece, threw it and put it straight in the kiln when it was dry, fewer salt crystals would come out. It would probably turn out black and kind of bubbly-ish. But if you let the salt crystals grow, it almost creates its own glaze when all those salts start dissolving,' Didier says. I am reminded of Charly's monstrous salt sculptures – I wonder what she would do if she got her hands on a Martianware clay to play with, or if in fact she's already making the sort of art we'll be building off-planet.

Originally Didier created a super-smooth body, but then asked himself if a Martian clay would be so refined. 'It's from Mars, so it's out of this world,' he points out. 'Then it also has this quick drying time, and with the salts it has an expiration date of sorts, which is really interesting. It's as if we're bringing something from Mars here, but it can't survive here for long. I was really interested in the way those ideas might play out.'

He wanted the clay he made not just to imitate Martian clay, but also to *look* like what we'd expect from Martian soil too – while Cuadros laughed at me presuming the clay would be red, Didier figured it was too far an imaginative leap to tell potters that a Mars clay body would be anything *but* red. 'It was originally this muddy, brownish colour,' he says. 'I thought: that's not Mars. If someone picked up a bag, they'd think it looked like dirt from the yard, not Martian soil.'

It took some trial and error to get a clay that was close to the actual make-up of a Martian clay; that looked like we'd expect a Martian body to look; and that was workable on the wheel. 'It was really difficult,' he says. 'I was constantly on the wheel

throwing with it and failing, finding it was just not plastic enough for people to work with. I kept going back to the drawing board.'

Eventually he got it right, 'releasing' the Martianware clay on the day that the *Perseverance* rover landed – 'a clay body that is truly out of this world' boasted their website. 'People just loved it,' he says. Since then, he's seen a lot of people making sculptures, including animals where the efflorescence started looking like fur. He tells me how one man who was more used to creating functional ware ended up making 'really harsh pieces of sculpted ware' – they were vaguely functional in shape, but the clay body meant they weren't functional at all in the end: upside-down creations that looked usable but weren't. 'It was really interesting to see people creating their normal functional wear that then they couldn't use, but which had all these weird variations. They loved the result, even though that's not the outcome they're usually looking for.'

I ask if he himself made anything from the Martianware clay. 'I got a bowl out of it that was semi-functional,' he says, brightly. 'It was a bowl that actually had a glaze *in* it, a smooth, glossy surface, which was really cool, to see that it was naturally almost self-glazing. It leached toxins though, so I would never actually sell it to someone and advise they use it for salads!'

Didier is captivated by the thinking triggered by the clay body – what it prompts him to ask about our possible lives on other planets, about the art we make and the vessels we eat off, and about clay's role in our day-to-day existence in the future of humanity. 'The question of whether we can live on Mars is a huge question for our generation,' he says. 'If I went to Mars, as a potter, I'd want to be able to throw. Travelling and living in other places would be rad – although obviously we're not there yet. But to think or experiment with that even now – I think

hey, maybe we could still be potters there! It completely remakes my idea of what might be possible on another planet.'

A few weeks later, Didier sends me the recipe for the Martian clay. I gather the raw ingredients, making a round of adjustments of the US materials for the UK. I also can't find olivine – a mafic rock – though I'm informed it might be swapped for talc, which is similar enough, chemically speaking. I make the clay in a messy corner of the large kiln room set aside for glazing and spraying, while another studio member sits monitoring his first gas firing. I measure out the ingredients: ochre and red oxides, white talc, pale quartz, charcoal-coloured fireclay, along with bentonite, wollastonite and a few grams of other trace ingredients. It's another, entirely different palette of place, synthesised and adjusted, and extremely high in oxides.

To make a test batch of a clay body, you mix it like pasta – a moat of dry materials with water poured in the centre, blended until it's smooth. A few grains of the oxides could ruin someone's work here, so I mix it in a bowl with a spatula, adding a little water at a time. When it's done, it is redder than the reddest red clay I have ever seen. My hands are red, the tools are red, the bowl is red, but the clay is the reddest: a ketchup rouge so heavily saturated it makes even the brightest terracottas on the shelves look pale. It leaves redness in the studio like it has been blown across the surface of Mars. My clean-up is extremely careful.

I test a lump, form a tiny Martian head with big ovoid eyes, large skull, pointy face, leave it to dry on the shelf. Strangely, I find it springy and odd – similar to the clay I pulled from the riverbank in Cornwall. I let the rest of the batch sit for a week, to allow it to become populated by earthly bacteria that might make it easier to work with.

A week later, I come back to the studio to try and throw something with it. I have decided on a primitive dinner set – or futuristic, depending on how you view it. But it is difficult clay: bouncy like dough, unruly like porcelain, heavily grogged like the crank you use for sculpting and garden pots. It refuses to hold a shape – it seems slippery somehow and won't stick to the wheelhead easily. I thought it was too dry to throw with, but now it seems too wet. It is as if it is not suited to our gravity. After a frustrating half-hour, I manage to throw a small sake-sized cup, a side plate with an edge that slumps over its own footring, and a shallow bowl. I leave each of them on the shelf to dry, and as they do, the salts begin to gather.

I message Cuadros, sending him the recipe, to ask how close Didier's composition is. What's the same? What's different? Mainly, the clay from Mars would have a lot more magnesium and a lot less aluminium, he says. Other ingredients are out of balance scientifically speaking, from the Earth bentonite being too aluminium-rich in comparison with the bentonite found on Mars, to the fireclay and wollastonite Didier has used to make the clay body usable being present in far higher percentages in his recipe than is usually found on Mars. This means that Mars clays will be even more difficult to throw with than the batch I have made from Didier's recipe, and I have already adapted and acclimatised the synthesised Martian clay not just to Earth's environment but to a UK recipe from a US one. I have switched olivine for talc; swapped the American fireclay for one available in the UK. Crucially, to use it at all, I have added water, and let earthly bacteria begin to accumulate.

Tyler Didier's clay body is a product of science and the imagination. Things he doesn't know; that science doesn't

know. We investigate, we imagine, we dream. There might be near-insurmountable hurdles to inhabiting Mars, particularly on the surface. But these impossibilities do not extinguish the imaginative possibilities offered by another planet. It is not the actual potential of colonising Mars I find compelling – the idea that we would live on Mars after we used our own planet up is an ultimate worst-case scenario – but I am interested in how our knowledge of Mars can influence what we make on Earth. Like Didier said: if we went to Mars, would we not make art?

From this provocation, we can work back, and in the process offer a way of building new worlds, telling stories about the ways we might live, the ways we might have lived, the ways we might never have come to be. Gone are the science-fiction metal and glass domes, sunk into a hostile red desert. They have been replaced in my mind by a planet scattered with the fired domes Khalili dreamed of undulating across an alien desert; glistening under the radioactive light. I think of domed roofs; of dinner eaten from red bowls, red cups, red platters. I think of kaolin; of white slip. Perhaps the walls will be washed in pale buffs, the floors in dark brown. Perhaps we will smear the clay on our faces under our space suits, an exaggeration of our human features that shows through the protective gear. Perhaps we will paint the landscapes of Earth on the walls; tile them in the colours of Mars; build gardens of monoliths, or sculpt portable figurines of loved ones back on Earth.

When I take my Mars pots from the kiln, they are encrusted in ochre where the salts spread the most, the throwing rings imprinted in the friable surface. Underneath, the bases reveal flecked red clay where I scraped back the form and removed the salts before firing. All three pieces are completely unusable. The

clay feels brittle and the wares are underdeveloped forms that shouldn't exist, or rather, have been made from a material that was never destined to exist like this.

I turn over the distorted plate and run my finger over the rough surface, the redness more pleasing than the flaking ochre, but a product of our actual knowledge of Mars fused with a human construct of what Mars is. As I turn the strange clay bowl in my hand, I know it is not Mars clay at all, and it does not offer a vision of how we might live off-planet either. It is Didier's clay and it is my clay – clay made from materials found on Earth, adjusted for our environment. Water is added, then the clay is transformed by fire, neither of which exists on Mars. Crucially, even the bacteria I let grow invisibly inside the raw clay body belongs to Earth too. Mars geology might contain clays, but life did not develop there as it did here. It is life on Earth that means I can make imitation Martian pottery. These objects are odd, unimpressive, until you realise that within them there is a marriage of human imagination and a human history of science. Perhaps life on Mars is not the point after all: it's life on Earth that this Martian bowl pushes me towards.

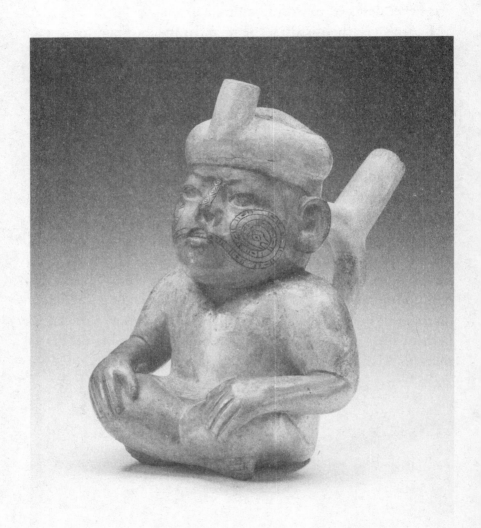

Portrait vessel of a man with a cleft lip and tattoos,
The Art Institute of Chicago.

14
Death

Clay did not just give us life, but has often accompanied us in death. I wrote at the start of this book that one of the reasons we know so much about previous cultures, and why clay objects fill museum vitrines, is because of the resilience of fired clay. It's also because this long-lasting material was preserved in burials or as objects in customs performed around death in many different times and places. The vessels found in graves, or used in burials, throughout human history are as numerous and varied as those we have eaten off and drunk from in the many millennia of our existence. It is not just in living that we leave traces of our past beliefs, but in the way we die.

Pottery is the most common material grave goods are made from, and is present in some of the earliest ever discovered. Archaeologically speaking, these artefacts have been so crucial as to define the very existence and spread of some peoples, such as the European Beaker culture, which is defined by the particular pottery found in burials, shaped like an upside-down bell with a gently flaring rim. In other instances, the pottery left contains evidence of what a settlement looked like, as in Han dynasty tombs, where ceramic models of various buildings – watchtowers, houses, workshops,

farmhouses and other structures – have become a crucial source of information about their timber building practices.

The earliest pottery grave goods are found in Egyptian prehistory, although it is later Egyptian burial practices that became best known, for the meticulous removal of organs that were placed in canopic jars as part of the mummification process, as well as the leaving of food and drink and other things needed for the afterlife.

In some cases, whole bodies were interred in clay vessels. People were either buried whole in large pots, or reinterred in jars when they had decomposed. Jar burial has been documented back to the Neolithic in Taiwan, the Philippines and Borneo, and in early prehistory in Thailand, as well as other sites across the islands of South East Asia. Jars ranged from crudely baked earthenware cylinders to finer pottery with cord markings. People were often buried with beads, tools and ornaments, and the jars were covered with bowls that acted as lids. At one site in the Mun Valley in Thailand, complete human skeletons were found interred in pots seventy centimetres high, with tall bowls used to seal the vessels.

Clay also formed part of mourning practices. Across various indigenous communities in eastern and western Australia, white is a colour symbolising death, and white pipeclay or gypsum was slathered on the skull to form *kopis* – what archaeologists called 'mourning caps' (and which were also known as *korno, mulya, mung-warro, pa-ta* and *yúgarda*). The mourner's hair was cropped, then a net was placed over the head and the clay pasted on in layers over the course of a few hours. The caps were worn for mourning periods of anything from a week to six months, and the Australian Museum has records of them weighing between two and seven kilograms. In some cases, the amount of clay was relative to the depth of the grief suffered.

Some of these practices are found in geographically distinct regions and time periods: the Nahuatl in Nicaragua and the Jōmon in Japan both buried their dead for a number of years, before excavating the bones and reburying them in clay vessels thought to represent a womb. Many cultures have also left figurines with or for their dead. The Haniwa in Japan left life-sized figurines with gentle faces, sometimes playing instruments or doing other activities. The Yungur in Nigeria make anthropomorphic wiiso vessels to contain the spirits of their deceased chiefs to sustain their lineages, and the Tang dynasty left figurines decorated in vivid dripping greens and yellows. But the best-known and most iconic are perhaps the terracotta warriors, an example of what one writer calls 'funereal megalomania'.

The army was made for China's first emperor, Qin Shi Huang, whose name is the root of our word 'China' and who unified the country after the Warring States period, ruling from 221 to 210 BCE. In 1974, his tomb was accidentally unearthed by farmers. The site was known about since the time of the succeeding Han dynasty, mentioned by historian Sima Qian writing only a hundred years after the first emperor, although the clay army was not mentioned.

The first collection of warriors was found about a kilometre from the main tomb. 'These perfectly executed life sized sculptures, some over 190 cm in height, seem to have appeared out of nowhere,' wrote the British Museum's Jane Portal. 'There had been no tradition of such large or such realistic ceramic sculptures in the centuries preceding the Qin.'

It is estimated that there are 7,000 or more warriors across the tomb site, only around 1,900 of which have been excavated to date. Each is fashioned as a unique individual, with a hollow upper body and solid legs. It is a monumental and uncanny body

of work – a stadium's worth of soldiers to see you into the next life. The notion of encountering thousands of life-size model soldiers in a tomb is one thing, but crafting and firing life-sized forms would have been a mammoth undertaking. Some sections of the tombs are empty, suggesting difficulty in the making process, or that soldiers often cracked in the firing.

Grave goods like these, whether entire life-size armies or miniature replicas of buildings, contain the evidence used to decipher and interpret a culture's beliefs about the transition between life and death. The supplying of armies, food and drink suggests that a culture considered the afterlife to be one where there were bodies that needed nourishing; that it perhaps looked something like this one. What is left in graves can not only be very well preserved, but is evidence. Was there another life beyond this one? What did it look like on the other side? Did we have bodies there, did we need to eat, to drink? What would we need, and what could be left behind?

Some cultures are more perplexing, showing us more about death itself than any afterlife that might follow. If Old Europe's figurines became vehicles that reflected societal values, grave goods found in burials can also say more about our present day perceptions of what is an appropriate way to mark death, or about our squeamishness about dying. The Moche culture, which flourished in ancient Peru, offers a particular puzzle and a challenge, in a proliferation of erotic and explicit vessels that connect the living world and the dead.

My first encounter with the pottery of the Moche was in the Art Institute of Chicago, where in a large vitrine I saw thirty or forty elaborately moulded stirrup vessels – figuratively moulded

bodies and faces in 3D, with a looped spout. Some were in the shape of leaders – like serious, statesmanlike Toby jugs; others were in the form of animals: a spotted deer, a bird eating a lizard, an anthropomorphic owl with hands crossed over its chest, a woman riding a llama backwards. One in particular stood out: a young man or boy, sitting cross-legged in a turban-like headdress and cream tunic, his face formed to show a cleft lip, his cheeks engraved with what are thought to be face tattoos in the form of a snake picked out in black that is coiled as if curling from his mouth.

I was captivated by this boy, perhaps because it was a face that I was not used to seeing memorialised – the last few hundred years of Western culture has rarely glorified or celebrated images of those with birth defects or disabilities. I looked further into Moche iconography, into what this vessel was, what the status of the boy was in that society and what the snake meant. I found that the Moche often made portrait vessels of those with various forms of facial paralysis, cleft palates and visual impairments. They were often tattooed, which denoted status, and it's thought that a character like the boy with the cleft palate had been touched by the gods, and was considered holy, or sacred.

The sheer variety and imagination I saw in the Moche vessels captivated me. I saw images of vessels depicting people with their lips and nose removed (thought to have been a brutal punishment), anthropomorphic vegetables where ears of corn were given faces, an image of a bowl sculpted so that a skeletal figure inside pulls another figure by the legs through the wall of the vessel. What I also found were countless numbers of erotic scenes, few of which were on display in museums. In a crucial early monograph collecting the erotic pottery of the Moche, eminent scholar Rafael Larco Hoyle wrote:

The first question that arises is why the ancient Peruvians placed erotic pottery in the tombs as funerary offerings . . . Although I have spent forty years and more as an archaeologist, the answer is still an enigma to me. It may be that the friends and relatives of the dead man sought by the offerings to enjoy the pleasures of sex, or perhaps to transmit some idea of the continuity of life. Or were the offerings, along with the other vessels left in the tomb, an indication of what his sexual life had been?

The Moche flourished on the northern coastal region of Peru around 100–800 CE, and were more or less contemporary with the early Mayans. They pre-dated the Aztecs, emerging around the height of the Roman Empire. They did not call themselves the Moche; this is the name we have imposed on a set of artefacts found around the location of two enormous prehistoric adobe structures, the Huaca de la Luna and the Huaca del Sol – enormous ziggurat-like temples with no stairs, just ramps. It derives from 'Muchik', the name of the language spoken when colonial Spain arrived in the region in the sixteenth century.

There was no explicit market economy that involved cash or money, but the Moche are the first culture thought to have achieved the level of complexity of a functioning state in the region, although they had no known writing tradition. They reared guinea pigs, which were fed kitchen scraps to fatten them up for eating. They also ate shellfish, fish and trapped sea lions. They farmed maize (fermented into alcoholic chicha), squash, manioc, sweet potato, avocado, various beans and fruits in land irrigated by canals. They had specialist workshops for metal-working, textiles, lapidary and ceramics, but archaeologists argue that their visual identity, in art depicted on vessels and in other

crafts, and in their architecture, was evidence not so much of a unified culture as of a unified system of power, with ruling houses in each region. Jeffrey Quilter, a leading archaeologist specialising in Latin America, describes the pottery of the Moche as functioning within society not primarily as art objects but as being of a 'corporate style' that aligned with and was made for a central administration, with workshops found within a few hundred metres of the temples, which some have interpreted as meaning that the ornate decorated pottery may have formed part of state operations.

Early Moche vessels were made by a combination of pinching and coiling, with the stirrup spout made using clay wrapped and rolled around wooden sticks. A hole was cut into the moulded form and fixed in place with a small coil of clay. Later, moulds were used to make the 3D stirrup vessels, in much the same way moulded ceramics might be made today. Moulds found in excavated workshops show that they used two-part press moulds, where soft clay was pressed into each side and dried, probably to leather hard, then the parts were fixed together with slip. The vessels were then decorated with liquid clays, and some were hand-polished to a shine. To look at them now feels like time travel – a leap into a different world of sex and death, but represented in undeniably modern styles. The moulds effectively allow for repetition of forms, and, as a production technique, lend the vessels a modern feel.

It's not known if roles were divided, as Maria and Julian divided up forming and decorating on the pueblo at San Ildefonso, but in an exhaustive and iconic study of fineline painting on Moche vessels, Christopher B. Donnan and Donna McClelland painstakingly traced images from multiple photos of thousands of vessels and unexpectedly found themselves able

to identify over forty individual artists through how each had painted features like eyes and noses; how they had laid out their designs, or their brushwork.

While we know something about what it was to die for the Moche, what we don't know is what caused the death of the culture as a whole. Large previously populated areas began to be abandoned sometime in the sixth century, and various theories have been put forward centring on environmental stresses. In some parts of the region there is evidence of flooding, though ice cores from the nearby Andes show the climate of the time to have been dominated by drought, with a devastating thirty-year drought towards the end of the century. Moche agricultural land with its irrigation canals has also been found to have been encroached upon by sand, and there is much scholarly debate about the role of an El Niño event in these environmental stresses. Other reasons suggested are the aggressive expansion of the Wari empire, traced by the influx of Wari iconography, or internal instability in the top-down power structures.

The Moche left no writing, so much of what we know about them has been interpreted from their ceramics, along with exquisite metalwork found in various graves, and the stone pyramids they erected. While the arid desert landscape of northern Peru offers excellent conditions for preservation, looting often decimated tombs, meaning many vessels now in museums and collections have no provenance.

The more elaborate vessels were often created with much more care and in more detail than pottery intended for cooking, although some made for eating and drinking have been found in more than purely functional designs. The finest wares are thought to have not had a domestic function, and scholars have disagreed about their purpose – many, such as Quilter, Donnan

and McClelland, thought they had some use in life, even just to display prestige during a person's lifetime as destined for burial offerings in death, although Steve Bourget thinks they were solely used in burials.

Of the thousands of known burial sites, 700 have been excavated, and in a number of key instances of undisturbed burials, the way the Moche died began to tell us much about their cosmology and beliefs. The most famous of these was in 1987 at the Lambayeque Valley site called Sipán, where a crucial undisturbed set of burials was found in a much larger architectural complex. The tombs were thought to be the resting place of Moche royalty, and date to 200–300 CE. Ten high-ranking individuals were found, along with others apparently sacrificed alongside them. They were dressed in profusions of gold: headdresses and backflaps; bells and sceptres. Three of the occupants wore robes and headdresses that can be matched to a repeated scene on various stirrup vessels, which has since been named the Sacrifice Ceremony, after its depiction of naked victims being led up to a richly dressed individual on a plinth for their blood to be ceremonially presented. Two individuals were dressed like characters in another scene called the Presentation Theme.

The Moche pose an interesting case because the vessels that people were buried with are decorated with elaborate line-painted scenes, some of which seem to correlate with the outfits they were buried in, and so there is debate about whether the vessels are showing real rituals or mythological scenes. This has particular implications for the Moche, because the rituals depicted often show brutal human sacrifices, and funerary events where people pass to what looks like some sort of underworld.

Prior to Sipán, the most significant archaeological find was at the Huaca de la Cruz site, in 1946. In this were found the remains

of five people, left with ceramics and gourds filled with maize, vessels in the shape of sea lions and bats, portrait vessels and stirrup spout vessels held by those buried. One coffin contained multiple bodies, separated by cane platforms, and included a boy aged between eight and ten years old, who was buried with two portrait vessels, one of an adult and one inventive form that was a potato with a face, where the eyes of the potato had become the eyes of the potato-child. The potato vessel had a malformed forehead and the boy buried was found to have a similar deformation of the skull.

Other ceramics that formed part of this burial included multiple vessels showing scenes that included a character called 'Wrinkle Face' – a recurring character in Moche iconography, named in the 1970s by Donnan and McClelland when they noticed a number of recurring characters in their landmark study of Moche ceramics. The name caught on, and he is now referred to as such in most literature. He can be recognised by his wrinkled face, fanged mouth, feline headdress and snake-headed belt, and is found as a sculpted character on mould-made stirrup vessels as well as on fineline vessels. These latter types of stirrup spout vessel are from the later Moche period, and are decorated with intricately detailed slip-painted scenes that draw easy parallels with contemporary manga and comic strips, sometimes laid out like a side-scrolling computer game, and which have often been compared to classical Greek red figure pottery. Wrinkle Face is often depicted with an anthropomorphic iguana sidekick, and the pair engage in burial rituals, sacrifices and fights with supernatural beings (in one case, a large anthropomorphised crab).

Steve Bourget identified four types of subject in Moche iconography: humans and animals in their natural form;

transitional beings such as skeletons, which often perform specific acts; anthropomorphic animals, vegetables and objects; and individuals with supernatural attributes such as fangs. Many of the vessels depict sex acts, and, as Bourget writes, have a crucial link to death and burial in a way that appears in some cases extreme and in others deeply improper to us now. He identifies nine types of images shown on these vessels: sodomy, masturbation, fellatio, sexual depictions on libation vases, anthropomorphic genitals, copulation between animals, copulation between animals and women, copulation with sacrificial victims, and copulation between Wrinkle Face and women. Hoyle also catalogued the specific sex acts on the vessels, concluding that only 5 per cent of the acts depicted are, as he says, 'natural' with the other 95 per cent comprising a range of other sex acts. He writes of vessels that depict skeletons performing various sex acts with women, and interprets these as having a moral message, because he finds the women's faces often show negative emotions, rather than expressing pleasure.

The fineline vessels depict scenes and rituals involving sex, death and sacrifice that may or may not have taken place in Moche culture. These vessels, Bourget says, show that for the Moche there were funerary practices that involved ritual sex acts. What these vessels demonstrate is that in Moche culture, sex and death were linked in a duality: as above, so below.

The Burial Theme is one of the most complex scenes, found across six vessels. It's not known whether these vessels were used in burials or funerary rites, but the scene 'portrays a ceremony in which the central participant moves from the physical to the supernatural realm of human experience, facilitated by ritual violence'.

There are four distinct activities in the Burial Theme: burial, assembly, conch exchange and sacrifice, always arranged on a vessel in the same way even if there were slight variations in the actual scene. The burial section shows Wrinkle Face and Iguana lower a wicker casket into a deep, narrow grave, which looks the same as those that have been found in tombs. Occasionally there is a llama tethered on a lead in this section. The assembly part is a grouping of figures holding staffs: some human, some animal, some anthropomorphic. There is also a conch exchange, where inside a grand building decorated with conch shell gargoyles, a character kneels, holding a shell in an outstretched hand. Above the conch shell section is depicted a sacrifice in which a woman is devoured by birds as Wrinkle Face and Iguana stand nearby with knives and spears.

Archaeologists have questioned whether these were documentary scenes, depicting real funerary rituals; depictions of mythological events; or symbolically related to burial practices. Bourget suggests it might be something in between, where real people re-enacted mythological scenes in their lifetimes and then were buried as these characters.

The Moche funerary vessels depicting scenes of death and burial in fineline paintings have been compared to Christian iconography – the Burial Theme may have been like the Stations of the Cross. The various characters and ritual acts portrayed on the stirrup vessels may have been symbols that acted as synecdoche for a wider belief system – we don't need the whole story to be reminded of the main point.

For Bourget, the Moche burial themes and erotic skeleton couplings can be interpreted as making explicit the connections Freud made a millennium and a half later between sex and death – his study contains sections titled 'Eros' and 'Thanatos':

the life and death drives. Freud, a collector of pottery, might have been thrilled to see the Moche culture laid out in such a way – as cultural artefacts they sit easily with psychoanalysis' preoccupations with the connections between sex and death.

Hoyle is both fascinated and disgusted by the debauchery he sees in the Moche pottery – one vessel moulds a coupling between a well-hung skeleton and a woman, which he takes to be showing a moral lesson: that sexual excess will not only 'afflict and destroy the body, but also affects the mind'. The darkest of the Surrealists, George Bataille, might also have had something to say about it: 'the knowledge of death deepens the abyss of eroticism', he wrote, placing death and the erotic into a relationship his biographer described as one where 'death exalts eroticism, and eroticism renders death desirable'.

There is an eternal blank at the heart of the Moche – we can attempt to interpret the nuance and detail on these vessels as communicating certain values and beliefs about death and the afterlife, but we cannot know the emotions that accompanied them. What was mourning? What was desire? What was the sentiment that these vessels prompted? Is it possible that they were humorous? Were they perhaps scary? Archaeology generally treats its subjects seriously, but are the skeleton couplings a solemn memento mori, or a joke about death?

I had wanted to write about the Moche before I started this book. Like other clay objects that had deepened my understanding of our history as humans, they did not just reset my idea of how advanced the art and craft skills of very ancient craftspeople were; they also showed me something about our own society. These vessels, by modern standards, are shockingly explicit in some instances – they break with expectations around the ancient

pottery we expect to see in a museum; they reveal taboos and sensitivities in our own societies. It was revealing that ancient ceramics could be showing us something that was taboo thousands of years later.

The Moche make visible and memorialise people and actions that we shy away from in the present day. Despite the vast number of explicit vessels, I have only ever seen one or two in museum vitrines, and certainly not the reoccurring well-endowed skeleton. Looking at the Moche from the perspective of now teaches us as much about the way we think of sex and death as it does about the Moche. The Moche present, via their pottery and the designs painted on it, elaborate rituals, some extreme and confrontational to our modern values.

I do not agree with Hoyle that the vessels *must* constitute a moral warning. It is just one possible reading. I prefer to find something in the Moche's depictions of sex and ritual that connects our identities as both animal *and* human. Depicted in fired clay I see these resonances in double: the clay is the earth, is animal, and the fire it was subjected to is what makes us human.

The clay these scenes and symbols are painted on mirrors that connection: that if we come from clay we will return to it, with it. We are forever in its company. 'Imperial Caesar, dead and turn'd to clay/Might stop a hole to keep the wind away,' jokes Hamlet, but thought of like this, clay vessels carrying or accompanying us from this world to the next, whether holding our organs, our ashes, our bones or food for the journey, have a symbolic resonance.

Now, funerary traditions more often involve cremation, with ashes kept in urns of stone or metal; or burial, in coffins made of wood. But with the origin stories that opened this book still clear in my mind, I find an overwhelming significance to fired

clay used in burial contexts. We came from the earth, but fire (and control of it) is often what is spoken of as that which makes us human. There is something archetypal in this: in fired clay as a vessel that carries or joins us from this plane to the next. We are earth, we are clay; the fire is the spirit that brings us to life. A burial jar might be a womb from which we are reborn into another life, and in this the clay is a container for humanity. It is right that we are buried in it, with it, and that it comes with us when we die.

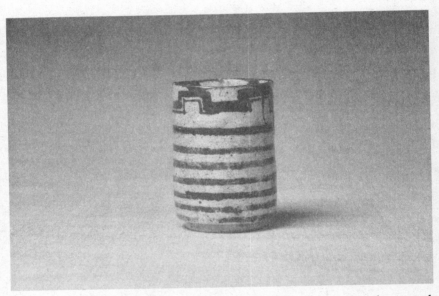

Striped tumbler with kintsugi. Made in the Edo period around the 17th Century, in Mino (now around Gifu prefecture in the middle of the mainland of Japan).

15
Repair

I'm standing in the Nara Craft Museum in Japan. In a vitrine in front of me is a large, roughly rectangular platter on stumpy legs. It's almost a stool – a slab laid like a scooped seat with a bold swirl gouged in the surface of the clay with fingertips. It is by an artist called Yusuke Nishi, and it looks like a storm on a weather map, only to either side of the storm's eye is a severe crack: two parallel fault lines from the edge to the middle, tropics of Cancer and Capricorn.

These are bold faults – devastating faults really – that would often send a piece to the bin. But Yusuke has absorbed them into the work, welcomed them by making the faults a feature. I look closer, and guess they must have happened at bisque stage or before – these are raw splits where the clay has torn itself apart from the uneven drying of a thick slab, or the faster reactions caused in a kiln. It's not unusual with a slab this thick. But instead of being discarded, the cracked piece has been glazed – drenched in a watery seaweed green with a high gloss. This glaze has sunk into the topography of the platter's swirls and raw edges, emphasising its two gruesome cracks. The decision to keep this slab, to fill it with glaze and to make it a feature, challenges what I think of as a 'successful' piece; what I think of as a fault and

what I think of as a feature. If I had pulled this from the kiln, I would have considered it a failure. Here, it is repaired by the glaze and becomes the focus of the piece.

In the process of writing this book, I have come to understand that there are big differences between repair, restoration and preservation, and how this affects the life of a clay object. In a small volume on repair, the philosopher Elizabeth Spelman goes so far as to suggest renaming *Homo sapiens* '*Homo reparens*' – writing that we are 'repairing animals'. Over the course of writing, I had often thought of this: had talked to those who repaired or conserved pottery. Most used epoxies, plaster and paints: none of them really worked with clay at all, only with finished ceramics.

Conservators at the V&A had explained to me how they 'stabilised' objects, and that the objects they worked on always had the capacity to last longer than any repairs or treatments they might receive. I perceived a tension in their role that paid attention to the way an object had aged while also freezing it in time for the museum so it could not age any further. In this way more than any other, I began to understand how museums were a sort of time machine.

I had also visited a repairer called Helen Warren in Devon, who often dealt with restorations of sentimental or valuable items. She too distinguished between restoration and conservation. A repair might look to disguise a break or chip, she had explained, whereas conservation is focused on preservation. A lost handle might be replaced to retain the form, but it might not be decorated.

What they all did was tied up with value. Cultural and historical in the V&A's case, and in Warren's often sentimental or defined by a marketplace. Her work was always a negotiation, she

explained, around an object's monetary and sentimental value. I had asked her how the repairs she did made her think about how we value material things, but she was equivocal: 'It's really just more about how much someone will pay for it, isn't it?'

When talking about ceramic repairs, kintsugi is the first thing many people think of. The word is now used as shorthand for a repair that is made visible; but the practice is of golden joinery: a system of repair in which resin, glue or lacquer is used to fix the object back together, and then decorated in gold or silver. Traditional kintsugi, involving the layering of lacquer and precious metal powders, often takes much longer than the object would originally have taken to make.

In the Folk Crafts Museum in Tokyo there are many kintsugi'd items. One in particular had stayed with me, made in the Edo period, around the seventeenth century. It was a small tumbler, striped in cream and dark brown, with a rough crenelated pattern drawn in double lines near the rim, and a shallow footring. The stripes were disrupted by kintsugi: a two-pronged brass-coloured bolt of lightning that dissected and disrupted the design, a fault line that set the stripes crooked for the rest of the tumbler's lifespan. The kintsugi denoted it as something with value, a mend that had changed the entire aesthetic identity of the pot. It celebrated the break.

Plenty in this book has been discarded or broken at one point or another in its lifetime – the Mycenaean figurines or Rengetsu's early pottery. To break something can be meaningful. To repair it gives it another meaning again. If Ai Weiwei had repaired the Han dynasty urns he photographed himself smashing, and exhibited the shards reassembled into vessels, the message would be entirely different. It's a work that is all about value – not

just the creation of the work, but in its afterlife too: the photos that constitute *Dropping a Han Dynasty Urn* are now far more valuable than the urn that was dropped (the work sold for nearly one million dollars at Sotheby's in 2016). 'People always ask me: how could you drop it?' he has said. 'I say it's a kind of love.'

The philosopher Jane Bennett writes in *Vibrant Matter* about the philosophy of 'thing power': the way we tend to divide the world into 'dull matter' and 'vibrant life' – things and beings – and to consider 'the curious ability of inanimate things to animate, to act, to produce effects dramatic and subtle'. What if we blurred this binary, she says, and began to think about the way the inanimate stuff of the world can act upon us 'as forces with trajectories, propensities or tendencies of their own'. It strikes me that this has a particular bearing on how we think of what we could, or should, repair.

We might think of all the clay and ceramic objects we encounter as acting upon us, as making up the material of our lives on Earth, from our earliest moments to the furthest future. These objects carry the stories we tell and have told, contain the secret of our skills, our artistry, our craft and our beliefs. To repair this material that accompanies us in our lives, through death into an afterlife, seems only natural. The possibility of repair speaks of value, and of the future: of continuation, of assuaging loss, correcting error. In Japan there is an aphorism that says, 'Everything that has a shape, breaks.' If this is the case, then repair is both necessary and an insurance policy; the guarantee that an object can endure. Practices like kintsugi offer the restarting of an object's lifeline, perhaps on a different trajectory. When we fire an object in the heat of a kiln, it experiences a death: the infinity of possibilities it had as plastic clay are extinguished. But repair shows us that beyond this death, an object's afterlife may take unexpected forms. This is useful, as

we move into a phase of our existence on this planet when there is a weighting towards repair rather than creation.

Across human history, clay has carried our food and our drink, we have lived in it and with it, and it has accompanied us in birth and death. When we subject this material to heat, we drag it from its infinite cycling into our human timelines, fixing its shape so we may use it. We owe it to these objects to repair or restore them for as long as possible. More generally, considering repair before disposal is a mode of thinking that might help us carry on so we can still use the objects we have made five, ten or even twenty thousand years into the future. Repair is now the roadmap. Breakages are assured and restoration seems unlikely, but if we repair the things we make, we might just be around in the future, connected to our past by the earth we have formed and fired, and that can carry the weight of our human history.

Acknowledgements

Thanks most of all to Madelaine Hanman-Murphy, who first put a lump of clay in my hands and showed me how to pinch a pot, and then continued to support my explorations through all their successes and disasters. If I had not turned up looking for something at that shipping container on the edge of the Thames, this book would never have been written.

Thanks to Keith Harrison who said something while we were hoovering liquid Playdoh from a car speaker that made me feel this book was possible. Thanks also to Toshiko, whose studio I used after the pandemic, and to everyone at Cernamic, especially Ali, Nam and Susie for bringing me in as a member.

Thanks always to my ever-supportive agent Natalie Galustian and to my editor Lee Brackstone, and my patient readers whose feedback and encouragement on drafts were essential: Laura Snoad, Ellie Matthews, Ellie Broughton, Rosie Beaumont-Thomas, Keith Harrison, and David Moats.

Thanks to all who were so generous with their time and expertise: Casey Lazonick, Jade Montserrat, Starr Goode, Ceylan Öztrük, Leila Dear, Ina Berg, Tomoko Sauvage, Andrew Popp, Charly Blackburn, Valentine Roux, Jareh Das, Florian Gadsby, Ray Meeker, Alan Jupp at Keymer Tiles, Javier Cuadros at the Natural History Museum, Tyler Didier at Seattle Pottery Supply, Greta and the archivists at the Crafts Study Centre, Paulina at

Earth Hands & Houses, Martin Karcher and the family of Nirmala Patwardhan, Colleen and the team at Mayco for the tour and the BBQ (what a great place to work), to Mike and Lou for the field trip and writing time, to Annea Lockwood for gifting the M.C. Richards mug, and everyone else who aided my research.

For tip-offs and crucial facts, thanks to: Andy Bloor, Jane Porter, Nigel Veevers, Zoe Miller, Tanya Harrod, Linda Bloomfield, John Mitchinson, Frances Scott, Amber Massie-Blomfield, Lorna Ritchie, John Higgs. Thanks also to Luke Turner, Tim Burrows, and Phillip Clark for reassuring conversations and moral support.

Bibliography

Unless otherwise stated, all interviewee quotes are taken directly from interviews with the author. Material was gathered from and accessed through archives and other repositories: CSC at Farnham, OPUS at Pacifica Graduate Institute, the M.C. Richards papers held at The Getty Research Institute. Material was also gathered on field trips to: a valley near Liskeard in Cornwall; Ráquira, Colombia; Terracotta House, Colombia; Tokoname, Japan; Stoke, Dresden, plus various museums and galleries in London, Bogotá, Dresden, LA, Chicago, Tokyo, Kyoto, Nara, Cambridge. Where sources have been used in more than one chapter, they are listed in the chapter where they are drawn on most heavily.

The referencing for this book was seriously affected by the cyber attack at the British Library in October 2023, and all attempts have been made to correctly source and reference texts used.

General reading and resources

Cardew, M. (1969) *Pioneer Pottery.* St Martin's Press
Charleston, Robert J. (Ed.) (1968) *World Ceramics: An Illustrated History.* Hamlyn
Cooper, Emmanuel (1972/1988) *A History of World Pottery.* B.T. Batsford Ltd

Freestone, I. and Gaimster, D. (Eds) (1997) *Pottery in the Making.* British Museum Press

Hamer, F. and Hamer, J. (2015) *The Potter's Dictionary of Materials and Techniques.* Bloomsbury

Leach, B. (1976) *A Potter's Book.* Faber & Faber

Livingstone, A. and Petrie, K. (Eds) (2017) *The Ceramics Reader.* Bloomsbury

Piccolpasso, C. (1934) *The Three Books of the Potter's Art.* Victoria and Albert Museum

Rice, P.M. (2015) *Pottery Analysis: A Sourcebook, Second Edition.* The University of Chicago Press

de Waal, E. and Clare, C. (2011) *The Pot Book.* Phaidon

Yanagi, S. (1972/2013) *The Unknown Craftsman.* Kodansha USA

Technical resources

glazy.org
digitalfire.com
ceramicartsnetwork.org

Introduction

Duus, M. (2006) *The Life of Isamu Noguchi: Journey Without Borders.* Princeton University Press

Mud

Baer, E. (2012) *The Golem Redux.* Wayne State University Press

Courlander, H. (1974) *A Treasury of African Folklore.* Crown Publishers

BIBLIOGRAPHY

George, A. (Trans.) (2002) *The Epic of Gilgamesh: The Babylonian Epic Poem and Other Texts in Akkadian and Sumerian.* Penguin

Hansma, H. (2010) 'Possible Origin of Life between Mica Sheets'. *Journal of Theoretical Biology.* 266. 175–188. *web.physics.ucsb. edu/~hhansma/mica.htm*

Hazen, R.M. (2010) 'Evolution of Minerals'. *Scientific American*, 302(3). 58–65. *www.jstor.org/stable/26001944*

(2005) *Genesis: The Scientific Quest for Life's Origin.* Joseph Henry Press

(2013) *The Story of Earth: The First 4.5 Billion Years, from Stardust to Living Planet.* Penguin

Huggett, J.M. (2005) 'Clay Minerals'. *Encyclopaedia of Geology.* *doi.org/10.1016/B0-12-369396-9/00273-2*

Kennedy, M., et al. (2006) Late Precambrian Oxygenation; Inception of the Clay Mineral Factory. *Science.* 311. 1446–1449. *10.1126/science.1118929*

Levi-Strauss, C. (2021) *Wild Thought.* The University of Chicago Press

Levy, M., Shibata, H., Shibata, T. (2022) *Wild Clay.* Bloomsbury

Pausanias (Trans. Jones, W.H.) (1918) *Description of Greece.* Loeb Classical Library

Righi, D., Meunier, A. (1995) 'Origin of Clays by Rock Weathering and Soil Formation'. Velde, B. (Ed.) *Origin and Mineralogy of Clays.* Springer. *doi.org/10.1007/978-3-662-12648-6_3*

Schroeder, P. (2016) 'Clays in the Critical Zone: An Introduction'. *Clays and Clay Minerals.* 64. 586–587. *doi.org/10.1346/ CCMN.2016.064045*

Velde, B. (Ed.) (2010) *Origin and Minerology of Clays.* Springer

Wilford, J.N. (April 3 1985) 'New finding backs idea that life started in clay rather than sea'. *The New York Times*

Fire

Bachelard, G. (Trans. by Ross, A.C.) (1964) *Psychoanalysis of Fire*. Routledge & Kegan Paul

Finlay, R. (2010) *The Pilgrim Art*. University of California Press

Lopez, B. (1998) 'Effleurage: The Stroke Of Fire' in *About This Life*. Harvill Press

Rhodes, D. (1968) *Kilns: Design, Construction & Operation*. Pitman Publishing

Xiaohong Wu, et al (2012) 'Early Pottery at 20,000 Years Ago in Xianrendong Cave, China'. *Science*. 336. 1696–1700. *10.1126/science.1218643*

Figures

Bailey, D.W. and Chi, J. (2010) *Lost World of Old Europe*. The Institute for the Study of the Ancient World, Princeton University Press

Feininger, A. (1961) *The Image of Woman*. Thames & Hudson

French, E. (1971) 'The Development of Mycenaean Terracotta Figurines'. *Annual of the British School at Athens*. 66. 101–187. *10.1017/S0068245400019146*

Furumark, A. (1941) *The Chronology of Mycenaean Pottery*. Stockholm [Kungl. Vitterhets, historie och Antikviets akademien]

Gimbutas, M. (1992) *Goddesses and Gods of Old Europe*. University of California Press

(2001) *The Living Goddesses*. University of California Press

(1994) *Civilisation of the Goddess*. Thorsons

(1958) *Ancient symbolism in Lithuanian Folk Art*. American Folklore Society

Goode, S. (Director) (1991) *Voice of the Goddess*. [Film]

Leslie, J. (11 June 1989) 'The Goddess Theory: Controversial

UCLA Archeologist Marija Gimbutas Argues That the World Was at Peace When God Was a Woman'. *LA Times. www. latimes.com/archives/la-xpm-1989-06-11-tm-2975-story.html*

Marler, J. (Ed.) (1998) *From the Realm of the Ancestors: An Anthology in Honor of Marija Gimbutas.* Knowledge Ideas & Trends

McDermott, L. (1996) 'Self-Representation in Upper Palaeolithic Female Figurines'. *Current Anthropology.* 37(2) 227–275. *www. jstor.org/stable/2744349*

Nowell, A. and Chang, M.L. (2014) 'Science, the Media, and Interpretations of Upper Paleolithic Figurines'. *American Anthropologist.* 116(3). 562–577. *10.1111/aman.12121*

Öztrük, C. *Call Me Venus. ceylanoztruk.com*

Renfrew, C. (2017) *Marija Redivia: DNA and Indo-European Origins.* [Video] YouTube. *www.youtube.com/watch?v=pmv3J55bdZc*

Schallin, A. and Pakkanen, P. (Eds) *Encounters with Mycenaean figures and figurines. Papers presented at a seminar at the Swedish Institute at Athens, 27–29 April 2001.* Skrifter utgivna av Svenska Institutet i Athen

Steel, L. (2020) '"Little women": Gender, performance, and gesture in Mycenaean female figurines'. *Journal of Anthropological Archaeology.* 58

Ucko, P. (1968) *Anthropomorphic Figurines.* Andrew Szmidla

Hands

Blandino, B. (1984) *Coiled Pottery.* A & C Black

Bleed, P. (1976) 'Origins of the Jōmon Technical Tradition'. *Asian Perspectives,* 19 (1) 107–115. University of Hawai'i Press. *www. jstor.org/stable/42927913*

Body Vessel Clay: Black Women, Ceramics & Contemporary Art (2022) Two Temple Place

Harrod, T. (2012) *The Last Sane Man: Michael Cardew*. Yale University Press

Kidder, J.E. (1968) *Prehistoric Japanese Arts: Jōmon Pottery*. Kodansha International

Kobayashi, T. and Kaner, S. (2003) *Jōmon Reflections*. Oxbow Books

Levi-Strauss, C. (Trans. Chorier, B.) (1998) *The Jealous Potter*. The University of Chicago Press

March, P.L. (2020) 'Project Holocene: The Clayful Phenomenology of Jōmon Flame Pots'. *Cambridge Archaeological Journal* 31(1). 1–19. doi.org/10.1017/S0959774320000189

Maria Martinez: Indian Pottery of San Ildefonso (1972) [Video] YouTube *www.youtube.com/watch?v=SkUGm87DEok*

Morse, E.S. (1879) *Shell Mounds of Omori*. Memoirs of the Science Department, University of Tokio [sic].

Odundo, M. (1995) *Interview directed by Victoria Vesna*. UC Santa Barbara. *www.youtube.com/watch?v=TRl6piSLAFg*

Peterson, S. (1977) *The Living Tradition of Maria Martinez*. Kodansha International

Wheels

Berg, I. (2020). 'The Potter's Wheel'. *Encyclopaedia of Global Archaeology*. Springer Nature

Colbeck, J. (1969) *Pottery: The Technique of Throwing*. Batsford/ Watson Guptill

Connor, J. (2017/2018) 'Across Divides: The Poetry of MC Richards'. *Appalachian Journal*. 306–310

Gadsby, F. [YouTube channel] *youtube.com/@floriangadsby*

Larousse Encyclopaedia of Mythology (1960) Prometheus Press

Pinch, G. (2004) *Egyptian Mythology*. Oxford University Press

Rhodes, D. (1978) *Pottery Form*. A & C Black.

Richards, M.C. (1989) *Centering: In Pottery, Poetry and the Person.* Wesleyan University Press.

(1973) *The Crossing Point*. Wesleyan University Press

Roux, V. (2009) 'Revisiting the History of the Potter's Wheel in the Southern Levant'. *Levant*. 41(2). 155–173. *doi.org.10.1179/00 7589109X12484491671095*

Roux, V. and Harush, O. (2022) 'Unveiling the sign value of early potter's wheels based on a 3-D morphometric analysis of Late Chalcolithic vessels from the southern Levant'. *Journal of Archaeological Science: Reports*. 45. *doi.org/10.1016/j. jasrep.2022.103557*

Sodeoka K. and Simpson, P. (2014) *The Japanese Pottery Handbook: Revised Edition*. Kodansha USA

Sorkin, J. (2016) *Live Form: Women, Ceramics, and Community*. The University of Chicago Press

(2013) 'The Pottery Happening: M. C. Richards's Clay Things to Touch (1958)' in *Getty Research Journal*, 5. 197–202

Veach Noble, J. (1988) *The Techniques of Painted Attic Pottery*. Thames & Hudson

Food

Abrahams, P.W. and Parsons, J.A. (1996) 'Geophagy in the Tropics: A Literature Review'. *The Geographical Journal*. 162(1). 63–72. *jstor.org/stable/3060216*

Buruma, I. (2018) *A Tokyo Romance*. Penguin Press

Crichton-Miller, E. (2017) 'The Tale of Russia's revolutionary ceramics'. *Royal Academy Magazine*. *www.royalacademy.org.uk/ article/magazine-the-tale-of-russias-revolutionary-ceramics*

Goldmark Gallery (2012) *Lisa Hammond: 'A Sense of Adventure'*

feature film about British potter [YouTube] *www.youtube.com/
watch?v=JSDhR5__kRM*

Hasluck, F.W. (1910) Terra Lemnia. *Annual of the British School
at Athens.* 16. 220–231

von Humboldt, A. (2022) *Aspects of nature, in different lands and
different climates (Vol. 1 of 2, (1849)). www.gutenberg.org/cache/
epub/67183/pg67183.*

Hunter J.M. and de Kleine, R. (1984) 'Geophagy in Central
America'. *Geographical Review.* 74 (2). 157–169. *jstor.org/
stable/214097*

Khayyám, O. (2008) *Rubáiyát of Omar Khayyám.* LXII. Available
at: *www.gutenberg.org/files/246/246-h/246-h.htm*

Laufer, B. (1930) *Geophagy.* Field Museum Press

Lobanov-Rostovsky, N. (1990) *Revolutionary Ceramics: Soviet
Porcelain, 1917–27.* Cassell Illustrated

Okakura, K. (2010) *The Book of Tea.* Penguin

Yanagi, S. (2013) *The Unknown Craftsman.* Kodansha USA

Yanagi, S. (2019) *The Beauty of Everyday Things.* Penguin

Words

'A love song of Shu-Sin (Shu-Suen B)' Trans. *The Electronic Text
Corpus of Sumerian Literature. etcsl.orinst.ox.ac.uk/section2/
tr2442.htm#*

Buylaere, G.V., Watanabe C.E., Altaweel, M. (2019) '"Clay Pit,
You Are the Creator of God and Man!": Textual Evidence
for the Sources of Raw Clay Used in Mesopotamia'. *Orient:
Journal of Society for the Near Eastern Studies in Japan.* Sup-
plement I, 175–192

Chaney, M.A. (Ed.) (2018) *Where Is All My Relation? The Poetics
of Dave the Potter.* Oxford University Press

Charpin, D. (2010) *Reading and Writing in Babylon*. Harvard University Press

Fincke, J.C. (2003) 'The Babylonian Texts of Nineveh: Report on the British Museum's Ashurbanipal Library Project'. *Archiv für Orientforschung (AfO)/Institut für Orientalistik. jstor.org/ stable/41668620*

Finkel, I., Taylor, J. (2015) *Cuneiform*. British Museum Press

Finkel, J. (17 June 2021) 'The Enslaved Artist Whose Pottery Was an Act of Resistance'. *The New York Times*

Gates, T. (2021) *Clay Sermon*. Exhibited at Whitechapel Gallery, 29 September 2021–9 January 2022

Geller, M.J. (2009) The Last Wedge. *Zeitschrift für Assyriologie und Vorderasiatische Archäologie. doi.org/10.1515/zava.1997.87.1.43*

Isoda, M. (Trans. Carpenter, J.W.) (2017) *Unsung Heroes of Old Japan*. Japan Publishing Industry Foundation for Culture

Kramer, S.N. (1956) *History Begins at Sumer*. University of Pennsylvania Press

Pollock, S. (2016) 'From Clay to Stone: Material Practices and Writing in Third Millennium Mesopotamia'. Balke, T. and Tsouparopoulou C. (Eds), *Materiality of Writing in Early Mesopotamia* (277–292). De Gruyter. *doi.org/10.1515/9783110459630-013*

Roux, G. (1964) *Ancient Iraq*. Penguin

Smith, G. (1873) *The Chaldean Account of the Genesis*. Project Gutenberg. *gutenberg.org/files/60559/60559-h/60559-h.htm*

Stevens, J. (1994) *Lotus Moon: The Poetry of the Buddhist Nun Rengetsu*. Weatherhill Inc

Todd, L. (2009) *Carolina Clay – The Life and Legend of the Slave Potter Dave*. W. W. Norton & Company

Veenhof, K.R. (Ed.) *Cuneiform Archives and Libraries: Papers Read at the 30e Rencontre Assyriologique Internationale, Leiden, 4–8*

July 1983. (1986). Netherlands: Nederlands Historisch-Archae-
ologisch Instituut te Istanbul

de Waal, E. (8 October 2021) 'Theaster Gates on "Clay Sermon"
and the stories objects tell'. *Financial Times*

Colour

Baxandall, M. (1972/88) *Painting and Experience in Fifteenth
Century Italy.* Oxford University Press

Bloomfield, L. (2011) *Colour in Glazes.* A&C Black Visual Arts
(2017) *Science for Potters.* American Ceramic Society
(2018) *The Handbook of Glaze Recipes.* Herbert Press

Cooper, E. (2004) *The Potter's Book of Glaze Recipes.* Herbert Press

Gill, B. (2008) 'Potter: The Pleasure of Pottery'. *Ceramic Review.* 230

Horbury, D. (Ed.) (2019) *Making Emmanuel Cooper: Life and
Work from his Memoirs, Letters, Diaries and Interviews.* Unicorn

Nairne, A. and Spindel, E. (Eds) (2023) *Lucie Rie: The Adventure
of Pottery.* Kettle's Yard

Patwardhan, N. (1984) *A Handbook for Potters. handbookforpot-
ters2953318241.wordpress.com*

Pleydell-Bouverie, K. (1987) *Katharine Pleydell-Bouverie: A Potter's
Life, 1895–1985.* Crafts Council

Sound

Ayers, J., Impey, O. and Mallett, J.V.G. (1990) *Porcelain for
Palaces: The Fashion for Japan in Europe, 1650–1750.* Oriental
Ceramic Society

Bushell S.W. (1910) *Description of Chinese pottery and porcelain,
being a translation of the T'ao Shuo.* Clarendon Press

BIBLIOGRAPHY

David, P. (1971) *Chinese Connoisseurship: The Ko Ku Yao Lun: The Essential Criteria of Antiquities.* Faber & Faber

Emerson, J. (2000) *Porcelain Stories: From China to Europe.* Seattle Art Museum

d'Entrecolles, Père (2007) Letters 1712/1722. gotheborg.com/letters

Fang, L. (2011) *Chinese Ceramics.* Cambridge University Press

Finlay, R. (2010) *The Pilgrim Art.* University of California Press

Gerritsen, A. (2020) *The City of Blue and White.* Cambridge University Press

Gleeson, J. (1999) *The Arcanum.* Bantam

Gutiérrez, A., et al (2021) 'The earliest Chinese ceramics in Europe?' *Antiquity.* 95(383). 1213–1230. *doi.org/10.15184/aqy.2021.95*

Huang, E. (2008) *China's china: Jingdezhen Porcelain and the Production of Art in the Nineteenth Century.* [Doctoral Thesis: UC San Diego] *escholarship.org/uc/item/43w755pg*

Kerr, R., et al (2004) Song Dynasty Ceramics. Victoria & Albert Museum

Needham, J. (2004) *Science and Civilisation in China, Part 12, Ceramic Technology: Chemistry and Chemical Technology: 05.* Cambridge University Press

Polo, M. (1958) *The Travels.* Penguin

Sayer, G.R. (Trans.) (1951) *Ching-tê-chen, T'ao-Lu, or the potteries of China.* Routledge & Kegan Paul
(1959) *T'ao Ya, or pottery refinements.* Routledge & Kegan Paul

Vainker, S. (1995) *Chinese Pottery and Porcelain.* British Museum Press

de Waal, E. (2015) *The White Road.* Chatto & Windus

Wittwer, S. (2001) *A Royal Menagerie: Meissen Porcelain Animals.* J. Paul Getty Museum

Shapes

Ball, P. (2013) 'Fearful symmetry: Roger Penrose's tiling'. *Prospect Magazine. prospectmagazine.co.uk/ideas/philosophy/51532/fearful-symmetry-roger-penroses-tiling*

Behrens-Abouseif, D. (1999) *Beauty in Arabic Culture.* Princeton Series on the Middle East

Birks, T. (1983) *Hans Coper.* Stenlake Publishing

Critchlow, K. (1976) *Islamic Patterns: An Analytical and Cosmological Approach.* Thames & Hudson

Cruickshank, D. & Hall, W. (2015) *BRICK.* Phaidon

Hugo, V. (1862) 'Grenade' in Les Orientales. Librairie de L. Hachette et Cie

Lu P.J. & Steinhardt P.J. (2007) Decagonal and Quasi-Crystalline Tilings in Medieval Islamic Architecture. *Science.*315. 1106–1110

Necipoğlu, G. (1996). *The Topkapi Scroll: Geometry and Ornament in Islamic Architecture.* Getty. *getty.edu/publications/virtuallibrary/9780892363353.html*

Porter, V. (2004) *Islamic Tiles.* Interlink Books

Temenos Academy (2018) *Keith Critchlow: The Art of the Ever-True* [Video]. YouTube. *youtube.com/watch?v=6VIqwLOUKrI*

Van Lemmen, H. (2013) *5000 Years of Tiles.* British Museum Press

Walls

Alain and Patricia/Auroville Trust (1989) *1989 Agni Jata – Fire Born* [Video] YouTube *youtube.com/watch?v=GeG32VwCwnE*

Bourgeois, J.L. (23 December 1990) 'Half Baked Design?' *LA Times*
'Fired-Earth Home Process Developed by Local Architect'
(November 11 1990) *LA Times*

Khalili, N. (1983) *Racing Alone.* Harper & Row
(1986) *Ceramic Houses and Earth Architecture.* Cal-Earth Press
(1994) *Sidewalks on the Moon.* Cal-Earth Press

Kuhn, A. (January 27 2016) 'China's Great Wall Is Crumbling
In Many Places; Can It Be Saved?' *NPR. npr.org/sections/
parallels/2016/01/27/464421353/chinas-great-wall-is-crumbling-
in-many-places-can-it-be-saved*

Kundoo, A. (2008) *Building with Fire: Baked-Insitu Mud Houses
of India: Evolution and Analysis of Ray Meeker's Experiments*
[Bachelor of Architecture]

Moran, B. (11 November 1990) 'Former Contractor Uses Mate-
rials From the Soil "Geltaftan" Technique to Build His Own
Ceramic Dome Home: Feat of Clay'. *LA Times*

Cities

Baring-Gould, S. (1901) *The Frobishers; A Story of the Staffordshire
Potteries.* Methuen & Co

Bennett, A. (1902) *Anna Of The Five Towns.* Chatto & Windus

Bennett, A. (2000) *The Old Wives' Tale.* Academy Chicago

Cort, L. (1979) *Shigaraki: Potters' Valley.* Kodansha America

Hunt, T. (2021) *The Radical Potter: The Life and Times of Josiah
Wedgwood.* Penguin

Popp, A. (2003) The True Potter: Identity and Entrepreneurship
in the North Staffordshire Potteries in the Late Nineteenth
Century. *Journal of Historical Geography* 29(3). 317–335

Priestley, J.B. (1934) *English Journey.* Heinemann

Rhodes, D. (1970) *Tamba Pottery*. Kodansha America

Sawada, Y. (1982) *Tokoname*. Kodansha America

Scarratt, W. (1906) *Old Times in the Potteries*. William Scarratt – Sunnyside Stoke-on-Trent

Sekers, D. (2009) *The Potteries*. Shire Publications

The Six Ancient Kilns official website. en.sixancientkilns.jp

Weatherill, L. (1971) *The Pottery Trade and North Staffordshire, 1660–1760*. Manchester University Press

Space

Cuadros, J. (2015) 'Clays are messy–also on Mars'. *American Mineralogist. doi.org/10.2138/am-2015-5229*

Hartman, B. (2021) 'Martianware Pottery Clay'. *Seattle Pottery Supply. seattlepotterysupply.com/blogs/experimental-ceramics/martian*

Milliken, R.E. (2008) Which clays are really present on Mars and how did they form? *Martian Phyllosilicates: Recorders of Aqueous Processes*

NASA's Curiosity Mars Rover Finds a Clay Cache (29 May 2019) *NASA Science Mars Exploration.* mars.nasa.gov/news/8442/nasas-curiosity-mars-rover-finds-a-clay-cache

NASA (2008) *First Image of Mars*. [Taken on 20 July 1976] *www.nasa.gov/image-article/first-image-of-mars*

O'Callaghan, J. (28 June 2021) 'Clays found in Martian crater hint that the planet was once habitable'. *New Scientist*

Rieder, R., et al. (1997) The Chemical Composition of Martian Soil and Rocks Returned by the Mobile Alpha Proton X-ray Spectrometer: Preliminary Results from the X-ray Mode. *Science.* 278

Stewart Johnson, S. (2020) *The Sirens of Mars*. Penguin

Death

Bawden, G. (1996) *The Moche.* The University of Chicago Press

Bourget, S. (2006) *Sex, Death, and Sacrifice in Moche Religion and Visual Culture.* University of Texas Press

Davidson, D.S. (1949). Mourning-Caps of the Australian Aborigines. *Proceedings of the American Philosophical Society,* 93(1), 57–70. *jstor.org/stable/3143272*

Donnan, C.B. and McClelland, D. (1999) *Moche Fineline Painting: Its Evolution and Its Artists.* UCLA Fowler Museum of Cultural History

Garcia, C. and Haruna, T. (2017) 'Death and Clay: Cultural and Personal Interpretations in Ceramics' in Petrie, K. and Livingstone, A. (Eds) (2017) *The Ceramics Reader.* Bloomsbury

Goddard, R.H. (1936) 'Kopi: Funerary Skull Caps'. *Mankind* 2(1). 25

Hoyle, R.L. (1965) *Checan: Essay on Erotic Elements in Peruvian Art.* Nagel

Lowinger, R. (2011) Repair. *Change Over Time.* University of Pennsylvania Press. 1(1). 138–144

Nickel, L. (2013) The First Emperor and sculpture in China. *Bulletin of the School of Oriental and African Studies.* 76(3). 413–447. *doi.org/10.1017/S0041977X13000487*

Portal, J. (2007) *The First Emperor: China's Terracotta Army.* The British Museum Press

(2008) *Terra Cotta Warriors: Guardians of China's First Emperor.* National Geographic Society

Quilter, J. (2020) 'Moche Mortuary Pottery and Culture Change'. *Latin American Antiquity.* 31(3). 1–20

(2011). *The Moche of Ancient Peru: Media and Messages.* Peabody Museum Press

(2017) *Tales of the Moche Kings and Queens: Elite Burials from the North Coast of Peru.* [Video] Peabody Museum of Archaeology & Ethnology. *youtube.com/watch?v=4pI21jI6vfY*

Surya, M. (2002) *George Bataille: An Intellectual Biography.* Verso

Trever, L. (2019) A Moche Riddle in Clay: Object Knowledge and Art Work in Ancient Peru. *The Art Bulletin.* 101(4). 18–38. *doi.org/10.1080/00043079.2019.1602449*

Repair

Bennett, J. (2009) *Vibrant Matter: A Political Ecology of Things.* Duke University Press

Beres, T. W-Y (2015) A Battlefield of Judgements: Ai Weiwei as Collector. *Orientations* 46(7). 87–92

Guide of the Japan Folk Crafts Museum (2016) Japan Folk Crafts Museum

Kemske, B. (2021) *Kintsugi: The Poetic Mend.* Herbert Press

Spelman, E.V. (2002) *Repair: The Impulse to Restore in a Fragile World.* Beacon Press

Weiwei, A. (1995) *Dropping a Han Dynasty Urn*

Sources of quotations

Introduction

'**close embrace of the earth . . .**', Isamu Noguchi quoted in Duus, M. (2006) *The Life of Isamu Noguchi: Journey Without Borders*. p. 134

Mud

'**They smell very like the skin of a man . . .**', Pausanias (Trans. Jones, W. H.) (1918) *Description of Greece*. Loeb Classical Library. pp. 385–387

'**everything around him softening**', Courlander, H. (1974) *A Treasury of African Folklore*. Crown Publishers. p. 191

'**an accumulation of chemical mistakes**', Wilford, J.N. (April 3 1985) 'New finding backs idea that life started in clay rather than sea'. *The New York Times*

'**millions of tiny weathered pockets . . .**' to '**. . . each pore and crack a separate experiment in molecular self-organization**', Hazen, R.M. (2005) *Genesis: The Scientific Quest for Life's Origin*. Joseph Henry Press. p. 156

'**It is of little use to minimise its complexity . . .**', Rice, P.M. (2015) *Pottery Analysis: A Sourcebook, Second Edition*. The University of Chicago Press. p. 35

'a diverse group of hydrous layer aluminosilicates . . .', Huggett, J.M. (2005) 'Clay Minerals'. *Encyclopaedia of Geology.* p. 358

'there was time to experiment, try out new glazes . . .', Cooper diary extract in: Horbury, D. (Ed.) (2019) *Making Emmanuel Cooper: Life and Work from his Memoirs, Letters, Diaries and Interviews.* Unicorn. p. 133

'The men in the potter's art in the city of Urbino . . .' to '. . . they steal from this bank and that', from the first book in: Piccolpasso, C. (1934) *The Three Books of the Potter's Art.* Victoria and Albert Museum. np

Fire

'the ultra living element . . .' to '. . . burns in hell', Bachelard, G. (Trans. by Ross, A.C.) (1964) *Psychoanalysis of Fire.* Routledge & Kegan Paul. p. 7

'giving up to the metamorphic forces of the fire', Rhodes, D. (1968) *Kilns: Design Construction & Operation.* Pitman Publishing. p. 189

'The manner of making the kiln [is] as an important secret . . .', Piccolpasso quoted in Finlay, R. (2010) *The Pilgrim Art.* University of California Press. p. 92

'I actually saw the current of white heat moving slowly through the kiln . . .' to '. . . spectral eggs visible in a fundament of white heat', Lopez, B. (1998) 'Effleurage: The Stroke Of Fire' in *About This Life.* Harvill Press. p. 163

'as if a vibration at these points creates an incandescence of sufficient heat to fuse the tips together', Hamer, F. and Hamer, J. (2015) *The Potter's Dictionary of Materials and Techniques.* Bloomsbury. p. 138.

'a kind of death', Rhodes, D. (1968) *Kilns: Design Construction & Operation.* Pitman Publishing. p. 189

'Often the kiln confers graces on the pot . . .', ibid

SOURCES OF QUOTATIONS

Figures

'Often where sites reach several metres deep . . .' to '. . . generation after generation of inhabitants', Gimbutas, M. (2001) *The Living Goddesses*. University of California Press. p. 4

'Should we ask ourselves . . .', Gimbutas, M. (1958) *Ancient symbolism in Lithuanian Folk Art*. American Folklore Society. p. 124

'weapons, weapons, weapons . . .', Gimbutas quoted in Leslie, J. (11 June 1989) The Goddess Theory: Controversial UCLA Archeologist Marija Gimbutas Argues That the World Was at Peace When God Was a Woman. *LA Times*

'citylike' and 'larger than the earliest cities of Mesopotamia', Anthony, D. 'The Rise and Fall of Old Europe' in Bailey, D.W. and Chi, J. (2010) *Lost World of Old Europe*. The Institute for the Study of the Ancient World, Princeton University Press. p. 29

'The presence of the bird and snake goddess . . .', Gimbutas, M. (1992) *Goddesses and Gods of Old Europe*. University of California Press. p. 112

'the function of these objects is to be found at a deeper level of reality . . .', Bailey, D.W. and Chi, J. (2010) *Lost World of Old Europe*. The Institute for the Study of the Ancient World, Princeton University Press. p. 124

Hands

'spill out . . .', Blandino, B. (1984) *Coiled Pottery*. A & C Black. p. 9

'The flame pots, as if predicting their own destiny . . .', Kobayashi, T. and Kaner, S. (2003) *Jōmon Reflections*. Oxbow Books. p. 70

'a dazzling personality . . .' to '. . . big fine pots', Harrod, T. (2012) *The Last Sane Man: Michael Cardew*. Yale University Press. p. 265

'the translation of her traditional hand built pots . . .', ibid. p. 265

'marked inside with a diagonal pattern . . .', Cardew, M. (1969) *Pioneer Pottery*. St Martin's Press. p. 88

'how a mist rose up from the floor . . .', Harrod, T. (2012) *The Last Sane Man: Michael Cardew*. Yale University Press. p. 350

'traces of the storyteller cling to a story . . .', Benjamin, W. (1969) 'The Storyteller: Reflections on the Works of Nikolai Leskov'. in Arendt, H. (Ed.) Zohn, H. (Trans.) *Illuminations: Essays and Reflections*. New Schocken. p. 92

'to turn unstable clay . . .', Levi-Strauss, C. (2021) *Wild Thought*. The University of Chicago Press. pp. 17–18

'an exercise towards "real" potting', Blandino, B. (1984) *Coiled Pottery*. A & C Black. p. 9

'a way of building pots . . .', ibid.

'arresting a dancer in a gesture they cannot repeat again . . .', Odundo, M. (2019) *The Journey Of Things*. Hepworth Wakefield. np

Wheels

'Anyone who watches a pot grow . . .', Leach, B. (1976) *A Potter's Book*. Faber & Faber. p. 71

'Any verbal description of the manipulation of clay on a potter's wheel . . .', ibid. p. 70

'No written description, however careful . . .', Cardew, M. (1969) *Pioneer Pottery*. St Martin's Press. p. 97

SOURCES OF QUOTATIONS

'The simplicity of the process in terms of tools . . .', Rhodes, D. (1976) *Pottery Form*. Clay Space. p. 29

'Centring is done by the logical application . . .', Colbeck, J. (1969) *Pottery: The Technique of Throwing*. Batsford/Watson Guptill. p. 24

'the hardest thing comes at the very beginning . . .', Turner quoted in Richards, M.C. (1989) *Richards, M. C. (1989) Centering: In Pottery, Poetry and the Person. Wesleyan University Press*. p. 11

'so that when touched at any one point, the whole body of the clay will take form', Richards, M.C. (1973) *The Crossing Point*. Wesleyan University Press. p. 55

'the bringing of clay into a spinning, unwobbling pivot . . .', ibid. p. 9

'I find the potter's craft of centring the clay enacted in all realms of life', Richards, M.C. (1973) *The Crossing Point*. Wesleyan University Press. p. 4

'embraced the role of enlightened amateur', Sorkin, J. (2013) 'The Pottery Happening: M. C. Richards's Clay Things to Touch (1958)' in *Getty Research Journal*. 5. Getty. pp. 197–202

'returned clay to its roots as a pliant and connective material', ibid.

'He was centring the clay, and then he was opening it', Richards, M.C. (1989) *Centering: In Pottery, Poetry and the Person*. Wesleyan University Press. p. 13

Food

'consuming earth, mud or clay . . .', Laufer, B. (1930) *Geophagy*. Field Museum Press. p. 102

'swallow great quantities of earth . . .' to 'due to a little oxide of iron', von Humboldt, A. (2022) *Aspects of nature, in different lands and different climates (Vol. 1 of 2, 1849)*. https://www.gutenberg.org/cache/epub/67183/pg67183. p. 25

'compared favourably', Hunter J.M. and de Kleine, R. (1984) 'Geophagy in Central America. *Geographical Review*'. 74 (2). p. 169

'the earth was found in a tunnel-like aperture . . .', Hasluck, F.W. (1910) Terra Lemnia. *Annual of the British School at Athens*. 16. 220–231. p. 221

'Even people who don't buy hand made mugs will often have a favourite mug . . .', Hammond, L. in Goldmark Gallery (2012) *Lisa Hammond: 'A Sense of Adventure' feature film about British potter* [YouTube] www.youtube.com/watch?v=JSDhR5__kRM

'Ne'er a peevish Boy/Would break the Bowl from which he drank in joy', from the *Rubáiyát of Omar Khayyám. LXII* (2008) Available at: www.gutenberg.org/files/246/246-h/246-h.htm

'that it would have been so much better if we had arrived on time', Buruma, I. (2018) *A Tokyo Romance*. Penguin Press. p. 110

'The celestial porcelain, as is well known . . .', Okakura, K. (2010) *The Book of Tea*. Penguin. p. 31

'For a long time I had wished to see this Kizaemon bowl . . .', Yanagi, S. (2013) *The Unknown Craftsman*. Kodansha USA. pp. 191–192

'took absolutely no notice of it', Lobanov-Rostovsky, N. (1990) *Revolutionary Ceramics: Soviet Porcelain, 1917–27*. Cassell Illustrated. p. 13

Words

'depository in the palace of Nineveh . . .', Layard (1853) *Discoveries in the ruins of Nineveh and Babylon* quoted in Fincke, J.C. (2003) *The Babylonian*

SOURCES OF QUOTATIONS

Texts of Nineveh: Report on the British Museum's Ashurbanipal Library Project. p. 113

'My Fish, I have built a house for you . . .', Kramer, S.N. (1956) *History Begins at Sumer.* University of Pennsylvania Press. p. 348

'in a few thousand years, our photographs, books and hard disks will no doubt have disappeared . . .', Charpin, D. (2010) *Reading and Writing in Babylon.* Harvard University Press. p. 15

'Graphically the signature enunciates . . .', Introduction to: Chaney, M.A. (Ed.) (2018) *Where Is All My Relation? The Poetics of Dave the Potter.* Oxford University Press. p. 5

'personhood interjected', ibid.

'write passes to freedom', Lasser, E.W. in 'Writing In Clay: The Materiality of Dave's Poetry' from Chaney, M.A. (Ed.) (2018) *Where Is All My Relation? The Poetics of Dave the Potter.* Oxford University Press. p. 141

'a whole lot of imagining' to **'to build a noble jar'**, from Theaster Gates's 2010 exhibition *To Speculate Darkly: Theaster Gates and Dave the Potter.*

'difficult and frustrating', Todd, L. (2009) *Carolina Clay – The Life and Legend of the Slave Potter Dave.* W. W. Norton & Company. p. 45

'iconoclastic acts' to **'a permanent background for a text'**, Lasser, E.W. in 'Writing In Clay: The Materiality of Dave's Poetry' from Chaney, M.A. (Ed.) (2018) *Where Is All My Relation? The Poetics of Dave the Potter.* Oxford University Press. p. 143

'a culturally specific way of representing the sounds and rhythms . . .', Shockley, E. 'A Letter to David Drake from a Friend and a Relation' in ibid. p. 53

'It's great that his stuff has been rediscovered . . .', from transcript with Loraine James, (2022) 'For a long time I didn't even know Black composers existed: it's not just an absence, it's erasure'. *Guardian*

'The other ladies in waiting were appalled that . . .', Isoda, M. (Trans. Carpenter, J.W.) (2017) *Unsung Heroes of Old Japan*. Japan Publishing Industry Foundation for Culture. p. 161

'describe something directly . . .' to '. . . the ring of truth', ibid. pp. 169–170

'Slender graceful fingers were a symbol of feminine beauty' to 'considered to have lost her looks', ibid. p. 181

'second and third rate artists were selling well' to 'signed goods', Yanagi, S. (2013) *The Unknown Craftsman*. Kodansha USA p. 224

'make things to be used . . .', ibid.

Colour

'a few of the blues were overdone . . .', Leach, B. (1976) *A Potter's Book*. Faber & Faber. p. 254

'The exotic and dangerous character of ultramarine', Baxandall, M. (1972/88) *Painting and Experience in Fifteenth Century Italy*. Oxford University Press. p. 11

'Ray had faith in my glazes', Gill, B. (2008) 'Potter: The Pleasure Of Pottery'. *Ceramic Review*. p. 230

'In 1961 I was not good at potting . . .', Nirmala Pawardhan to Martin Karcher, personal correspondence

'**things like pebbles and shells and birds' eggs**', Pleydell-Bouverie, K. (1987) *Katharine Pleydell-Bouverie: A Potter's Life, 1895–1985*. Crafts Council. p. 7

Sound

'**They have in China a very fine clay with which they make vases which are as transparent as glass**', Suleiman quoted in Temple, Robert K.G. (2007). *The Genius of China: 3,000 Years of Science, Discovery, and Invention (3rd edition)*. André Deutsch. pp. 103–6

'**white like jade . . .**' to '**. . . sounds like a bell**', quoted unattributed in various places including in Cosentino, F.J. (1984) *The Boehm journey to Ching-te-Chen China birthplace of porcelain*. Edward Marshall Boehm. p. 111

'**Pinch a walnut-sized piece between thumb and forefinger . . .**', de Waal, E. (2015) *The White Road*. Chatto & Windus. p. 5

'**crisp metalling ring**', Fang, L. (2011) *Chinese Ceramics*. Cambridge University Press. np

'**especially suited to drinking of red tea**', Needham, J. (2004) *Science and Civilisation in China, Part 12, Ceramic Technology: Chemistry and Chemical Technology: 05*. Cambridge University Press. p. 152

'**By the middle of the 14th century, large dishes were densely decorated**', Vainker, S. (1995) *Chinese Pottery and Porcelain*. British Museum Press. p. 139

'**the blue and white (qinghua) and the multi-coloured (wuse) specimens are vulgar in taste**', Gardner Gates, M. (2000) 'Blue and White' in Emerson, J. (2000) *Porcelain Stories: From China to Europe*. Seattle Art Museum. np

'flummery of ideas', de Waal, E. (2015) *The White Road*. Chatto & Windus. p. 15

'the most irreproachably aristocratic . . .', ibid. p. 14

'the people of the city gather mud and decomposing earth . . .', Polo, M. (1958) *The Travels*. Penguin. p. 223

'like a man who gropes in the dark', Bernard Palissy quoted in 1911 Encyclopædia Britannica.

'a distinctive paste made of strange ingredients', described at Getty Museum Collection www.getty.edu/art/collection/group/103KBW

'The mountains' stony body . . .', Needham, J. (2004) *Science and Civilisation in China, Part 12, Ceramic Technology: Chemistry and Chemical Technology: 05*. Cambridge University Press. p. 28

'an avid porcelain collector and a self-professed lover of alcohol', Huang, E. (2008) *China's china: Jingdezhen Porcelain and the Production of Art in the Nineteenth Century*. [Doctoral Thesis: UC San Diego] p. 197

'whirlwinds of flame and smoke . . .', from the first letter in 1712 from Père d'Entrecolles (2007) https://gotheborg.com/letters/

'It is from kaolin that fine porcelain draws its strength', ibid.

'accumulator' and **'discriminating collector'**, Ayers, J., Impey, O. and Mallett, J.V.G. (1990) *Porcelain for Palaces: The Fashion for Japan in Europe, 1650–1750*. Oriental Ceramic Society. p. 65

'a hellish scene . . .' to **'. . . repeatedly said "O Jesus"'**, Gleeson, J. (1999) *The Arcanum*. Bantam. p. 62

'fine white porcelain', ibid. p. 63

SOURCES OF QUOTATIONS

'tiers upon tier of plates, saucers and vases . . .', Ayers, J., Impey, O. and Mallett, J.V.G. (1990) *Porcelain for Palaces: The Fashion for Japan in Europe, 1650–1750.* Oriental Ceramic Society. p. 65

'all kinds of birds and beasts . . .', Gleeson, J. (1999) *The Arcanum.* Bantam. p. 177

'the workers make some ducks . . .', From the first letter in 1712 from Père d'Entrecolles (2007) https://gotheborg.com/letters/

'a round intelligent face, a mischievous smile and an affable manner', Gleeson, J. (1999) *The Arcanum.* Bantam. p. 182

'Porcelain had never come so close to imitating the essence of life itself', ibid. p. 190

'water cups are musical instruments' to 'completing the scale', in chapter 30 of the *Tao Lu.* Sayer, G.R. (Trans.) (1951) *Ching-tê-chen, T'ao-Lu, or the potteries of China.* Routledge & Kegan Paul. np

'a kind of little organ called "tsem" . . .', From the first letter in 1712 from Père d'Entrecolles (2007) https://gotheborg.com/letters/

Shape

'infilling of prefabricated structures . . .', Birks, T. (1983) *Hans Coper.* Stenlake Publishing. p. 44

'I wanted to do something big and I did', from Watts Towers website: www.wattstowers.org

'almost hears pulsing', Qabbani, N. 'Granada' available on various sites including: www.arabamerica.com/granada-poem-nizar-qabbani

'gilded like a dream' and 'filled with harmonies', translation from Hugo, V. (1859) 'Grenade' in *Les Orientales*. Librairie de L. Hachette et Cie. p. 115

'nearly perfect quasi-crystalline Penrose patterns, five centuries before their discovery in the West', Lu P.J. & Steinhardt P.J. (2007) Decagonal and Quasi-Crystalline Tilings in Medieval Islamic Architecture. *Science*. 315. p. 1106

'Each girih tile is decorated with lines . . .', ibid.

'a nearly perfect quasi-crystalline Penrose pattern', ibid.

'My favourite anecdote is of Penrose inspecting a new tiling . . .', Ball, P. (2013) Fearful symmetry: Roger Penrose's tiling. *Prospect Magazine*. *www.prospectmagazine.co.uk/ideas/philosophy/51532/fearful-symmetry-roger-penroses-tiling*

'Right at the very beginning geometry had to be established . . .', from Temenos Academy (2018) *Keith Critchlow: The Art of the Ever-True* [Video]. *youtube.com/watch?v=6VIqwLOUKrI*

Walls

'The torch is ready for a match . . .', Khalili, N. (1983) *Racing Alone*. Harper & Row. p. 194

'My ultimate goal . . .', ibid. p. 29

'I explain to him what I am going to do . . .', ibid. p. 166

'one of the most beautiful sights I have ever seen in my life . . .', ibid. p. 213

'My anger and worried feelings change into joy . . .', ibid. p. 218

'The word WATER is shimmering on the wall . . .', ibid. p. 234

'Gilgamesh realised that his name stamped on hard bricks . . .', Cruick-shank, D. & Hall, W. (2015) *BRICK*. Phaidon. p. 10

Cities

'The four Tokoname villages have produced pottery since ancient times', from the Six Ancient Kilns official website: https://en.sixancient-kilns.jp/

'the window next to the bath . . .', Koji Takahashi, quoted on ibid.

'the sharp edge of the lip, the powerful swell of the body', Sawada, Y. (1982) *Tokoname*. Kodansha America. p. 8

'a masculine strength in their magnificently swelling shoulders, powerful lips and rugged clay surfaces', ibid.

'the most dreadful places I have seen . . .', Orwell, G. (1936) *Diary*, available at: theroadtowiganpier.wordpress.com/2011/02/03/3-2-36

'extremely ugly . . .' to 'seems a miracle', Priestley, J.B. (1934) *English Journey*. Heinemann. pp. 210–211

'takes a conscious pride in the antiquity of the potter's craft', Arnold Bennett quoted in Hunt, T. (2021) *The Radical Potter: The Life and Times of Josiah Wedgwood*. Penguin. p. 28

'Unless you are prepared to take a deep and lasting interest in what happens inside those ovens . . .', Priestley, J.B. (1934) *English Journey*. Heinemann. p. 209

'Here might be seen on fine days . . .', Scarratt, W. (1906) *Old Times in the Potteries*. William Scarratt – Sunnyside Stoke-on-Trent. p. 52

'elevated patch of moorland . . .' to '. . . and dog fighting', Hunt, T. (2021) *The Radical Potter: The Life and Times of Josiah Wedgwood*. Penguin. p. 51

'From the north of the county down to the south', Bennett, A. (2000) *The Old Wives' Tale*. Academy Chicago. p. 15

'Alas, I must be content with fashioning my clay at a humble distance from such company', Popp, A, quoting from archival Wedgwood letters in interview with the author in 2023

Space

'a clay body that is truly out of this world', Hartman, B. (2021) 'Martianware Pottery Clay'. *Seattle Pottery Supply*

Death

'funereal megalomania', Portal, J. (2007) *The First Emperor: China's Terracotta Army*. The British Museum Press. p. 162

'These perfectly executed life sized sculptures . . .', ibid. p. 26

'The first question that arises is why the ancient Peruvians placed erotic pottery in the tombs . . .', Hoyle, R.L. (1965) *Checan: Essay on Erotic Elements in Peruvian Art*. Nagel. p. 44

'corporate style', (2017) *Tales of the Moche Kings and Queens: Elite Burials from the North Coast of Peru*. [Video] Peabody Museum of Archaeology & Ethnology. *youtube.com/watch?v=4pI21jI6vfY*

'portrays a ceremony in which the central participant . . .', Bawden, G. (1996) *The Moche*. The University of Chicago Press. p. 284

'**afflict and destroys the body, but also affects the mind . . .**', Hoyle, R.L. (1965) *Checan: Essay on Erotic Elements in Peruvian Art*. Nagel. p. 87

'**the knowledge of death deepens the abyss of eroticism . . .**', Surya, M. (2002), *George Bataille: An Intellectual Biography*. Verso. p. 450

'**Imperial Caesar, dead and turn'd to clay . . .**', Shakespeare, W. *Hamlet*. Available at www.gutenberg.org/files/27761/27761-h/27761-h.htm

Repair

'**repairing animals**', Spelman, E.V. quoted in Lowinger, R. (2011) Repair. *Change Over Time*. University of Pennsylvania Press. 1(1). pp. 138–144

'**People always ask me: how could you drop it?**', Ai Weiwei quoted in Beres, T. W-Y (2015) A Battlefield of Judgements: Ai Weiwei as Collector. *Orientations* 46(7). pp. 87–92

'**the curious ability of inanimate things to animate**' to '**tendencies of their own**', Bennett, J. (2010) *Vibrant Matter: A Political Ecology of Things*. Duke University Press. p. 6

'**Everything that has a shape, breaks**', Kemske, B. (2021) *Kintsugi: The Poetic Mend*. Herbert Press. p. 17

Image Credits

p. 6 © Orion/Natalie Dawkins

p. 22 – The Metropolitan Museum of Art. MET public domain image/Mary Griggs Burke Collection, Gift of the Mary and Jackson Burke Foundation, 2015.

p. 40 © Alamy/The Natural History Museum

p. 64 – From the collections of the Crafts Study Centre, University for the Creative Arts, 2023.133.

p. 84 © Orion/Natalie Dawkins

p. 104 © Alamy/Associated Press

p. 122 © Alamy/World History Archive

p. 142 – From the collections of the Crafts Study Centre, University for the Creative Arts, P.74.191.a-w.

p. 160 © Alamy/INTERFOTO

p. 182 © Orion/Natalie Dawkins

p. 200 © Ray Meeker

p. 216 © Jennifer Lucy Allan

p. 234 © Orion/Natalie Dawkins

p. 250 – Art Institute of Chicago Public Domain. Gift of Nathan Cummings.

p. 266 – The Japan Folk Crafts Museum